emotional
content:
how to create paintings
that communicate

BY GERALD BROMMER

international
artist

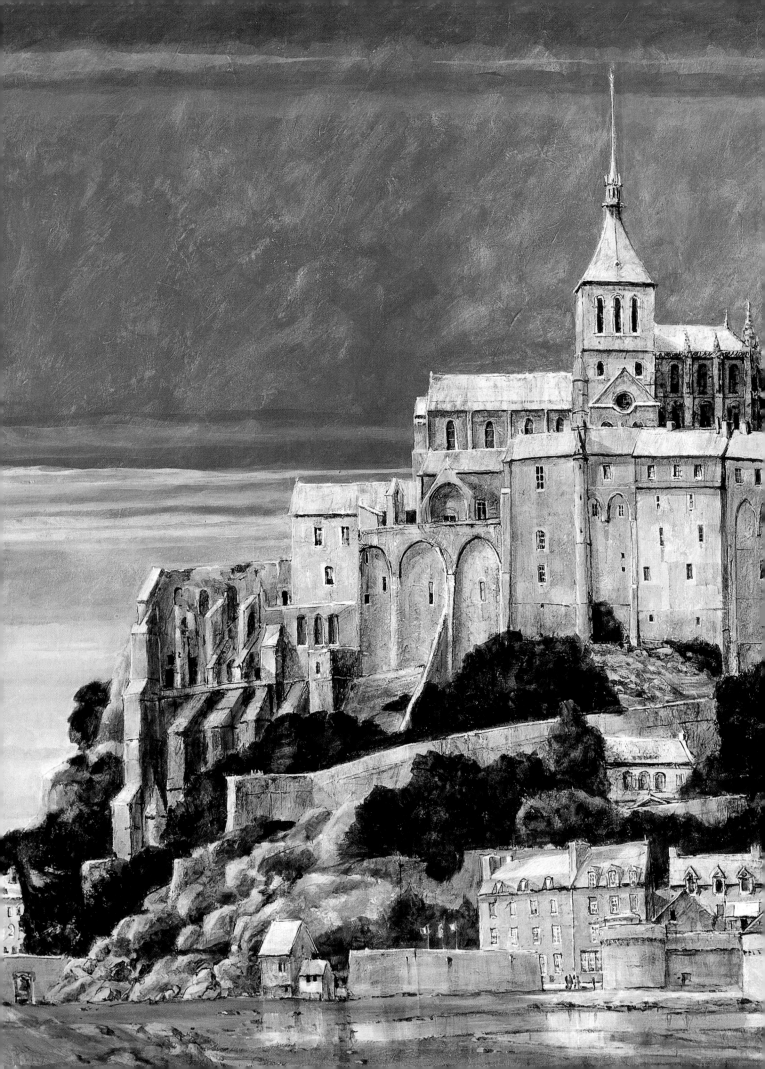

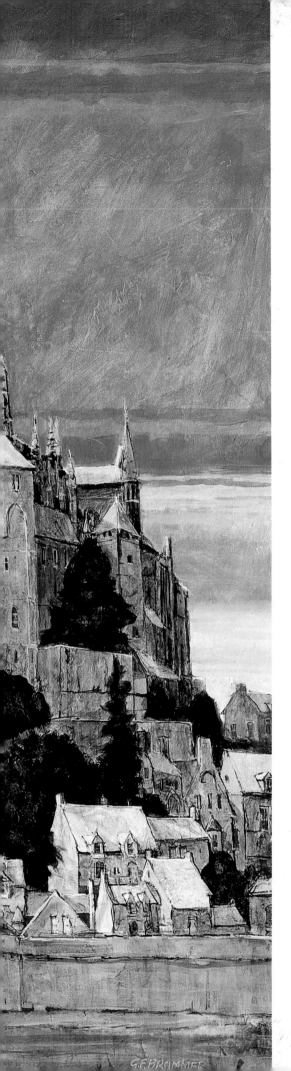

emotional
content:

how to create paintings that communicate

BY GERALD BROMMER

international
artist

international artist

International Artist Publishing, Inc
2775 Old Highway 40
P.O. Box 1450
Verdi, Nevada 89439

Website: www.intenationalartist.com

© Gerald Brommer

Edited by Terri Dodd
Designed by Vincent Miller
Typeset by Ilse Holloway
Editorial Assistance by Dianne Miller

ISBN 1-929834-25-X

Printed in Hong Kong
First printed in hardcover 2003
07 06 05 04 03 6 5 4 3 2 1

Distributed to the trade and art markets in North America by:
North Light Books,
an imprint of F&W Publications, Inc
4700 East Galbraith Road
Cincinnati, OH 45236
(800) 289-0963

Preface

Painting is sharing our love for our

This book is written for several interesting but different reasons. During 2002, I was asked by Vincent Miller, publisher of *International Artist* magazine, to write a series of articles for that honored publication. Since I had run into many questions in recent teaching situations that concerned the purposes of landscape painting and the meaning of form and emotional content in painting, I decided to write the four-part series on content in landscape painting. Artists' responses to the series were favorable enough that Vincent Miller asked if I would like to write a book on this important topic.

Since the 1960s I have written more than twenty books, many of which were resource books for American high school art teachers, while others were art text books for middle, high school and junior college art students. Several books on collage techniques were also written to assist interested artists in understanding and working with the dynamics of that exciting medium. And after thirty-five years of writing books, I had thought I was out of steam when it came to authoring another book.

Acknowledgments

THANK YOU . . .

— to Georgia, my wonderful wife of 55 years, who has been an essential part of all my art activities, encouraging me with unflagging enthusiasm. I love you.

— to Vincent Miller, Publisher, who asked me to work on this book, and who has made marvelous contributions to art through his magazine, *International Artist*.

— to Terri Dodd, Editor and Executive Publisher, who responds warmly and expertly to my ideas and who is the most busy and organized person I know.

— to my students of all times and ages who constantly ask the questions that make me verbalize my thoughts. You are the reason I teach and write.

— to all my fellow artists who share ideas and concepts. I learn from you constantly — from your work (which I cherish) and your words (which I heed).

— to the many people who have enriched my art life with their help in publication, organizing workshops, and directing the galleries in which I show.

— and most importantly, to my ever-gracious God for opening and closing doors that have provided direction for me and my work. I am continually and deeply grateful. To Him be the Glory!

Paiting on previous page:
Sunshine After The Rain, Mont St Michel,
acrylic and collage on canvas, 48 x 48" (122 x 122cm)

subjects

But Vincent Miller's interest and request, together with the recent interest of artists in my workshops that dealt with emotional content in landscape painting, provided the impetus for working on this book.

What I teach you applies to any subject

I am fascinated with painting landscapes, with the reasons for painting landscapes and with the process of reading those reasons in the work of other artists. This book is an attempt to understand and satisfy the necessity for expressing personal responses, reactions and feelings through visual art — and in this case through landscape painting. However, I would like to add that while the emphasis in this book is on landscape, I would not like to limit exploration to painters of the landscape, because what I will say about landscape painting can easily be translated and applied to any type of subject matter.

It's not just "how we do it" but "why we do it"

The book is not a "How to do it" book, it is a "Why we do it" book. I hope to explain many of the reasons for painting landscapes and the kinds of visual messages we can select, delineate, clarify and share in our work. Art is visual communication, and if the landscape is our chosen subject matter, we want to find ways to communicate our feelings about and our responses to the environment — both natural and human-built.

Listen to the wise words of my friend, Milford Zornes: "I happen to think the banyan tree is the most fascinating thing there is. And nobody else I know is carried away by banyan trees. So I try to take my excitement and add to it my ability to design a

Kona Memory, watercolor, 15 x 22" (38 x 56cm)

painting, hoping that color and line will conspire to say something dramatic and poetic through this tree. Then I feel I have something to communicate."

Painting is more than making pictures

One of the most difficult aspects of putting this book together involved the selection of work to illustrate the many concepts that concern emotional content in landscape painting. I have cataloged over 5000 slides of my paintings and the search for suitable examples was both enjoyable (I haven't looked at most of the slides for a long time) and daunting (there were so-o-o-o many from which to choose). I am sure that in some cases,

there are better examples hiding somewhere in my complicated filing system.

Painting is more than making pictures — it is sharing the love of our subjects with people who react to our feelings, understandings and the love we have in common for the environment. The landscape is a fascinating and ever-changing subject that provides an incredible range of experiences and visual resources from which to work. What we share and express about the landscape in our paintings is emotional content. How can we do that? Let's find out.

Enjoy the process.

Contents

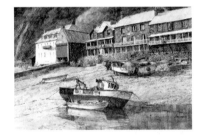

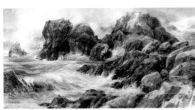
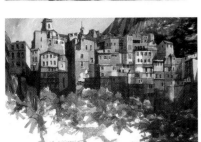

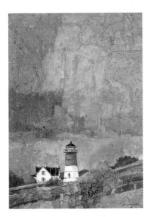

Introduction

The one dynamic experience that changed forever my reasons for painting

Without emotional content we make pictures; with it, we create art.

I always enjoyed "doing art" from as far back as I can remember, and as a child I had wondrous dreams of becoming an artist of some kind. But the Great Depression sort of put an end to such dreams. It was hard enough making a living in those days — let alone make a living in the fine arts. Since my second love was being outdoors, traveling and geography, I decided to major in the exciting field of geography, intending to become a teacher. To that end I studied the landscape — not as a painter might look at it, but as a geographer who needed to understand climate, weather geomorphology, geology, urban development and planning, human adaptation to the environment, ecology, plants and their adaptations, river systems, and so on.

It is no wonder then that many years later, when painting finally became a powerful force in my life, I chose to work with landscapes as my primary subject matter. It reflected my life-long fascination with the natural environment and my love and appreciation for its God-directed order and beauty, and for nature's characteristic aspects at home and in various parts of the world.

Beginning my career in art

After obtaining my initial degree in education in 1948, I began teaching geography, art and everything else in elementary school, and enjoyed that incredibly energizing experience for five years. I then "graduated" to high school, teaching both geography and art at Lutheran High School in Los Angeles. It was here, working with rooms full of eager drawing and painting teenagers, that I felt the exhilaration of the teaching/learning process. I furthered my art education by attending evening, Saturday and summer art classes with the best available teachers at both Otis and Chouinard Art Institutes, and at our two Southern California universities, USC and UCLA. I felt I was going in the right direction with my teaching career, but had not yet been bitten by the desire and need to paint for myself.

And then it happened!

While on a golfing trip to the Carmel/Monterey area of California during a Thanksgiving week vacation, we ran into a spate of bad weather. We played in the rain one day at Pebble Beach, and the following day a drenching downpour kept even us avid golfers off the courses. The four of us decided to spend the day sightseeing and drive inland to see if we could escape some of the downpour — but to no avail.

And then, in the village of Carmel Valley, we stopped at a wonderfully quaint building that was formerly a milk processing structure, but had been transformed into an art gallery. While my three friends remained dry in the car, I got out to look in the gallery window. The gallery was closed, but on an easel facing the window, and beautifully lit, was a painting that transfixed me — body and mind.

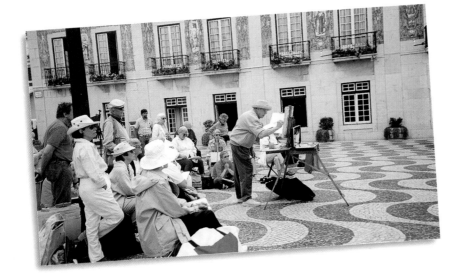

I love to teach — and in plein air workshops I teach in three ways:
1) by brief demonstration and discussion in the morning,
2) by individual assistance during the planning and painting processes, and
3) through critiques, after the work sessions are over.
This demonstration was taking place in Cascais, Portugal, and of course included several local critics.

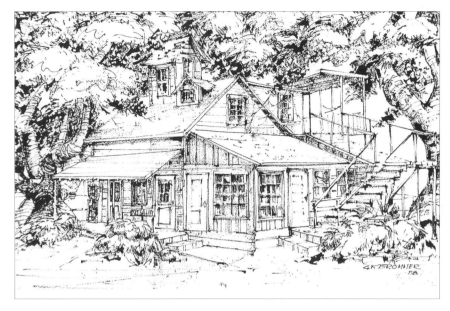

Carmel Valley Gallery, **stick and ink drawing,18 x 24" (46 x 61cm)**
A few years after my eye-opening experience with Donald Teague's painting (see text) and the birth of my watercolor painting life, I returned to the quaint milk-processing-building-turned-gallery and made this sketch with a stick and india ink. Teague's painting had been shown in the window nearest to us.

It was the work of Donald Teague, a marvelous watercolor artist who had portrayed the deck of an old sailing vessel with ropes, masts and sailors wrapped up in a marvelous tangle. He had conveyed the feeling of intense activity, brilliant sunshine at sea, even the noise of the activity and the saltiness of the air so clearly that I can still see that painting in my mind — and that was 46 years ago. It was awesome! I stood for fifteen minutes, drenched to the skin, and feasted my eyes on that painting — a happening that certainly turned my life around. I finally got back into the car and announced to my golfing buddies, "That is what I want to do! If a painting can excite me into standing for fifteen minutes in a rainstorm, I would love to touch other people like that."

Not just making pictures, but making powerful statements

Donald Teague became my hero. I never tried to paint like he did (few people could) but I wanted to share with other people in a visual way, my thoughts and feelings about my beloved natural environment and the activities of those who peopled it.

I understood years later that Teague's painting was not just a picture, but a powerful statement about a subject that he loved so much that he wanted to share it with me — and hundreds of other people. That was when I realized that I wanted to be a visual artist and share my love of nature, and be able to convey thoughts, ideas, concerns and information to viewers with paint and paper. And that is what art is all about. It was the beginning of a long and wonder-filled experience with watercolor and with

painting — an experience that is an on-going affair.

All my training and background as an art educator, plus my sheer enjoyment in the processes of painting, have melded together into a perfect combination for me.

I love to teach, having taught young people for twenty-six years and adults for twenty-seven years. I continue to enjoy teaching twenty or so workshops every year, all over the world. I love to paint, and am able to supply five galleries with work all year long, and a bit extra for yearly solo exhibitions. My wife Georgia and I share a passion for all the arts, and our myriad activities enable us to meet and talk with countless other people, in galleries and workshops — people also interested in the arts. It has been and continues to be a tremendous blessing in our lives.

The four basic elements in the painting process

Over the course of the past forty years, I have written more than twenty books — mostly resource books for art teachers or textbooks for use in middle and high schools. All of these books emphasize techniques, design, and control of several media because

I wanted to help artists (young and older) understand how technically to make better paintings, prints collages, drawings or sculpture.

This book will not attempt to do that. There will be a few explanations and demonstrations that describe some of the processes I use, but that is not the ultimate purpose of this book. There are many books that already do that. What I want to help you understand is the reason why we artists paint — how we visually express ourselves through our paintings, regardless of the medium we use or the subject matter that we love.

I would like to reiterate the four basic elements in the painting process:

1. **Technique** — how we make marks or put down paint.
2. **Drawing** — the ability to see and record what is in the world around us or in our mind.
3. **Design or Composition** — which helps us organize the many components in our painting.
4. **Emotional Content** — the personal expression of our feelings and attitudes about our subjects.

When I was beginning to paint, the first three elements were extremely

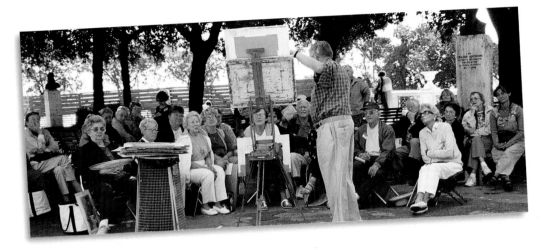

This critique session was happening in Pienza, Italy, where the class gathered in a small shady park after painting all day in town.

important, as they are with all artists. At that time I remember hearing experienced artists talk about emotion, feeling and the expressive content of paintings. I thought that was just old artists talking. In my struggles to make effective washes, draw with flair and certainty, vary my edges or create visual movement to a dominant focus in my work, I could not be concerned with expression or content.

Finding the power and importance of emotional content

Gradually I began to realize, however, that emotional content is the most important aspect of art. Without emotional content, we make pictures; with it, we create art. If we believe that art is visual communication, then we must communicate — visually instead of verbally. Donald Teague's painting touched me so very much, not because the ropes and people were so well painted, or the color was vital and intense, but because he was telling me how much he loved that difficult and strenuous activity on the high seas. I felt the tension and exhilaration of sailing without even being on a ship. I read his message loudly and clearly, but did not understand why, or how he accomplished that.

Let me tell you how I got my first inkling of the power and importance of emotional content in my own art. Some years ago, a young couple bought one of my paintings of Yosemite National Park in California. It was loaded with rocky textures, subtle color, powerful granite cliffs and good summer morning light — the essence of the valley. They wanted the painting because it reminded them of their courtship and honeymoon in Yosemite and they said the painting really felt like they remembered Yosemite to be. That was good. Then, some five years later, Dr. Yamamoto, the husband, was in the gallery for my reception that year — by himself. The couple had divorced and the wife had taken the painting in the settlement. And now, Dr. Yamamoto

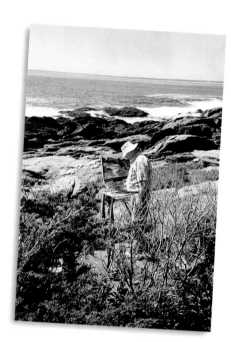

I love to paint outdoors — although it is much more lonely than painting in a workshop class, it is a most exhilarating experience. I am painting here on the rocks in front of Winslow Homer's studio and home in Prout's Neck, Maine.

" He wanted to meet the artist . . . I held out my hand to shake his, and he stepped forward and put his arms around me and wept and thanked me for bringing the real Yosemite back into his life. At that moment, I fully understood the powerful communicative aspect of art. Wow! How can a little watercolor paint on a piece of paper do that?"

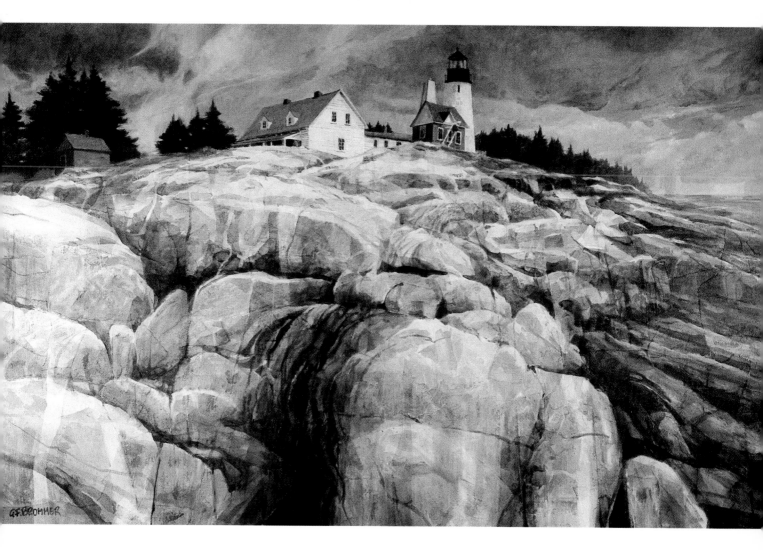

was back. In the midst of the reception's din, he sat quietly in a chair studying a new painting of a different aspect of Yosemite. As he pondered the new work, he kept referring to a photograph of the painting they had purchased together. Back and forth he looked, back and forth for close to forty-five minutes. He finally rose, went to the gallery director and said he wished to buy this new painting, and would like to meet the artist. As we were introduced, I held out my hand to shake his, and he stepped forward and put his arms around me and wept and thanked me for bringing the real Yosemite back into his life.

At that moment, I fully understood the powerful communicative aspect of art. Wow! How can a little watercolor paint on a piece of paper do that? He wasn't reacting to my technical skills or responding to my drawing ability or to the design and composition of the painting — but to something far more important and meaningful— to emotional content. He responded to the love I had put into that work, to the feeling of nature's strength that I had communicated, to the powerful sense of place, and to my personal visual insight.

That was one dynamic experience that changed forever my reasons for painting. I now realized that although technique, art theory, drawing skills and design were still extremely vital, they are simply very important tools to help me communicate my feelings to others. My purpose for painting and the direction of my art were changed because of that encounter.

Hopefully, this book will help foster an understanding of emotional content — which is the ultimate quest of the artist.

***Clearing Storm, Pemaquid Point,*
acrylic and collage on canvas,
36 x 60" (91 x 152cm)**
I have often painted the lighthouse complex at Pemaquid Point on the Maine coast, but never with this much energy and striking drama. Using the combined resources of on-site sketches, several photographs and indelible memories, I chose to emphasize the weather (a passing storm) and the natural environment (tortured rocks) to depict the drama and power of nature, together with the fragility and tenacity of humankind.

Emotional content

The lighthouse and rocks could have been much more benign, but when this was painted, I was overcome with the desire to express this dramatic struggle, and the inevitable coexistence of people and the natural environment.

Chapter 1

What is content?

Content is not the subject or things in the painting. Content is the communication of ideas, feelings and reactions connected with the subject. It is emotional content. When we look at a painting, its content is what is sensed rather than what can be analyzed. It is the ultimate reason for creating art!

Several years ago I was working on an art dictionary intended for middle and high school art classes and libraries. When it came to determining a definition for "content", I was awe struck by the variety of statements by various authors. I must have had ten or more existing art dictionaries on my desk, none of which actually agreed on what content is and only a few that provided suitable definitions of content. I began to realize that in the field of visual art, definitions are often confusing, and are the products of individual artists, teachers and authors — we do not have many commonly used definitions on which we all agree. To those outside our field, I am sure this is quite a mystery and a troubling aspect of our unique discipline.

In this book we will naturally work with my concept of emotional content — that it is what is said about the subject we have painted. It is not the physical subject matter in the painting, but what we relate about the subject through our art — how we visually describe it and tell others about our reaction to it.

Working with visual adjectives

Notice the words used: "describe", "what is said", "what we relate", "tell others". These words and phrases imply communication — visual communication which is, of course, a concise definition of art. What we supply through the content in our work are visual adjectives that describe our location, a building's texture, the warmth of sunshine, the devastation of a storm or the condition of a person.

For example: the subject of a painting might be a barn as seen from a field. If I say, "I see a barn near a field", I have told you nothing. Every person who hears me would envision a different barn and field. But if I say, "I see a huge gray barn", you are already seeing it more like I see it. If I add, "with a large and faded Pepsi-Cola sign on one side, a decrepit roof that sags from old age, splintered boards and shingles — some of which are missing and large doors that hang askew from rusted hinges", you will see and feel almost

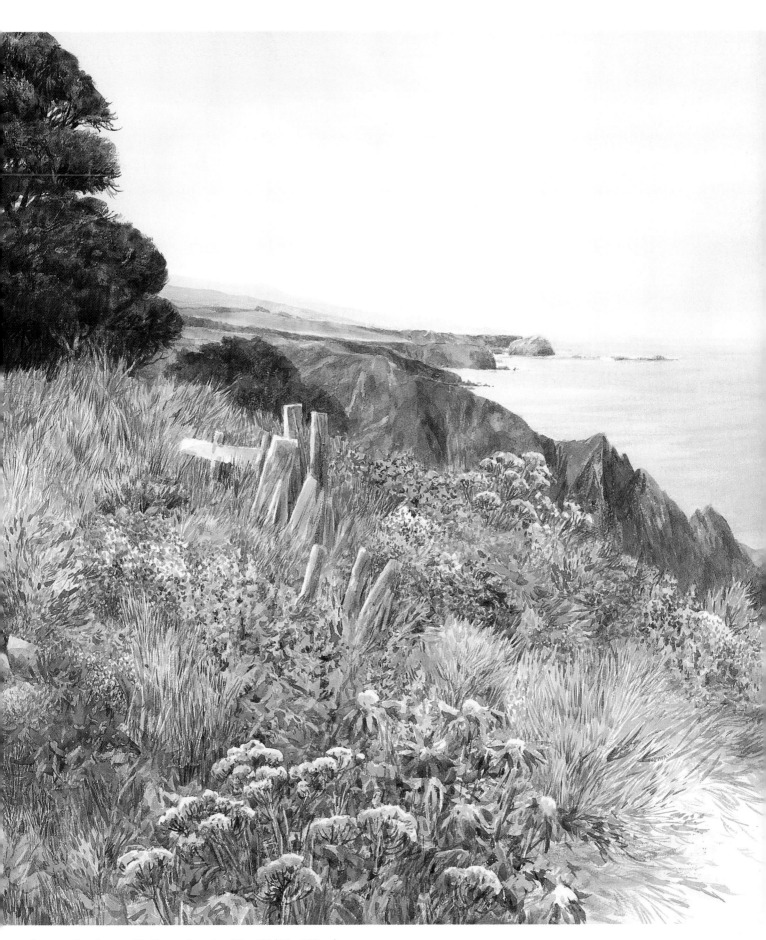

Summer Landscape, Big Sur, watercolor, 30 x 40" (76 x 102cm)

the same barn I am seeing as I am describing it. If I add the fact that the field is full of wind-whipped and dry weeds that have not been mowed in several months, your image of the location is further enhanced.

Such verbal adjectives help define my statement about a barn. In painting, visual adjectives do exactly the same thing. They help describe our image of the barn to viewers of our painting. If right now we all tried to paint the barn I just described, we would probably have nearly the same kinds of images to look at. That is how important the verbal adjectives are. Visual adjectives are just as important in communicating

our thoughts about a subject to our viewers.

Emotional content describes the message

When I was still teaching art in a Los Angeles high school, my definition of content for my teenage artists was simple —"Content is the reason for making the painting". It answers the question, "Why do I want to paint this subject?" The answer is the emotional content — "I want to paint this painting because . . . perhaps because I want to share the characteristic conditions, colors and textures of the scene I am putting on paper with other people or I want to communicate to them how

I feel about this subject or idea or how it affects me."

The emotional content visually describes the message we wish to share with or communicate to others.

Emotional content is the communication of ideas, feelings and reactions connected with the subject. It is the ultimate reason for creating art! A picture that looks good but doesn't tell us anything about the subject is just like a book with words that sound good but have no meaning — the result is gibberish.

Visually, emotional content communicates the spirit of a place, person, idea or thing as sensed and

How the concept of emotional content works

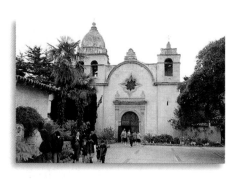

The scene
The subject of this painting is the sturdy mission built under the direction of Father Junipero Serra over 100 years ago, in Carmel, California. I have sketched and painted it many times, each time with a different emphasis. Over the years I have met and known a succession of gardeners who each had his own concept of how the mission gardens should look. One of my favorites was Tom, who could never plant enough flowers to please him. I thought of him as I started developing the concept for this painting in my studio.

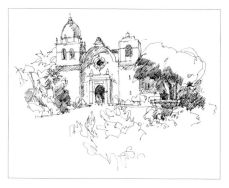

A factual sketch
I had several photographs and a dozen or more sketches from which to work, if I needed them. I decided to use two sketches, this one is rather factual.

An interpretive sketch
My second sketch is full of personal interpretation and joy.

*__Mission Dream — The Garden__,
__watercolor and collage, 15 x 22" (38 x 56cm)__
I planned, on the basis of the second sketch, to push the mission building far back in the painting and emphasize the garden — No! Actually to over-emphasize the garden! I added an acre or more of flowers to the grounds which would have made Tom ecstatic. The flowers then became more important than the structure. (This watercolor and collage process is demonstrated on pages 74-75)*

Emotional content
The emotional content concerns the garden's glorious color, its variety of textures, a love of flowers, the wonderful witness they bear to their Creator and the abounding joy they bring to the gardener, the visitors and also to me. In this painting, the mission building is secondary, and although the grounds do not look like this (I wish they would), they feel the way I wished to make them at the time the work was painted.

felt by the artist, and put not just onto but into the paper or canvas so viewers can share the artist's insight and feelings about the subject.

Developing and using content

There is no formula for capturing the spirit of a subject because it is so personal. Each artist sees and feels differently about the same subject. The feeling I get from watching a sail boat pirouette in a brisk breeze is quite different from the feeling other artists might have about the same scene or event. Therefore, we will all paint it differently, each emphasizing what is significant and most appealing to us.

Even with no sure formula for success, it is possible to better understand what emotional content is and learn how it can be used to make more personal, powerful and vital visual statements. Eventually we can grow into that realm of art where content is the lifeblood of painting.

How can we develop and use this understanding of content? It begins with discerning the difference between "form" and "content", two words we flip around as easily as ordering a morning cup of coffee.

Form involves drawing, design, painting techniques, composition and the subject matter – the things in the painting or the physical aspects of art. Naturally, these are important in the creation of a painting, but are not sufficient and driving reasons to paint.

Content refers to the meaningful substance of the work — the spiritual or emotional aspects of painting. Why was the painting made? What ideas and concepts of the artist can we sense? Can the personality and sensitivity of the artist be felt when studying the work? What is the artist telling us about the subject? What response do I get from the message of the artist? Do I know the artist better because I have studied the painting? Ultimately, this is what painting is all about!

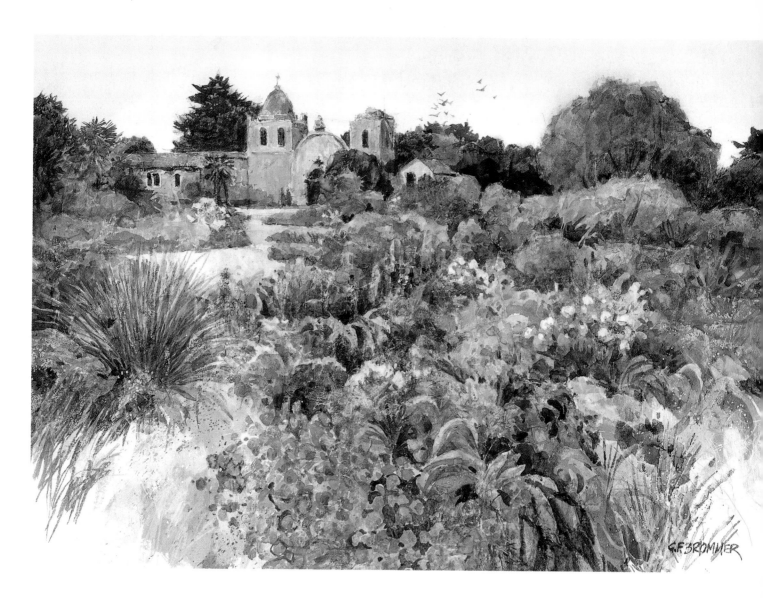

Is emotional content something new to art?

Absolutely not! Although there have been different emphases throughout history, content remains a powerful force that makes art a vital part of all the world's cultures. There are two basic directions in which content can be used: classic, or intellectual and romantic.

The classical art vocabulary includes: order; emphasis on design and composition; a cool and analytical approach to the subject; the use of rules; an emphasis on neat, clean arrangements and proper proportions; abstraction; and an excellence of realistic drawing.

Aspects of a romantic approach to art include: an active and colorful interpretation of the subject; a necessary interaction with the viewer; use of distortion; personal approaches to the subject; a strong interest in nature; emphasis on personal feelings; a sense of place, and so on.

Emotional content is used in both of these extremes, and a myriad of personal directions in between. When we use the word "classic", we are referring to a cool and analytical approach to the subject. Historically, classic art includes the Golden Age of Greece the Renaissance, Neoclassicism, Cubism, Abstractionism, Super Realism, Op and Pop Art, and so on, all of which were made by artists whose content was based on order and control.

When we use the word "romantic" we are referring to a personal, emotional approach to the subject.

Hellenistic Greek Art, Roman, Early Christian, Byzantine, Romanesque, Gothic and Baroque art; Romanticism, Realism, Expressionism and Abstract Expressionism forms of art were all made by artists whose work was based on personal feelings and aesthetic expressiveness.

All of the fine artists during these periods and movements were speaking from their hearts when thy painted, even though their personal visions were extremely varied. It is not the painting style, subject, technique or medium that determines content. Instead, it is the honest presentation of the artist's concepts and the personal communication of ideas, responses, spiritual convictions, social commentary and individual convictions that describes emotional content.

Emotional content in a painting is not something you can visually determine or analyze, but is something that must be instilled by the artist and sensed and felt by the viewer.

Though we can probably name some artists that are at the extremes of classicism and romanticism, most artists fit in between someplace. Most painters are interested in some degree in both design and expression; both form and content; both formalism and freedom of expression. It is advantageous that we strive for a balance of sorts between the two extremes and paint to satisfy our personal goals, directions and attitudes. That is what makes painting such an individualized form of personal communication.

In the pages of the book that follow, I will use the landscape in all its aspects as subject matter, and the communicative processes of painting and collage will reflect my personal convictions and my individual sense of expression as it relates to the natural environment.

Remember that what I say and emphasize is vital to my own way of thinking and working. It is applicable to an extremely wide range of subjects and means of expression. The important aspect of the landscape painting process is that we honestly speak from our hearts when we visually describe the world as we see, react to it and feel it.

Clues to Emotional Content

To jump-start the process of understanding emotional content and making it a vital aspect of your work, consider these sensations or feelings about places or things. They are clues to content.

Feel the heat	*The weight of steel of bronze*
Feel loneliness	*Hear the noise of a marketplace*
Feel the power of the waves	*The pounding sound of the surf*
Sense the humidity	*Hear the slosh of water*
The aching of peeling paint	*Express holiness*
The silence of velvet	*Sense the dryness of the desert*
Feel the bulk of a hill	*The crispness of starched linen*
Make a wagon express its carrying power	*Show the elegance of an oak tree*
Feel the texture of a rock	*Paint the weight of a stone wall*
Feel the ominous power of a storm	*Sense the power of wind*
See swaying waves of grass	*Paint the smell of a flower garden*
The grainy quality of sand	*Feel the shiny surface of a car*
The sound of fog or snow	*The clinging nature of dry thistles*
The crisp chill of ice	*The warmth of terra cotta*
Sense solitude on the shore	*The noise of crumpled paper*
The power of water	*Describe the wispiness of clouds*
The softness of fur	*The patina of time*
The crispness of a spring day	*The coolness of deep shadows*
The weight of a boulder	*The dreariness of rain*
The mustiness of an attic	*The drooping of a willow tree*
The shiver of cold	*The clutter of a desktop*
The mistiness of fog	*The taste of salt spray*
The texture of granite	*The warmth of evening light*
The congestion of small streets	*The lushness of the tropics*
	The color and texture of a Tuscan wall

Three examples of different expressions of content

These three works provide an sampling of the wide range
of expressive content possible in art.

Black Mesa Series #12, monotype print,
18 x 26" (46 x 66cm)

Content Design

*Several years ago I became interested in the printmaking process
of monotypes, where oil printing inks are applied to a plate which
is run through a press to transfer the image (in reverse) to paper.
I worked once or twice a month in a printmaker's studio, making
a dozen or more images a day. The direction of many of my
monotypes placed emphasis on cool design and structure — or
abstraction. Design became emotional content. In this painting,
the colors are bold and intense, and the landscape subject is
reduced to a few simple shapes.*

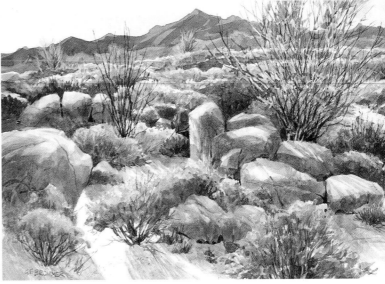

Morning Light, Palm Desert, watercolor,
15 x 22" (38 x 56cm)

Content Complexity of rocks and vegetation backlit by the desert sun

*This watercolor painting is nearly the same subject — a desert scene
in the American Southwest. The landscape was painted on location
and emphasizes the rocks and vegetation back-lit by the rising
desert sun. It features the complexity of these nearby elements
while the simplified mountains recede into the distance. Note that
the subjects of the two works are similar, but the emotional content,
techniques and treatment are vastly different.*

Cruciform 87, watercolor, acrylic and collage on board,
11 x 11" (28 x 28cm)

Content Design

*This third image has no relation to the other two, except
for an emphasis on design. It is a demonstration project
from one of the design classes that I teach. It is non-
objective — having no recognizable subject matter at all.
The cruciform design format is used to establish the
concept of visual movement to a focus. What is it about?
What emotional content could there be? It is designed to
tell us about movement and focus, which is its prime
emphasis — therefore its content. Here, effective design is
delivered as emotional content.*

Cannery Row,
watercolor and collage, 24 x 36" (66 x 91cm)

Emotional content The smell of the salt air

*Cannery Row in Monterey no longer exists. There is
a huge aquarium in its place. The painting was made
in 1976 using an old photograph and several sketches
as resource material. My thinking at the time was to
emphasize the weather-beaten structures as living
memorials to past sardine-fishing activities on the
Monterey peninsula. The dreary weather, low tide,
worn boards, rust and dilapidation contribute to the
emotional content. The smell of the salt air was a bonus.
This group of structures seems both age-resistant and
ready to collapse at the same time. Needless to say,
I have painted it many times in many different ways.*

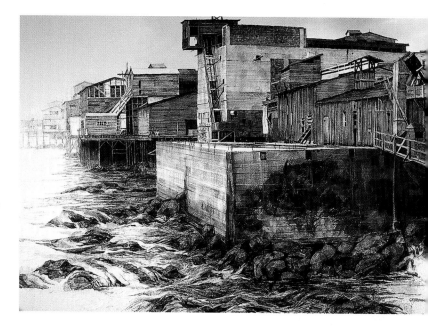

Afternoon Light/Lyme Regis,
watercolor, 22 x 30" (56 x 76cm)

Emotional content The dramatic light

*This special and powerful momentary vision was
photographed, and later painted in the studio. The
drama is created by looking into the fading afternoon
sun at Lyme Regis in England and it provided the
impetus for this painting. People, sand bars and coastal
structures are silhouetted against the powerful glare
of the sky, which is repeated in the still water and wet
sand. This nearly black and white drama is the emotional
content. I want you to feel the need to shield your eyes
from the glare and still enjoy letting your eyes follow the
many figures as they wander around the beach. You can
almost feel the light beginning to fade as you look.*

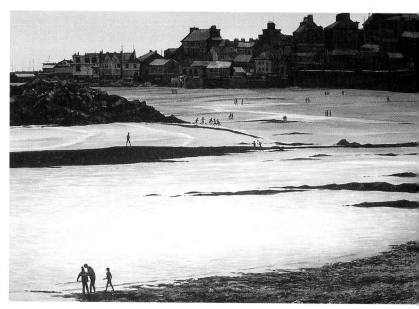

Walpi Remembered,
acrylic and collage on canvas, 24 x 48" (61 x 122)

Emotional content Sense of decaying history

*One is no longer permitted to photograph this subject
out of respect for the customs of the people, so the
painting was created from a very old photograph,
a sketch and lots of memories. Though this was once a
thriving Hopi village, it is now a mere echo of its former
stature. The Native-American cluster of adobe buildings
seems like a citadel, perched on an inaccessible mesa. Its
power (though diminished) can be felt as the structures
appear to emerge from the rock itself. It is still inhabited,
though in lessening numbers, but the daily activities
continue. You can feel the dryness, the isolation, the
on-going crumbling, the sense of history and the
continuing human activity as a new morning sun lights
up the village and life continues. (The technique used
for this painting is demonstrated on pages 100-102)*

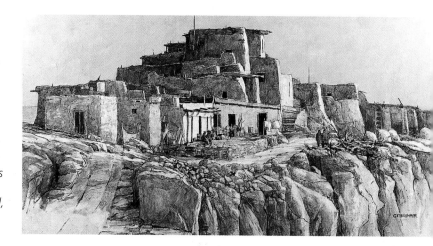

How does emotional content effect the viewer of art?

People do not come into a gallery and say, "Wow! Look at the design in that landscape painting. It is composed perfectly. I must buy it because of its great design." Collectors do not generally choose landscape paintings for their homes because of technique or design. Something in a painting must appeal or speak to the heart, spirit and soul of the viewer — and that is emotional content. Visual communication. Something in the painting must link the artist and the viewer and bond them. People appreciate and/or buy paintings with their hearts and not with their minds. Something in the work appeals to them so strongly on a feeling level that they desire to enjoy it permanently in their lives. A story might illustrate this connection between artist and viewer.

A perfect example of emotional content

Quite a few years ago, a couple bought one of my paintings from a gallery in Carmel, California. The subject was of a section of old Cannery Row in Monterey, the place that John Steinbeck made famous. It was a subject I painted often for many years. Five or six years later, we were visiting friends in Ventura, and after a church service, a woman approached me and asked, "You're Gerald Brommer, aren't you?" I said I was, and she proceeded to tell me how they had bought this painting and how it had enriched their lives. She said, "I used to live near San Francisco Bay and we miss that part of the country very much. But every morning when we pass our painting in the dining room, I look at it and . . . I can smell the salt air." Wow! She did not remark about how wonderful the boards were, or how nicely the water sloshed, or how perfect the perspective was, what a wonderful design format I had used — but she could smell the salt in the air! That is emotional content. When you can capture the essence of a place with such positive feeling that people can even smell the environment, you have touched something in them other than their intellect. When such a solid connection is made between artist and viewer, true communication has taken place. And content is the catalyst for that communication process. Emotional content therefore is at the heart of art. It is why we paint. We want to connect on this level with viewers and share our deepest feelings of a place with them.

Content can take on many forms, depending on what the artist wants to say in the work. Reading through several of these image captions will help in the understanding of content as found in landscape paintings. And more specifically, why I paint landscapes the way I do in various parts of the world with unceasing drive and enjoyment.

"The emotional content visually describes the message we wish to share with or communicate to others."

Really see things, not just their outward appearance

Before continuing into the hows and whys of emotional content, I would like to share with you a few words by Robert Henri, whose statements are contained in "The Art Spirit", the book his students put together after his death in 1929. They are excerpts of notes taken by students in his classes in New York, and I think of one passage when I study my finished paintings to see if I have really done what I intended to do.

A former student had sent him some paintings to critique, and this was Robert Henri's reply:

"I want to see these houses solid. I want them to feel like houses. I don't care about your drawing and your values — they are your affair. They will be good if you make me sense the houses and they will be bad, however 'good' they are if you do not make those houses live.

"I want more than the outline — of houses and I want more than the frames of windows. It is impossible for me to see only what the eye takes in, for the surfaces are only symbols. The look of a wall or a window is a look into time and space. The wall carries its history. What we see is not of the moment alone.

"Windows are symbols. They are openings in. To draw a house is not to see and copy its lines and values, but to use them."

You can substitute any landscape elements into this statement and the resulting paraphrase will tell you to emphasize emotional content in your work. Henri charges us to really see things, not just look at their appearances. Paint solidness, wear, age, history and color into your walls, so that they speak of the essence of the place. The same charge applies to all of landscape painting, regardless of the subject or its location on the face of the earth. In the rest of the book, I will attempt to help you understand how to do this.

Selectivity and editing are basic to emotional content

Here's where you discover that you have the power to choose what to put into your painting. And once you start that process, you are on your way to understanding emotional content.

What is Selectivity? Selectivity is choosing what to include in your painting.

I recently taught a workshop on the central California coast, in and around the village of Cambria. The first day's painting was done right on the driftwood-clogged beach, below orange-colored cliffs that were topped with a variety of trees and motel buildings. The Pacific Ocean was on our left and people were strolling in the sand. We couldn't possibly include all of that in our paintings — there was simply too much driftwood and an overload of other information; too many resources.

To exercise selectivity is to begin the emphasis on content

Each of the artists selected five or six elements to include in their paintings, leaving the rest alone. That sounded easy enough. Elements included:

1) several driftwood logs
2) the beach
3) some surf
4) a section of cliffs
5) some typical trees atop the cliffs.

Polperro Morning, watercolor, 22 x 30" (56 x 76cm)

When these were sketched as five individual elements, they could then be put into several arrangements for painting. A few other elements could be added as the painting progressed (a few beach walkers, some more pieces of driftwood, and so on). The resultant paintings were personal statements about the place. None of our paintings looked alike and none were replications of the place, but all were effective paintings that represented each personally-selected group of components that felt like Moonstone Beach on that August morning.

"Paint it the way you would

like it to be, not the way it is!"

Spring Coast, watercolor on collage, 22 x 30" (56 x 76cm)

By selecting important pieces of the environment, we were emphasizing emotional content, in this case our feelings about the major elements in this location.

The world is full of resource material and it is the responsibility of artists to select the elements from that world they wish to include in their paintings. It is futile to run around with a small mat or viewer, searching for the perfect or ideal landscape composition. Through selectivity and editing we make our own ideal landscape. What we select are the things that are the most important to each of us in that location — the things we want to show and share with our viewers. After this selection process, we go through an arrangement or compositional process and then we paint. Selecting, responding, composing and editing are vital activities that help us create the unique message we wish to share — which is the content of our work. The Moonstone Beach sequence illustrates the selective process from start to finish.

When working from photographs, the process of selectivity, composing and editing is exactly the same, and the same steps can be followed in developing a painting. The results of such a process are personal statements and not replications of a photograph or of a particular location.

1. Selectivity

Selectivity answers the questions, "What do I want to include in the painting?", "What do I want to show viewers about this place?" and "What touches me enough that I want to share it with others?"

2. Editing

To make the best possible painting that says what we want it to say about the place, we must eliminate what is not needed.

Art in the making Selecting, responding, composing and editing for emotional content *Moonstone Beach*

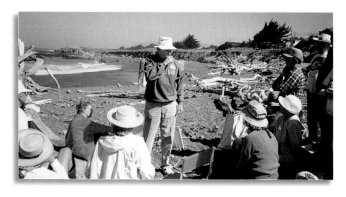

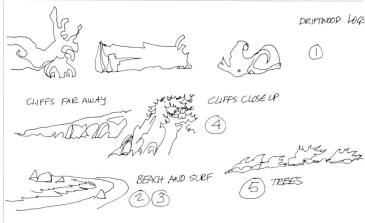

Let's begin this demonstration session on Moonstone Beach on the central California coast by talking about selective inclusion — what we might select to put into the painting. Which pieces of driftwood, which parts of the cliffs, which trees and rocks shall we each include? These are personal choices, not corporate decisions. Selection answers the question, "What do I want to include in the painting?" and "What do I want to show viewers about this place?" and "What touches me enough that I want to share it with others?"

1 Elements of the scene
Selected and isolated elements from this bit of coastline include: 1) driftwood, 2) beach, 3) surf, 4) cliffs and 5) trees. If each of these elements is drawn quickly and simplified, the artist will be very familiar with them and will easily be able to put them into a variety of arrangements.

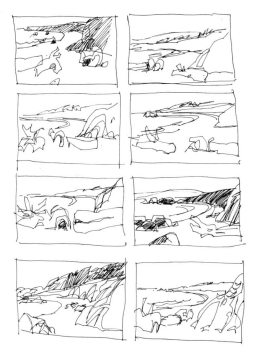

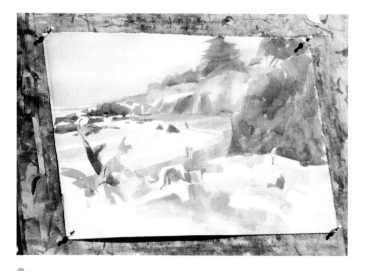

2 Mini-compositions in thumbail sketches
Eight possible compositions or arrangements were drawn quickly in the sketchbook as thumbnail sketches, mostly contour drawings. These should not be carefully planned and detailed drawings, but instant responses to the isolated elements and the place. Each mini composition was different and each emphasized a different aspect of the whole scene. Many more arrangements are possible simply by using this same group of elements. As you can see, an unlimited number of paintings could be made at this one location.

3 Beginning the painting
I took one of the thumbnail sketches and lightly outlined the major elements on a half-sheet of watercolor paper. In this first painting step, I quickly put down light values of local color with a large brush. In this instance I worked to fill the page with muted hues that suggested the foggy atmosphere of the place. Several other color arrangements could have been used. As you can see, my drawing board is nearly vertical when I paint on location.

What is editing?

If you understand what emotional content is, it follows logically that editing is a fundamental activity in establishing content. We usually associate editing with the publishing of newspapers, magazines, or books — like this one. The book editor's job is to go over every word I have written and correct spelling and punctuation, change words for better clarity, delete sentences and paragraphs that are not needed, or at least rearrange the written elements to make the best possible manuscript.

The visual artist's task is similar. Remembering that our desire is to make the best possible painting that says what we want it to say about the place, we must eliminate what is not needed, to do that we must:

- **Rearrange items for better composition.**

- **Change colors and shapes if necessary.**

- **Add whatever is needed to make the image as meaningful and exciting as possible.**

This process in the visual arts is also called editing. The guiding principle becomes: "Paint it the way you would like it to be, not the way it is!" If you want the tree bigger, make it bigger. If you want it darker, make it darker. If you want to make the scene feel like winter, then do it. If you want to add specific details, that is your choice. It is your painting and you are the editor-in-chief. Make all the changes, alterations, additions and deletions that you feel are necessary to fully express yourself about your subject.

This book is really about editing the landscape — making landscape paintings just the way you want them to look; saying what you want to say about your subject in your own words — in your own way. And the reason you edit is to better express and define emotional content in your work, to depict in the most effective way, what you want to say about the subject in your painting.

What is said about landscape painting in this book, is applicable to any subject matter and any medium.

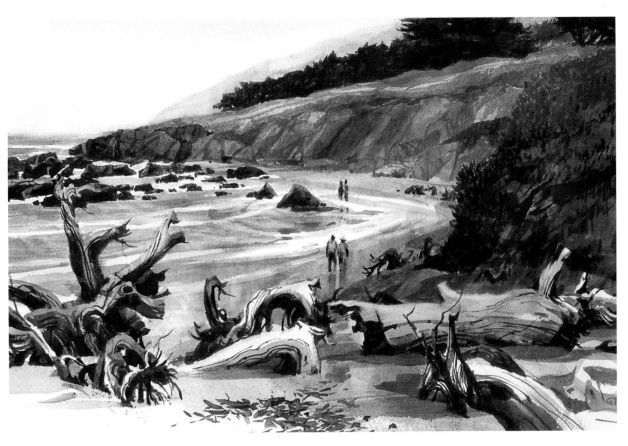

4 Finished painting —
Moonstone Beach, watercolor,
15 x 22" (38 x 56cm)

Emotional content

Other elements were added as the painting evolved and grew — a few more pieces of driftwood, lots of rocks, some people strolling on the beach, and so on, until the image reflected my response to the locale. The initial selective process is essential in gathering resources and homing in on the emotional content of the painting. The finishing process puts my personal stamp on the final image. It is now my painting about this place, which will be different from anyone else's painting about the same place. Both the subject matter and emotional content were of my own choosing, step by step. Which is as it should be.

Paint your own way, using your own responses

When I was in high school, I remember our English teacher assigning essays to write for the week, to be handed in on Friday. Some classmates (mostly girls) started working on Monday evening, doing research and beginning to write, while others (mostly boys) frittered away the week, and shockingly realized after baseball practice on Thursday that the essay was due tomorrow. So we went to the library to find resource material and look for information in encyclopedias. Finding just what we wanted, we copied the words verbatim. They sounded so good! Naturally, when the papers were returned, they were given a poor grade, accompanied by the comment, "Use your own words!" At first I wondered how the teacher knew these were not my words; they seemed to be just about perfect. Naturally, what we were supposed to do was to select and edit information from our resources and write what we had discovered in our own personal and inimitable styles. Lesson learned!

Does that sound familiar? As artists we are to go through exactly the same process — selectively gathering visual information, editing as we see fit and painting our responses in our own words — in our own ways.

What we say about the subject matter in the painting is

Art in the making Selecting and editing *Portleven*

The scene
This is Porthleven, on the Penwith peninsula of Cornwall. This lovely place was a sketching stop on one of our workshop tours in England. The photograph shows ideal (however atypical) weather conditions — no wind, no clouds, no rain, lots of sunshine, great shadows and reflections in the water. As the artists scattered to search for their own subjects, I zeroed in on this wonderful cluster of buildings fronting one of Porthleven's three harbor areas.

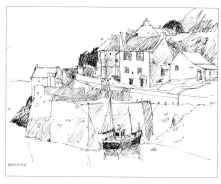

1 Editing my first sketch
As I started to draw in my sketchbook, I felt the need to edit as I worked. I liked the shape and position of the small structure on the left, and made it larger and more important. I eliminated the houses in the upper right corner because they were too important and bright. I wanted to feel the protected clustering of houses by the harbor. Although Porthleven is quite a large town, I liked the smallness of this grouping of structures and wanted to emphasize the sturdiness of the buildings and their ability to survive together in a severe location (although the weather today was superb). These were my selected elements, put together in a single sketch.

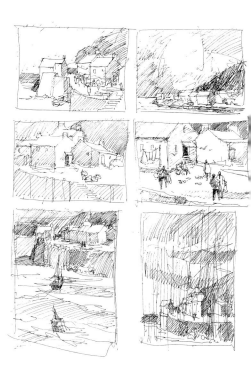

2 Working from the first sketch not the photograph ▶
These two panels of about a dozen sketches were drawn from my single sketchbook page, not from the photograph. They were part of a later workshop session back in the United States and are done on bond paper, each piece being 24 x 18 inches in size. They illustrate some of the possible compositional arrangements as well as some indications of possible weather conditions on the coast. My pen acts like

emotional content, and editing implies that we arrange and rearrange the visual elements in the painting in order to express that concept in the best possible way. To our personal satisfaction.

How I edit

In my own work, I edit by moving things around to improve the composition. I edit to simplify the subject, to create visual movement and establish the focal area. These are design activities in the construction of a painting, but they help me to create emphasis, which is the basis for emotional content.

My ultimate goal in every painting is to make a personal statement about my subject and about my reaction to it. Editing permits me to rearrange the scene in front of me (in nature or in a photograph) so I can express my feelings more clearly and make my own painting. It is one of the most enjoyable activities in the entire process of painting, and it is a powerful and dynamic way to begin the understanding of content in art.

The sequence involving a coastal village in England (below) will clarify the incredible range of possibilities in working with a limited number of elements.

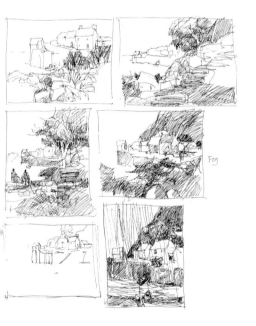

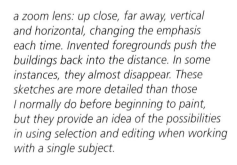

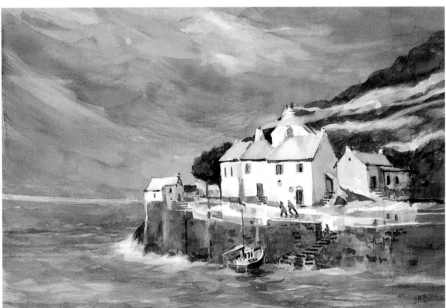

3 **Finished painting — *Porthleven on a Gray Day*, watercolor and gouache, 15 x 22" (38 x 56cm)**
Many dozens of paintings could be made from those sketches, but this was painted to emphasize the hard weather conditions and the sturdiness of the people and their homes to withstand such beatings. Again, editing takes place even when working from already edited sketches of the subject matter. The expanded space allotted to ocean and sky places emphasis on the stormy elements. Boats are rocking, people are leaning into the wind, fireplace smoke is blown horizontally, and it feels miserable — but the town has withstood many such storms and there is hope that the weather will clear and things will return to normal. Can you "feel" the windy coldness and wetness?

a zoom lens: up close, far away, vertical and horizontal, changing the emphasis each time. Invented foregrounds push the buildings back into the distance. In some instances, they almost disappear. These sketches are more detailed than those I normally do before beginning to paint, but they provide an idea of the possibilities in using selection and editing when working with a single subject.

Emotional content

In this painting, there is hardly anything of the original photograph and sketch, although some buildings may be recognizable. The painting stands on its own. It certainly is not a copy of a place, but a painting that has its own reason for being made — and that reason is its emotional content. It is based on resource material (the sketch and photograph) but has been edited to make its own powerful statement about the English coast and the strength and persistence of the people and buildings that continue to withstand the powerful forces of nature that batter away at them.

Art in the making Editing from beginning to end *Point Pinos Lighthouse*

Another editing sequence, this one developed while working in the studio from photographs and sketches, will clarify the entire selecting/editing process, from start to finish. It involves the Point Pinos Lighthouse in Pacific Grove, California.

Several photographs and location sketches were the basic resource materials. From them I selected five major elements as a starting point:

These five elements were combined in various ways to suggest many possible directions that paintings including these five elements could take.

Three paintings were based on these five elements, each started as a demonstration for art organizations in the Los Angeles area and each based on one or more of the sketches. You can see how the visual material changed in each case, based on what I wanted to express — what the content was.

With sketchbooks full of images and boxes full of photographs in our studios, the number of possible combinations of elements cannot be calculated. Study this sequence to gather ideas for your own work.

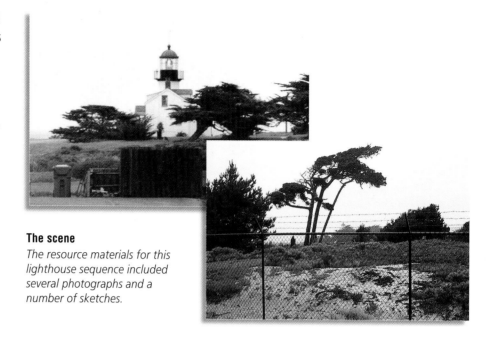

The scene
The resource materials for this lighthouse sequence included several photographs and a number of sketches.

Five major elements

1 *The lighthouse*

2 *A cluster of tall pine trees*

3 *A group of low cypress trees*

4 *Ground cover and small rocks*

5 *Cliffs and surrounding water*

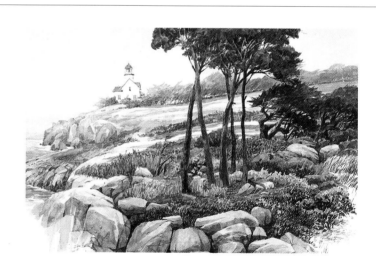

4 **Finished painting —** *Hazy Bright*, **watercolor, 22 x 30" (56 x 76cm)**

Emotional content

In this painting, I used all five elements, placing them to fit the feeling I wished to express. I like the central California phenomenon of filtered sunlight coming through a thin layer of gradually disappearing fog. I call this happening "hazy bright." I also wanted to capture a feeling of loneliness and distance from the rest of the world, so I added a few dark trees to provide stronger value contrast with the lighthouse in the hazy distance and the rest of deep space. By doing this I pushed those elements farther back into the painting. The water is calm, the air is still, and the cool palette suggests a chill in the air — the essence of this location.

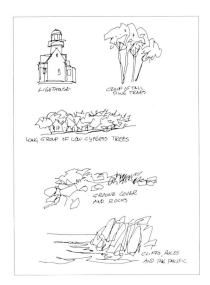

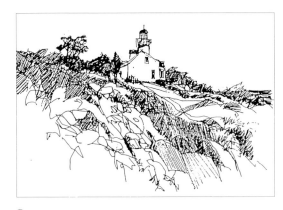

1 The five elements

I chose to use five elements from these resources — eliminating all the others. Emphasis was already placed on the natural elements in the area, with the focus on something that is different and contrasting — the geometrically shaped lighthouse structure.

2 My concept studies

I then began to sketch concept studies, using most or all of the five elements. My options included different arrangements, several formats and a variety of feelings, weather, seasons and combinations. These twenty-one brief sketches could easily have been expanded to fifty or more, each with distinct possibilities for painting. From this group I was sure to find one that was more appealing than the others — one that demanded to be painted. In making my choice, I would be emphasizing emotional content without being aware of it, because my choice would reflect my feelings about the subject and the place at this time.

3 Making sketches is the beginning of understanding

After making twenty-one sketches, I understood my subject very well, and the paintings that followed actually flowed easily from my brushes.

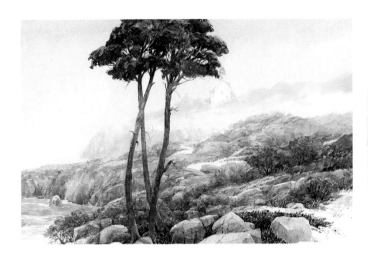

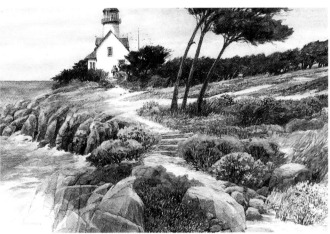

Here's another version

Through the Foggy Haze, watercolor, 22 x 30" (56 x 76cm)

The five elements are again represented in this painting, even though some are almost disappearing in the fog. They have been edited a bit and things are in different locations. The techniques used emphasize the cool, wet feel of dense fog. Now there is a reason for the lighthouse to be here. The things in the painting remain the same, but the emotional content has changed. There is a sense of cool dampness and the muffled sound that thick fog creates.

And another

Brisk and Windy, watercolor, 22 x 30" (56 x 76cm)

The third painting has a completely different feeling. What makes the difference? The lighthouse is closer and has visitors, so there is no loneliness here. The sun is shining, the wind is blowing, the water is choppy, the colors are richer and brighter and wildflowers are in full bloom. Crisp edges and strong value contrasts change the atmosphere and create a new concept with different content. The subject matter is the same in all three paintings, but the emotional content is different in each one.

Art in the making Painting a scene the way you want it to be

Example 1

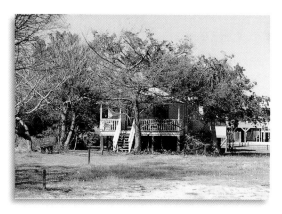

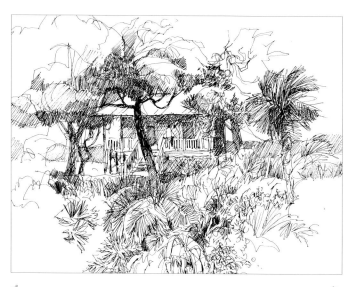

The scene

The Low Country of South Carolina includes some wonderful locations on Pawley's Island — another of my favorite painting places. Old houses are being replaced by modern structures, but there are still some relics just waiting to be sketched and painted. More editing took place when making the painting from the sketch. Parts of the island are densely overgrown with native vegetation, and that remembrance was edited into the sketch and painting. I was not concerned with replicating the place or the sketch, but tried to capture my remembrance of the place. Robert Henri once said, "If you work from remembrance, you are likely to put in your real feelings". Trust your memory when you paint and you will begin to understand emotional content better. By editing, you can put your remembered vision into your work.

1 The sketch ▶

Look at the photograph of the subject area, and then at the sketch, done on location, to see how much editing was done.

Example 2

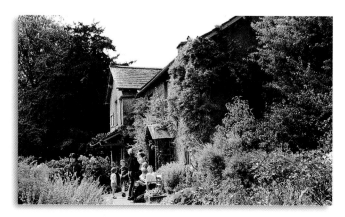

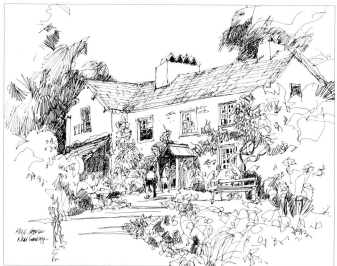

The scene

Hill House in England's Lake District was the home of the noted author Beatrix Potter. It is perched atop a small hill and surrounded by trees and flowers, paths and hills, all of which she drew as illustrations for her books. Peter Rabbit and his friends are no longer there, however. This photograph shows how it looked the day we visited.

1 The edited drawing ▶

The sketch shows my edited version of the place on the same day.

2 Finished painting —
***Conversation on the Front Porch*,**
watercolor, 22 x 30" (56 x 76cm)
*Notice how visual movement
on both dark and light valued
passages leads your eye to the
focus of the porch. This design
feature is also part of the
editing process.*

2 Finished painting —
***Waiting for Peter Rabbit*,**
watercolor, 15 x 22" (38 x 56cm)
*Back in my studio, I wanted to
paint Hill House with lots of
flowers because it should be
that way, and probably often is.
So I changed the direction of
the path to allow a wandering
approach to the house and to
make room for more flowers.
I changed the perspective to
give the house the feeling of
being up above me. The location
does not look like my painting,
but in my memory bank, it
appears like the painting. And
that is the way I should paint it.
Isn't editing wonderful?*

Chapter 3

Is sketching important to emotional content?

Absolutely! Sketching is a way of seeing. It is a major component of an artist's personal visual vocabulary.

To draw well is to possess confidence — confidence to interpret, edit, reflect or create in the visual environment in which we find ourselves. To draw inadequately is to be creatively crippled, an inadequacy that can harm the painter in much the same manner that laryngitis diminishes the effectiveness of a powerful speaker. Sketching opens the channels for the creative spirit that all artists seek. It is a direct and immediate response to the visual stimuli that we encounter on a daily basis.

Draw whenever you can

Skill in sketching increases with practice, which means that you should draw daily, if possible. Draw wherever and whenever you can. Look around you and you will find the world is filled with things to sketch. Drawing is a basic language of art and is an integral part of the creative artist's range of skills — and an effective way to make visual statements. It is also a fine editing tool when it comes to arranging the components of the landscape in preparation to painting. In many ways it is a basic aspect of visual communication, and therefore of emotional content.

We sometimes hear people say that you can be an artist without knowing how to draw. There might be a few instances where that could be true, but for the great majority of us, sketching is impulsive, essential and vital to effective visual communication.

I previously wrote a book that dealt with careers in art — detailing hundreds of exciting career opportunities related to art. You may think that drawing might be outdated because of today's incredible advances in computer

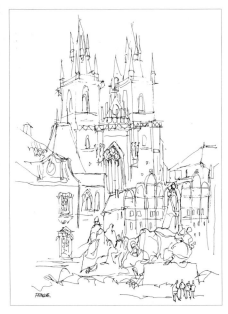

A sketch
This took ten minutes while I was in the old town square of Prague, where the Gothic church and the John Huss monument dwarf the people. A rough sketch like this is not meant to depict accurate details but is an orientation and information gathering tool, because after several such sketches I understood the proportions, scale and feeling of the huge square.

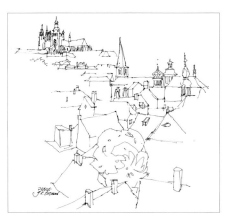

A sketch
Here's another sketch of a different part of Prague, looking up at Hradcany Hill with St. Vitus Cathedral at its crest. A little more accurate, this sketch shows the structural character of the built-up hillside from the Vlatava River up to the church. I can paint back in my studio from this kind of information, even though a lot of imagination, memory and imaging would be involved.

Turning a sketch into a drawing
In this photo, a sketch of Vajdahunyad Castle, located in a beautiful park in Budapest, is being transformed into a finished drawing, with value contrasts and a sense of weight and age. Once I start doing this I no longer consider the work to be a sketch.

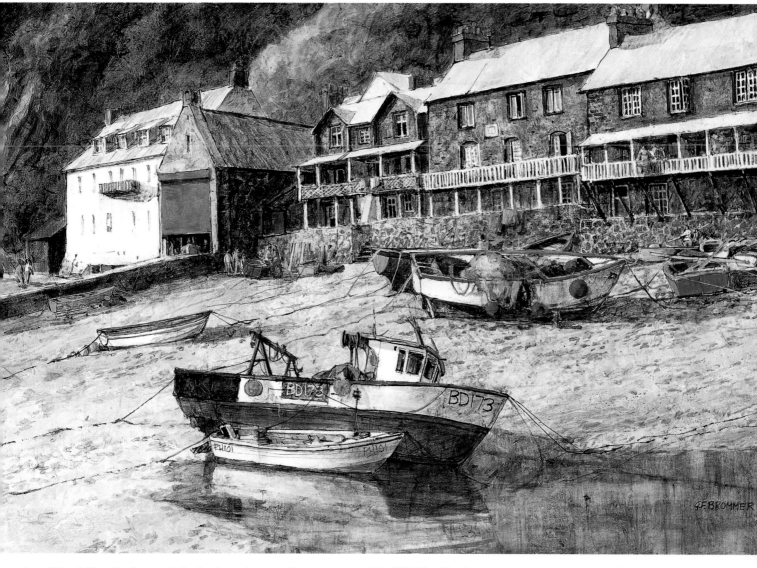

Low Tide at Clovelly, Cornwall, England, acrylic on collage on canvas, 24 x 36" (61 x 91cm)

Here I am sketching boats, buildings and fishermen in the harbor of Mevagissey in Cornwall, England. It is wonderfully refreshing to be sketching, lost in thought, concentrating on the process of simplification and editing information for future paintings. We are so fortunate to be artists!

technology. In compiling information to provide to art students, I asked the people who hire digital graphic designers, "What do you look for in the young people you hire? What skills are essential to success in today's competitive design market?". In every instance, the answers were the same: "We look for people with drawing skills, fundamentals of design and skills in verbal communication". These are things they felt to be essential. Every design (if it be graphic, editorial, industrial or architectural) starts with a drawing or sketch, just as almost every painting starts with a sketch of some kind. If drawing skills are vital to digital graphic designers, think how much more important they are to painters,

whose products need to communicate to be effective. It all starts with sketching.

Drawings are personal

Did you ever notice that artists do not usually want to part with or sell their drawings and sketches. Why? Because they are so personal. There is much more of the artist in a sketch or drawing than in a painting that is worked to completion. Expressed in the sketches are the personal confrontations with the subjects, the personal responses to places, a personal shorthand way of expressing what the artist sees and feels. It is the very soul and spirit of the artist, delineated on paper. It is that

important. It is emotional content in the truest sense.

My wife and I love to collect drawings and have had some interesting encounters with artists whose drawings we would like to have in our collection. Once, in the Cotswold town of Stow-on-the-Wold, we were visiting in the studio of the late John Blockley, probably my favorite English painter and one of the premier sketchers in recent history. We had just purchased one of his small abstract landscapes which we so admire, and just on a hunch, I asked him if he ever sold any of his drawings. He replied without hesitation, "No, I never sell my drawings!" I simply said that I understood perfectly, but I told him the names of several artists whose drawings are in our collection. He considered for a moment, and happily said, "I think maybe you could have one of mine also". What a great moment! He got out a portfolio of wonderful landscape and village drawings, and we selected one that was especially handsome. I asked him how much he would ask for it, and he replied, "I don't have the slightest idea. I have never sold one before." He thought for a minute or two and came up with a figure that was more than satisfactory to us, and we now are the proud possessors of a John Blockley drawing, as well as a small watercolor landscape. But you see, he really did not want to part with it. His books are full of reproductions of his wonderfully expressive drawings, but to part with an original sketch was just about impossible. That is how personal and important sketches are to artists.

The difference between sketches and drawings

Sketching differs from drawing in that a sketch is not really a finished product, ready for a gallery wall or other exhibition venue. Often sketches are left unfinished — as the term "sketchy" implies. Once the essential elements are recorded, the sketcher's eye moves on to another subject. Drawings involve a bit more finishing, care and concern for detail, and are often recognized as completed products. Of course, drawing skills are required in both forms of expression.

Why do we sketch?
Here are 7 Good Reasons!

There are many reasons for sketching, and several important ones are outlined here:

1. We sketch to gather information

For example, say I was going on a trip to Hawaii I would be confronted with palm trees, hillsides covered with mango trees, and spectacular gardens full of unfamiliar tropical vegetation. I need to sketch to understand the magnificent trees, exotic foliage, leaves, and flowers which are uncommon where I live in California. When I start to paint, these new elements will be somewhat familiar and much easier to put into a painting in a convincing manner. Information-gathering sketches are included in the resources I rely on for most of my studio paintings. They provide enough information from which to work, and also help me to recall many important aspects of the referenced location — triggering remembrances of weather, sun, colors, season of the year, activities of local people and so on. But they do not contain great amounts of detail which might tempt me to copy.

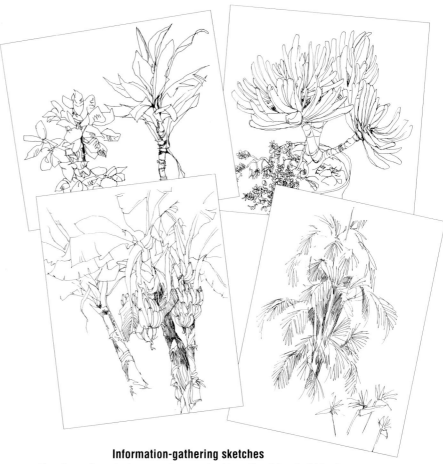

Information-gathering sketches
Sketches of tropical vegetation on the Hawaiian island of Maui. Many pages of such sketches make the painting process much easier because I quickly become familiar with the characteristic forms.

2. We sketch for simplification and understanding

If I visit New Zealand, I will have to draw sheep. If I'm off to Venice I will need to know pigeons. I cannot imagine a sheepless New Zealand or a pigeonless Venice. In the process of flying to these locations, I prepared myself for representing these creatures by drawing them in my sketchbooks from memory — until they became simplified, recognizable shapes. They will not be perfect replications, but will serve the purpose when I start to paint. I may fill five sketchbook pages until I am sure I can draw them into a painting quickly and easily without having to think too much about how to do it. See the sketchbook pages for examples.

I do the same thing with people, if I am going to Mexico, Guatemala or China, where I will be painting busy market scenes or colorful street locations jammed with a great many active people engaged in multiple daily activities. Such practice before actually having to include them in paintings is time well spent.

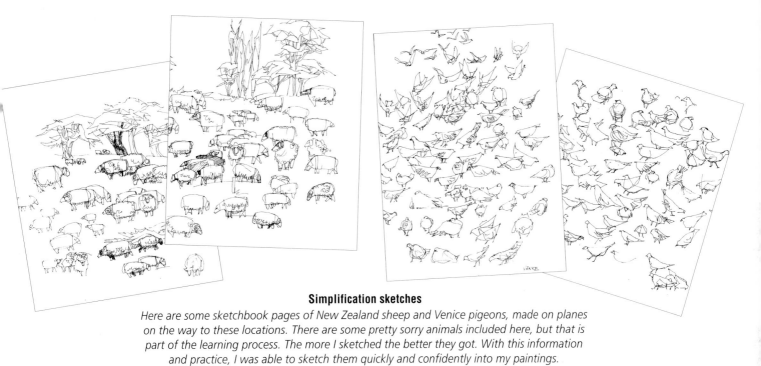

Simplification sketches

Here are some sketchbook pages of New Zealand sheep and Venice pigeons, made on planes on the way to these locations. There are some pretty sorry animals included here, but that is part of the learning process. The more I sketched the better they got. With this information and practice, I was able to sketch them quickly and confidently into my paintings.

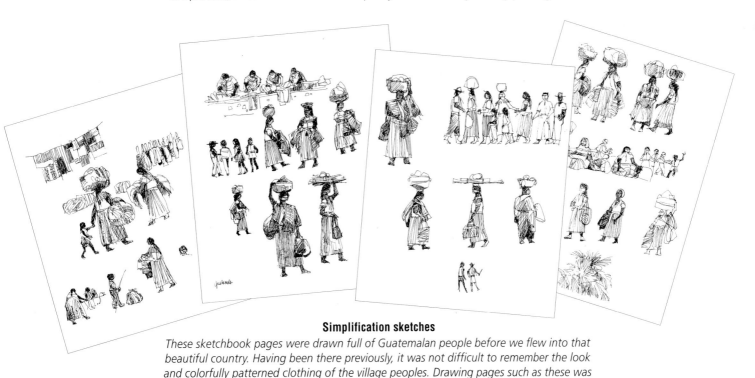

Simplification sketches

These sketchbook pages were drawn full of Guatemalan people before we flew into that beautiful country. Having been there previously, it was not difficult to remember the look and colorfully patterned clothing of the village peoples. Drawing pages such as these was a valuable experience that helped me when painting in the villages several days later.

3. Contour drawing — a variation on sketching

All village, city or rural scenes can all be simplified and better understood by making contour sketches. Contour drawings rely on single lines to outline shapes and forms. Often the pen is not removed from the paper. Some interior edges can also be drawn, but details and value shading are left out. We usually think of contour drawing in connection with figure drawing, but trees, buildings, bridges, flowers and other landscape elements can be simplified by treating them in the same way. With an emphasis on simple outlined shapes formed by the edges of major shapes and objects, these sketches are very helpful in later putting down the large shapes on watercolor paper when you begin painting.

How a simplified contour drawing leads to a finished painting

The contour drawing

Most of my sketches begin with contour drawings such as this one of the village of Lower Slaughter in England. No values, details, textures or shadows are included — only major outer edges and a few interior forms are outlined. Later, I could add values and consider design, but this contour drawing contains enough information from which to paint. Naturally, it is an edited version of the village.

The painting — *Lower Slaughter*, watercolor, 15 x 22" (38 x 56cm)

This subsequent watercolor of the village of Lower Slaughter was painted from the contour sketch. Note that some editing was done as the painting progressed, but the information for the work came from the contour sketch.

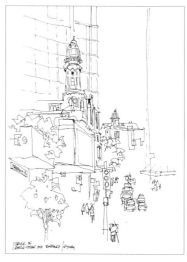

Another contour drawing

Even a major city like Sydney, Australia can be reduced to its simplest forms via a contour drawing. I will probably never paint this subject, but the practice of simplifying complex subjects with contour drawing is essential to the skill required to respond quickly and directly to various subjects.

4. We sketch for design and composition

There are a variety of ways to do this, but let me tell and show you how I use sketches for this important activity. I like to sketch innumerable design formats as small, one-by-two inch thumbnails on sketchbook pages. Almost every one of my fifty or more sketchbooks has several of these pages. I do them when traveling on planes or in quiet moments in my studio or at not-so-exciting meetings, and the like. By sketching hundreds of these formats over many years, my sense of design has become clearer and sharper — to the point where it becomes almost automatic — something done without thinking too much. Some of these design sketches are simply contours while others use value contrasts to emphasize movement, focus, balance and compositional arrangements. I still sketch many pages of these fundamental designs every year, even though I will never use them or look at them when I paint. However they are vital to my sense and understanding of design.

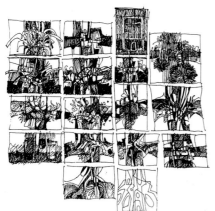

Design and format sketches

Every one of my sketchbooks includes several pages of compositional studies such as this example from a single page. Each little image provides me the chance to exercise my design sensitivity by creating movement and focus in a variety of formats.

I also edit my location sketches for composition while I am drawing them (See the explanation and illustrations in Chapter 2 on selectivity and editing). This process encourages rearrangement of selected elements and the honing of design skills. I consider it one of the most important things that I do in my sketchbooks.

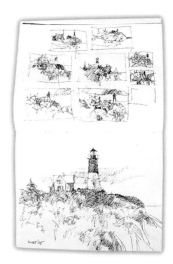

Cape Cod lighthouse

This double page of one of my sketchbooks illustrates several different sketching activities. The large sketch was done on location, and gathered all the information I needed to paint the scene. On the other page, I drew several edited and trial compositional sketches, prior to painting. Both kinds of sketching are essential to making vital and meaningful paintings back in the studio.

5. We sketch to arrange and rearrange elements

When getting ready to paint, I make quick, small sketches to see how the elements to be incorporated in the painting will best relate to each other, and to express what I would like to say about the place. As you have seen in Chapter 2, I edit the landscape by relocating elements to get the best possible composition, and to place emphasis on my choice of focus and content. The sketches I make prior to painting are wonderfully playful, loose and free, and they reflect an economy of line and an exploratory attitude, "What if I leave out this tree?" or "What if I move the house to the left and bring it close up?" or "What if I add groups of people?" After three or four of these experimental positioning sketches, I am ready to paint, feeling that I have eliminated possible arrangements that might have given me trouble.

Example Bosporus, near Istanbul

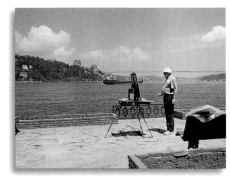

The scene
I am pictured working on a painting involving an old fortress across the Bosporus, near Istanbul.

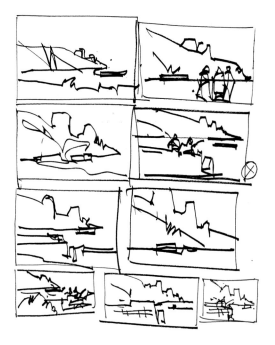

1 The sketches
This sheet of paper contains a group of very loose and quick sketches made with a heavy marker (each sketch took about 15 seconds) that arrange and rearrange the items to be included. Some elements were moved into place from the surrounding environment until I thought I would be happy with one of them (the one marked with an X).

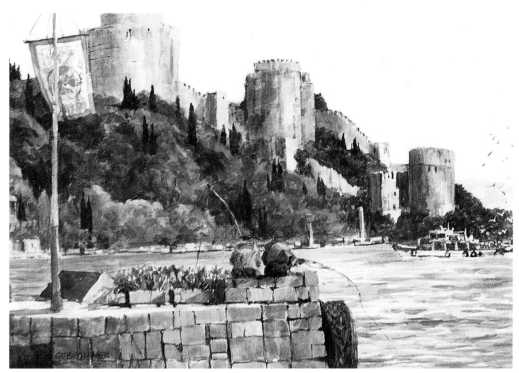

2 The finished painting —
***Turkish Fishermen, Istanbul,*
watercolor, 15 x 22" (38 x 56cm)**
In the half-sheet watercolor painting, the bridge was eliminated and fishermen were brought in, along with a passing fishing boat (replete with a trail of seagulls), and a local banner from a nearby building. The quick sketches were instrumental in generating an interesting grouping of elements before the painting was started.

6. We sketch for our painting

On a sheet of watercolor paper, I like to place the major elements in approximately the right places for my message to be best expressed before I start painting. Often, before I begin sketching, I will quickly run my hands and fingers over the paper to "feel" where things might go. Then I use either a large drawing pencil or a round #9 brush and a pale, neutral wash to sketch the selected objects in position. Notice, I said "sketch" and not "draw", because the sketch simply locates elements in roughly the right places. If I were to draw them carefully, I would tend to paint the drawing, and not feel the action of painting in response to the place, person or thing.

This is a personally satisfying technique, but many other artists begin their paintings with much more drawing. It is wonderful that we do not all start the same way — or finish the same way.

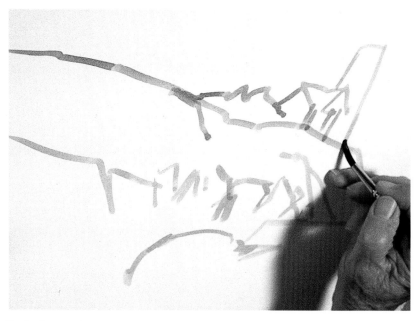

Beginning a painting

Here, I'm beginning to work on a painting of a lighthouse in Maine, by sketching with a brush to locate the major elements (large shapes). Usually this is a very light tonal valued wash, but I am using a darker value of watercolor here so it is easier to see. In this kind of sketching prior to painting, it is important to keep lines and shapes simple, unencumbered with detail. Other artists may start with much more detail — or less.

Which sketching media are best to use?

The answer depends on the artist. In my sketchbooks I use extra-fine line markers of various types (Pilot Fineliner, Papermate Gel Roller, Uni-ball Micro Roller, ball point pens of various types, and so on). None of these are permanent enough to last into the next millennium, but all will last far past the end of my life span. Other artists like to use pencils of various kinds, or even charcoal, stick and ink, brush and ink, wash drawing and ink, technical pens and the like. After trying several tools, opt for ones that feel comfortable to you and that will provide the most useful sketches from which to work. There are plenty of sketching tools to try (catalogs and art stores are full of them), so do not continue to struggle with some that are uncomfortable for you to use or that give you problems.

7. We sketch to practice the art of seeing

We cannot sketch unless we see; and we can learn to see better and more completely when we sketch. So better seeing comes with more sketching — an ongoing activity that never ends for an artist. When he was ninety-three years old, my good friend George Gibson, a nationally recognized painter, still went to a life-drawing class every Wednesday morning — just to practice his sketching and thereby enhance his seeing. He didn't even paint figures very often, but he painted landscapes beautifully and with passion — because he could see . . . deeply, questioningly, intensively and sensitively. Mostly as the result of a continued life of sketching.

"Sketching is a basic visual practice for the painter seeking to emphasize emotional content."

Sketching in any of the above instances will help you to see better and therefore paint with more insight and skill — an ever present goal. We need to practice sketching because it is vital in the development of our craft and the important ability to communicate visually, and therefore to express content. When sketching, we are already selecting and editing the resource material in front of us, and we are recording personally meaningful references for possible use at another time. Or we often simply put down what is most meaningful to us, or things which we need to practice. But notice, all these aspects of sketching involve personal responses and a full and complete involvement with our subjects. Sounds like emotional content to me!

How to develop sketches

I work my sketches in several stages, as you can see in the demonstration sequence on the next page. Here's how I do it.

1. Usually, my initial response (selecting and editing) is done in contour. If there is time, I will add a bit of shading on location, to perhaps show where the darkest darks might be located. I usually want to gather as much information as possible by starting two, three or more of these outline or contour sketches before leaving an exciting location.

2. Then, away from the site, I begin to create a pattern of darks and lights based on my personal sense
of design and not on actual values at the location (more editing and personal sensitivity). That is often enough information and direction for me to use when starting to paint.

3. At another time and place, I may work on the sketch to balance tonal values, observe design principles and emphasize the focus or core of the sketch. Not all my sketches are carried this far, but most are developed just enough for me to recall and "feel' the place again, and to start painting. If time permits, I sometimes like to finish a sketch, actually making it into a completed drawing.

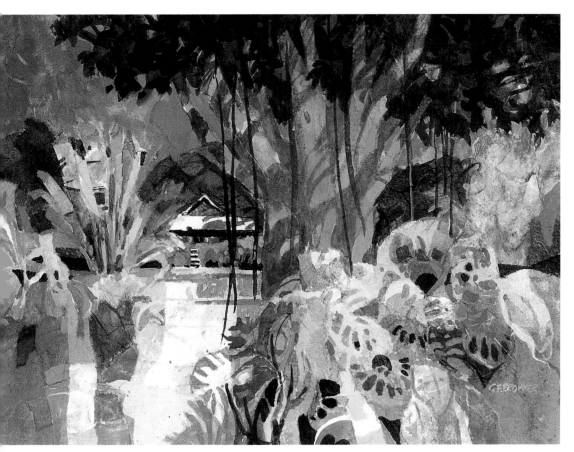

***Maui Impression*, collage, watercolor and gouache, 11 x 15" (28 x 38cm)**
When I create collage pieces with watercolor-stained washi (rice papers), I generally edit still more to make abstracted imagery. Many elements from a sketch may still be present, but are almost unrecognizable. So it goes with editing! The sketch is not sacred, but is merely an important resource.
(The technique for creating these images is demonstrated on pages 48-49).

Art in the making From sketch to painting

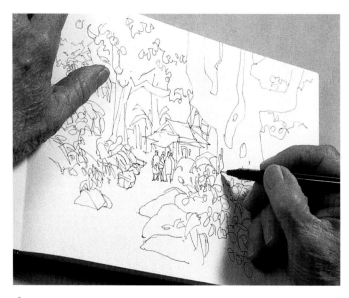

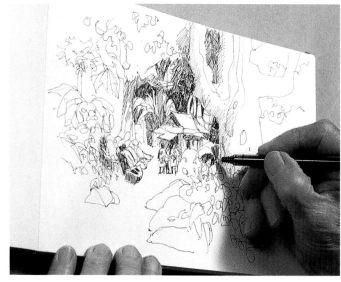

1 **Starting with a contour sketch**
This contour sketch of a cottage surrounded by tropical vegetation on the Hawaiian island of Maui was just about completed on location. I am adding a few final lines before starting to think of value patterns.

2 **Developing a value pattern**
Hatching, cross-hatching and scribble lines are used to start the development of a value pattern in the sketch. Dark and middle value areas are beginning to form as shadows and backgrounds contrasts are developed.

▶

Treasure your sketchbooks as a valuable resource

My sketchbooks contain thousands of sketches that are potential resources for paintings. There are also many pages of practice, exploration, trial ideas, design formats, written notes and other pages that I will never use for anything except for the experiences and confidence they provide. They contain the evidence of my struggles and the gradual improvements that constant practice encourages. They are actually a visual record of my life in art, workshop teaching and travel.

The place where I make most of my sketches is in a sketchbook, which is often a visual journal of trips, daily activities, a workshop experience, and also a verbal expression of personal thoughts, explorations and occasionally a bit of poetry. I see some aspiring artists' sketchbooks that are only half filled — a task that has taken several years to accomplish. Not good!!! If you want your "eye" to improve, then sketching must be done almost incessantly. I once heard an interview with Wayne Thiebaud in which he stated that we need to draw until our hand aches and/or until we begin to dream about drawing. Only then, he said, are we drawing enough and in the right way. (He was known to give his college drawing classes the assignment of making 500 drawings for the next week's class).

My own sketchbooks are now referenced by areas of the world — England, France, Pacific Coast, Low Country South Carolina, Tuscany, Mexico, and so on. By doing this,

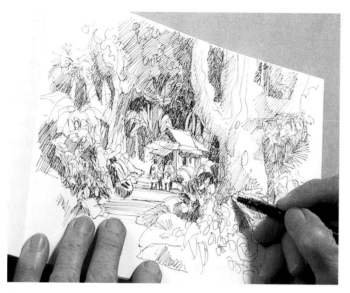

3 **Setting the focal point**
The final value pattern is nearly completed, and establishes focus, linkage and movement on both dark and light value passages. I can easily develop a painting from this resource as it now stands.

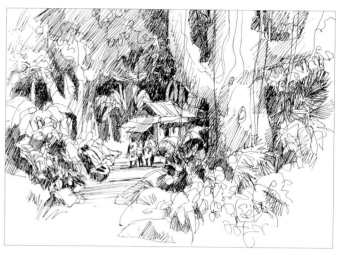

4 **The finished sketch**

5 **The finished painting — *Hawaiian Shadows*, watercolor, 17 x 28" (43 x 71cm)**
As the watercolor painting illustrates, the sketch has been edited still more. The basic elements are still present, but they are manipulated to make the final composition — and the resultant painting.

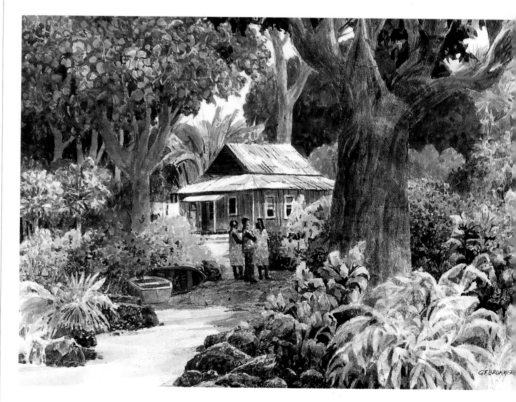

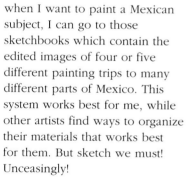

when I want to paint a Mexican subject, I can go to those sketchbooks which contain the edited images of four or five different painting trips to many different parts of Mexico. This system works best for me, while other artists find ways to organize their materials that works best for them. But sketch we must! Unceasingly!

The more quickly you can select, edit and sketch on location (or in five minute sketches from slides or photographs) the more quickly you will be able to paint on location with direct response to a place — a response that is immediate and that captures the sense of place. However, it all starts with sketching, which is a basic visual practice for the painter seeking to emphasize emotional content.

Can color effect emotional content?

Yes! In fact, color is often a dynamic factor in determining the visual expression of mood, weather, seasons, time of day and emotions, and therefore of emotional content.

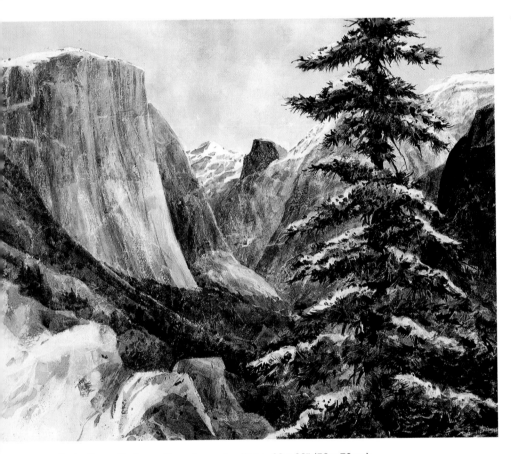

Early Sierra Spring, watercolor and collage, 22 x 30" (56 x 76cm)
It was cold in Yosemite Valley in March. My sketches constantly contained notes that said, "Make it cold!" These were directions to myself to concentrate on cool colors when making subsequent paintings in the studio — cool colors to reflect the cold that I felt when sketching. No warm hues here!

We are aware of such familiar expressions as "feeling blue", "seeing red", "green with envy", "golden sunrise", and so on. Pablo Picasso went through what has been called a "Blue Period" and a "Rose Period" in his early development as an artist. His Blue Period paintings were sad, morose, very unhappy and reflected the artist's sensitivity toward himself at that time. During his Rose Period, his life, temperament and self-esteem improved and he saw himself in a happier light — rosy, in fact. We might not spend long periods of our lives working with a single color emphasis because most artists change their color orientations from time to time in their lives, depending on their subject matter, travels, schooling and other powerful influences.

Color in painting can be used to create feelings about the subject and therefore about the painting's emotional content. Think of colors as adjectives in such expressions as "a rosy future," "a gray day," "a golden harvest." 'white snow," "red hot," "green lawn" and so on. If you understand and are sensitive to color, its qualities and the factors discussed in the pages that follow, you will be able to use color effectively to emphasize your feelings about the subjects in your paintings.

What color is Guatemala?

An artist in a recent workshop in Guatemala asked me at the end of our sessions, "What color would you say represents Guatemala to you?". My instant response was, "red-orange". As I write this, I don't know exactly why I said that, but at the moment the brilliant hues of Guatemalan fabrics, the strong colors used on many walls and houses, the soil in places, the busy activities of the people in the fields and in many markets, the volcanoes that are ever present, and my joy in painting there — all added up at that moment to a vivid red-orange. It was very interesting that when I started writing this paragraph, I went to look up some of my Guatemala demonstration paintings — and there it was! Red-orange! Several of my paintings had a red-orange dominance.

Street in Antigua, watercolor, 15 x 15" (38 x 38cm)
One of several paintings made in Guatemala that had not only a warm dominance to add to the sense of tropical warmth, but also had a red-orange dominance. I actually was not aware I had done this when I answered the question about a color representing Guatemala.

Color is personal

The colors that artists choose to use in their paintings are very personal, as it should be. It is therefore logical that each company that manufactures watercolor, oil or other pigmented paints, makes so many different kinds of color. The choices are overwhelming. If there were only a dozen or so "correct" colors to use, Daniel Smith, Winsor & Newton, Maimeri and the rest of the paint manufacturers would need to make only those few paints. Thank goodness for abundant color and personal choices!

Many of my own paintings are earth-colored and rather neutral, but I have artist friends whose paintings are primarily violet, green or gold ochre. These are choices that artists make after experimenting with many color combinations over a long period of time, and quite often their preferred colors change over time, just as we change. You could probably tell which colors are your own favorites, or which ones dominate your work and your palette at the present time, by counting the tubes of paint that you need to reorder the most.

What follows will not be a technical discussion of color and its properties of hue, value and intensity, because that has been successfully treated in many other art books. What will be discussed and demonstrated is how color effects emotional content and how color can be used to emphasize and clinch the messages about the subject that we wish to share in our work. I will try to explore and explain several kinds of expressive color in the following pages.

What is local color?

Local color refers to the actual colors of the various components in a location as we see them at the time we are painting them. A color photograph often provides us with the local color — if both the camera and film are working properly. Local color is determined by rays of sunlight being absorbed by some things and bouncing off those things in our immediate environment. However, the color of sunlight is not constant all over the world. At the equator color is quite warm; at the fortieth parallel (north or south) it is somewhat cooler; and in Alaska, Finland or the southern part of New Zealand's South Island it is still cooler. The local color of the same tree or flower (or even your skin) will appear different at each of these locations because of the color of the sunlight that strikes it.

The reason I mention this, is that as a landscape painter I am concerned about the color of the light itself. My personal response and sensitivity to light at my painting location is essential in understanding the quality of the local color and eventually the colors I might wish to use in my paintings. A pine tree in Maine or Scotland will be a different kind of green than the same sort of pine tree in Southern Italy or Central Mexico — due to the color of the light. You are probably aware of how the color of your own skin and lips change when you walk under yellow or red or blue lights. It is not a pretty sight! Shine a yellow light on one of your paintings and see what happens to your colors This same phenomenon is evident in nature, although not to such an extreme extent.

Three different geographical areas — three different

Local color in three different areas of Europe reflect the quality and temperature of the light and the local color which makes each place distinct.

Notice how the local color in each painting is different. One key to making each painting feel like the part of the world it represents lies in the use of local color.

1 Local color Cool
Foggy Morning, Cornwall, **watercolor and collage, 22 x 30" (56 x 76cm)**

The coolest environment in this group is represented by a small village in England's West Country. The foggy weather adds to the chilliness of the place, and of the painting. My selection of cool local colors (a variety of grays and greens) contributes to the feeling of a damp, cool village.

Detail

2 Local color Warmer
Cotswold Color, **watercolor and collage, 22 x 30" (56 x 76cm)**

Another part of England is a bit warmer in color and has a different local color. The honey-gold colored stones and walls combine with flowers found in the Cotswold area to project a sense of the place. The local color is warmer than in Cornwall, but still not as warm as around my home in Southern California.

local color temperatures

Detail

3 Local color Much warmer
The Colors of Provence,
watercolor, 22 x 30" (56 x 76cm)

The local color of this location creates a much warmer feeling. It is a farmhouse in Provence, in southern France, where rocks, buildings, lavender and other flowers provide a warm, calm feeling. Local Provencal colors are not only evident, but create the ambience and warm local color toward which northern European artists gravitate.

Detail

Color and time of day

The color of light (and therefore local color) also varies throughout the day. If I paint in a single location for a long time, not only do the shadows change, but so does the color of the light — and its effect on local color. The actual color of the trees and grass are apt to change without my noticing.

- Light in the early morning and late afternoon is warm and mellow — use that knowledge or compensate for it in your painting.
- Light at noon is bright and actually cooler and whiter because it arrives here on earth through less atmosphere than when the white sun is setting and shining through very thick layers of our atmosphere. It can then become very orange.
- Light arriving in my back yard through a cloudy or overcast sky is cooler than light on a clear, sunny day.
- At higher elevations (less atmosphere) the light is cooler and whiter than at lower elevations or at sea level.

Local color is effected by geographical and atmospheric conditions in any location. Have you noticed how the warm light of an evening sunset changes the colors of a green pine tree? Or even the colors of flowers in your garden? If you aware of these differences, you can apply that knowledge in making your paintings more responsive to local conditions — and even project your own feelings about local color into any painting on which you are working.

Why do artists chase the light?

I remember the first time I read in an art history text that Reubens, Dürer, Turner and many other northern European painters traveled south to Southern France or to central Italy because of the light. At the time, I did not know why this was necessary. Surely, they had light in northern Europe. But if you have been in northern Germany, Belgium, the Netherlands, England or France in the winter, you will know how cool the light is, and also how long winter lasts and how short the daylight hours are. These northern artists began to crave the warm light of summer, and it could be found in southern France and Italy, even in winter. So south they went! Even in other seasons of the year, the quality of light in Italy and southern France is warmer and more inviting than up north. A dozen degrees of latitude can make a tremendous difference, especially when the quality of light in the north is also strongly effected by cold weather, cloud cover, marine influences, rain, snow and fog.

Sunset's effect on landscape

Mendocino Coast, Orange Glow, watercolor, 18 x 24" (46 x 61cm)

Warm evening light strengthens the warmth of things that are already warm. It also changes the character of cool colors by warming them up. Here, the orange sunset saturates the elements in this northern California coastal scene with warm, orange-related hues. Even the dark green bushes in the foreground become orangey-fied!

Creating a sense of place

The golden honey-colored of stone walls and houses in England's Cotswold area contribute to its sense of place. The cool greens, grays and blues of Alaska's dramatic and wild scenery will determine the local color. The red intensity of the rocks in Sedona in Arizona or Ayers Rock in Australia push us to use and emphasize the local color. The local environments of deserts, rain forests, tropical jungles, autumn grasses, the cool Maine coast, Carolina's warm low country, Colorado's crisp yellow aspen trees and the like, are all painted more convincingly if artists are aware of and sensitive to local color.

Many years ago I had an autumn opening for a solo show in a gallery in Tucson, Arizona. Beautiful mountains of various earth colors wrap themselves around the north and east edges of the city. During the reception, the entire gallery suddenly emptied. I couldn't figure what was wrong — until I followed out the front door to look. The deep warm color of a dramatic Arizona sunset was saturating the warm-hued mountains with red — deep, warm and absolutely astonishing and breathtaking red. The local color at that moment was amazing, and my puny paintings inside the gallery were no match at all for the intensity of that moment outside. Being aware of such changing effects of light on color will help you make paintings that reflect your personal responses to various locations, and also enable you to use color effectively to communicate the emotional content by manipulating these elements.

What is dominant color?

Dominant color is an expression we use to explain the use of a hue that permeates an entire work. Also called a "mother color", the dominant color often is a wash put down on paper or canvas before other colors are used. I remember at one time, watching Rex Brandt start his paintings with washes of Raw Sienna over entire sheets (except for future white areas), before brushing down a single mark.

Other artists, myself included, often glaze a single color over sections of a nearly finished painting to create a dominant color. Some artists want to speak of their images as green, gold or purple paintings, and that determination is made by using a dominant color in some way. It is a powerful influence in creating visual unity in a painting.

In my own paintings, I am not concerned as much with a single color dominance as I am with a temperature dominance — either dominantly warm or cool. This is almost the same as a color dominance, but allows for some latitude as far as specific hues are concerned. I am inclined to speak of a cool painting rather than a greenish-blue painting, but either a color dominance or temperature dominance will enhance the quality of unity in a painting.

Cool color dominance

Mendenhall Reflections, watercolor, 22 x 30" (56 x 76cm)
This subject was painted at the foot of the Mendenhall Glacier in Alaska. The colors are cool, the air is still, and the chilly mist is seeping into tree-clad hills. The cool local color of the image is a chilling reminder of that morning's painting experience. I shiver when I look at it again.

Warm color dominance

Acoma, watercolor, 16 x 20" (41 x 61cm)
The Native American village of Acoma is called Sky City because it perches atop a New Mexico mesa. You become aware of the local color as it pervades the painting. It is warm because both the earth and the structures are a warm, tawny-beige color. TIP: Look into the middle value areas of paintings to see the local color because these are not saturated with white sunlight nor grayed down with shadows.

Expressive color

Expressive color is sometimes called personal color. This is because we can tell from the selection of hues, or their intensity, that the artist is expressing something personal about the place, rather than trying to paint it literally. German Expressionists, American Abstract Expressionists, France's Fauve painters, some individual artists throughout history and today continue this emphasis on color to help express feelings and emotions. This is often an admirable trait and allows the artist great latitude in selecting both colors and intensities.

However, it is also true that some artists push or distort color simply for the joy of doing something different in their work, or for experimental purposes.

My own colors are generally muted or subdued because my sensitivity to most subjects emphasizes color subtleties while retaining strong value contrasts. You can see examples throughout this book. Occasionally, however, I use intense color to express certain concepts, or when working with some of my collage techniques. Actually, in much of my work, the use of color is pretty much dependent on the intended content of the painting, because my emphasis is generally on developing and sharing a sense of the actual place.

On a workshop in Provence, we had planned to paint south of Arles, at the bridge that Vincent van Gogh once painted. When we arrived at the location, the sky was dreary and threatening rain. It was cold, windy and gray. Nobody wanted to get out of the nice warm bus to paint such dismal grayness in a vicious wind — myself included. To save the day from being a complete waste, I told the busload of warm artists that I would like to brave the elements and demonstrate how Vincent might paint this scene in watercolor, using his luscious colors to generate a joyfully painted image.

I painted yellow and purple trees, orange and blue bushes, and so on. The colors were not literal at all, but were expressive of Vincent's influence on us and on our art. And beside that, it warmed up the environment. Soon the artists were holding their easels with one hand (to keep them from blowing over) and applying intense golds, yellows, blues, greens and oranges with vigor and pure enjoyment — to the point that we could hardly get anyone to break for lunch. Color can be used to project personal feelings about a place (content) by using colors that are meaningful at the time and expressive of the artist's intent. Even if it might be simply to overcome the prevailing sense of grayness or gloom on a wintry autumn day. Our cry became, "This is the color I want it to be!"

Expressive color

Vincent's Bridge, watercolor, 16 x 20" (41 x 61cm)
This is one of three color-drenched paintings I made on that gray day near Arles. It is probably the tamest. Here the color was painted for its expressive qualities and warmth and in defiance of existing weather conditions. It was not painted to duplicate the local color, which was pretty dismal. Artists can control color and use it expressively to convey an intended message about the place or the day.

Detail

Detail

Color as a dyamic expression of emotional content

About ten years ago, I began working with a collage technique using watercolor-stained washi (rice papers) in which I use color as a dynamic expression of emotional content. The series began after a workshop trip to Greece, with the initial pieces in the extensive series emphasizing bright white structures set against Greece's intense sky and vivid earth colors. These plus other expressive colors became the epitome of my Greek island impressions. To me, those colors are Greece — and a positive expression of content.

Emotional color

Mykonos Impression, **collage, watercolor and gouache, 11 x 15" (28 x 38cm)**
To me, the essence of the Greek Islands is contained in one little collage, the first in a series of thirty or more Greek subjects constructed in the same medium. Stained washi pieces (see demonstration overleaf) were adhered to 300# watercolor paper, and then painted with watercolor and gouache. The incredible white structures (made from bits of white papers) seem to be encapsulated in vivid colors, whose shapes were edited and abstracted to form interesting patterns.

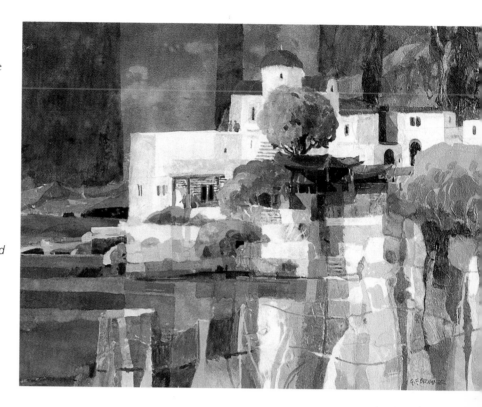

The Greek collages were followed by Irish subjects, in which I set white farmhouses against a variety of greens — this time a unique expression of the spare Irish countryside. Collages emphasizing the abstracted essences of parts of England, Provence, Tuscany, Nantucket, and finally Hawaii soon followed. These images relied on my impression of the colors and shapes of each place and not on local color. The intended emotional content dictates my personal selection of colors and their intensities. The sequential demonstration overleaf shows how this technique builds up surfaces over a series of steps. More importantly, notice how it reveals emotional content or my own unique sense of the place.

Abstract color and shape impressions

Irish Cottage/Stone Walls, **collage, watercolor and gouache, 11 x 15" (28 x 38cm)**
Irish landscapes followed the Greek series (followed by Italian, French, English and California landscape subjects), and this collage technique soon became part of my expanded visual vocabulary. I could express myself about locations with this technique that emphasized color, pattern and abstracted imagery.

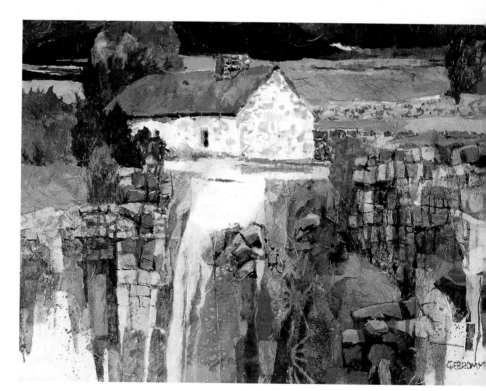

Art in the making Emotional content with an abstract collage painting

1 Staining and assembling my collage papers

My stained paper collage process starts with the staining of pieces of washi — lots of paper in lots of colors and varying values. I stained a middle value purple paper. To make the lightest values, I mixed white gouache with watercolor. Before I began I made sure I had light, middle and dark values of all the colors I intended to use.

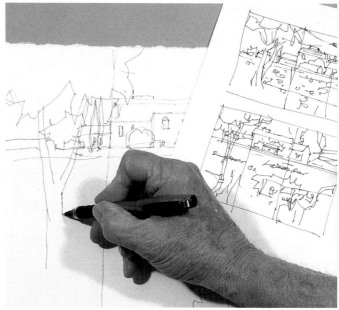

2 Making my plan

Next, I made an ink sketch to locate major elements and act as a plan when I began to stick down papers. Sometimes I might make a few pencil lines first, but here I began by drawing with a very fine black marker pen. These lines would all be covered by papers, and would not show at all when the work was finished.

5 Beginning the painting process

On the dried surface, I began the painting process by adding color to clean up the edges, to create abstracted patterns, to strengthen the design (creating movement), to change colors or shapes and to finish the process. I used watercolor to darken areas and watercolor mixed with white gouache to make areas lighter.

6 Adding tonal details

Color glazes were added for shadows. Then final darks and lights created details and finished the image. Stained paper colors were the key ingredient in this process in which color and abstracted elements contribute to emotional content. When pieces of paper could still be seen, the finished surface was partially integrated.

Emotional Content Element

Stained paper colors are the key ingredient in this process in which color and abstracted elements contribute to content.

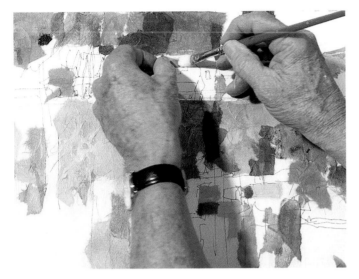

3 Sticking on the collage papers

Guided by the sketched lines, I began to adhere bits of torn color to the surface of an 11 x 15" sheet of Arches 300# rough watercolor paper. The adhesive was acrylic matte medium applied with a stiff, bristle brush. These large shapes could be altered a bit with paint as the process developed.

4 Evaluating the story so far

When this process was completed, the edges were rough and the entire image looked very unfinished — with chunks of paper visible and no detail included at all. At this stage, I gave the entire surface a coat of matte medium, mixed 50/50 with water, to unify the quality of the surface. This work was then ready for painting.

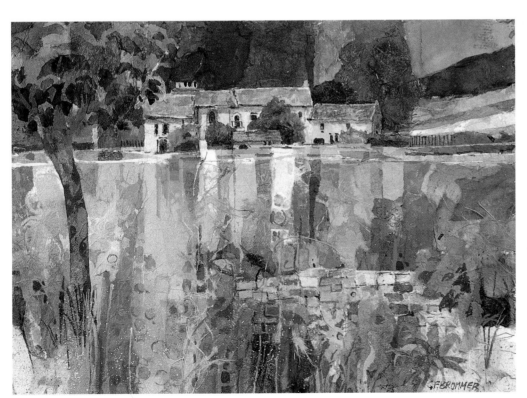

7 Finished painting —
***Sunflowers and Lavender, Provence**, collage, watercolor and gouache, 11 x 15" (28 x 38cm)*

After a few final details and color accents were added, the work was finished. I like the combination of representational and abstracted elements; of transparent and opaque passages and intense and muted colors. Visual tension results from such contrasts, and such tension creates exciting imagery.

Emphasizing color

Here you will see some examples of how I emphasized color in a series of monotype prints created in the studio of a professional printmaker, using his presses. Using oil inks, I was able to abstract landscape elements and even make some non-objective images that relied on my landscape background.

Because I was working with a different and innovative process, the need to use literal colors was removed and I was able to respond to the process by using vivid and intense colors at times, (see example on page 51), and at other times keeping the colors quite subdued. Such exploration and experimentation led to a fuller understanding of my own color requirements and sensitivities. I can now use intense colors or subtle neutrals with equal facility, in any medium, depending on what I wish to say in the work, and which processes I am using. Remember, intense colors, subtle hues, neutrals and grayed colors can be equally expressive, depending on what you want to share about the landscape you are painting.

Subtle nuances of color

***Mojave Desert Series, #14**, monotype print with colored pencil, 18 x 24" (46 x 61cm)*
My use of color in making monotype prints ranges from extremely intense (see page 17) to very subtle. When I made this print as part of a series, I was focusing on the subtle nuances of a desert landscape, and I wanted the neutral colors and light values of the print to reflect my intended emotional content.

Exercise

Try to think of places and situations where a dominance of color can become emotional content — or actually be more important than the subject matter itself. Color, as you can see through all these discussions and examples, is an important, vital and dynamic factor in painting, and is used by artists to express their ideas, concepts and feelings about their subjects. It is therefore a basic ingredient of emotional content. We could not paint effectively from our hearts without it.

Neutral colors suggest tranquility

Neutral colors (those that are grayed by mixing them with complementary hues) project a sense of tranquility and rest, because there will be a lack of color intensity and a minimal contrast of hues. If tonal values are also kept close, the sense of prevailing calm is strengthened and is more easily evident. Stronger value contrasts and/or more intense colors increase visual excitement in paintings. When these concepts are understood, you can certainly begin to use color to contribute to the content in your work.

"Remember that intense colors, subtle hues, neutrals and grayed colors can be equally expressive, depending on what you want to share about the landscape you are painting."

Warm and cool colors evoke a sense of place

Warm and cool colors are naturally expressive of temperatures or even the seasons of the year. Seascapes, snowy winter landscapes and wild Alaskan scenes are usually painted with cool hues (the blue side of the color wheel). Scorching deserts, hot summer scenes and Mexican landscapes are depicted with warm colors (the red side of the color wheel). For example, my Hawaiian collages (tropical influence) emphasize warm colors with cool accents, while collages of coastal villages in parts of England will make use of cool colors with possible warm accents. Depending on where the subject which I am painting is located, I can contribute to the feeling of the place and to its emotional content by selecting either a warm or a cool palette with which to work. (See warm/cool examples earlier in this chapter, page 45).

As you probably can tell by now, a Hawaiian scene will be warmer than a scene in coastal England. The two collages shown here strengthen that concept.

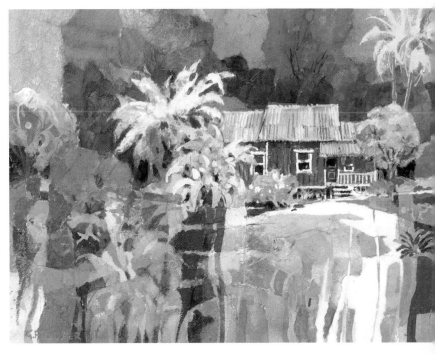

Warm color

***Cottage on Kauai*, collage, watercolor and gouache, 11 x 15" (28 x 38cm)**

I know that Hawaii actually is a dominant green. However, since nearly everything in Hawaii seems to have beautiful flowers, Hawaii to me is bright color — and my little stained paper collages reflect that feeling. In these pieces that is what I want to share about Hawaii.

Detail

Cool

***English Coastal Village*, collage, watercolor and gouache, 11 x 15" (28 x 38cm)**

This collage is of a coastal village in England. It is essentially cool, but has small accents of warm. It reflects through its color, the painting experiences I have had in this part of the world. It is possible to make Hawaii cool and England warm, but my reasons would be something other than local color and personal impressions of the places.

Detail

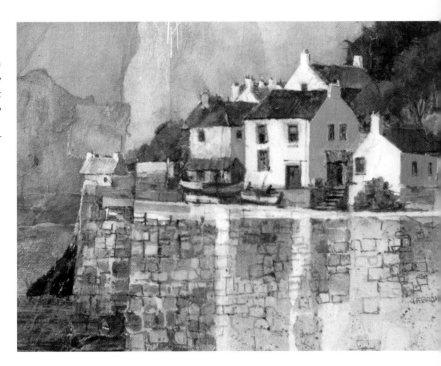

Color as expressive emotional content

Flowers are often used to emphasize color in paintings, providing an opportunity to explore color as an expressive ingredient in emotional content. They can also add spots of bright color accents to paintings in any medium.

On a recent workshop in The Drome region of Provence, we were drenched with several days of intense rains. We honed our skills at making rain paintings the first day, but the following day (deluge and all) we stayed indoors and emphasized Provencal color by painting several flower paintings using bouquets, ceramics and fruit available in our hotel. The colors we used to describe this Provence experience not only effected our sense of well-being, but allowed us a chance to use color as emotional content, to express the essence of Provence.

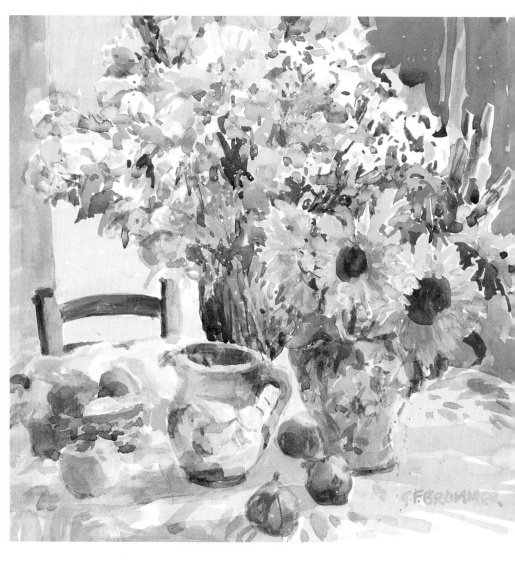

Color as emotional content

Provencal Color, watercolor,
15 x 15" (38 x 38cm)
The colors of flowers and ceramics that are typical of a small part of Provence, became the emotional content in this painting. The flowers are very impressionistic and somewhat generic, but the colors are true and become an identifying feature of Provence — and therefore a strong element of emotional content when painting there.

Detail

Detail

Art in the making Color used to express joy

On a workshop painting trip to the small town of Cambria, on the central California coast, the subject matter chosen to work on for one day was a small garden shop in town. The photograph shows the location, but with a scarcity of flowers because of the late summer heat and a lack of rain in the area. However, the sketch that was made and the painting that followed is about color — the color and joy that flowers are able to project. The color therefore grew to be the content of the painting and became dominant in the work. Notice I said, the color dominates. The flowers are an excuse for using color, but they are not detailed, not identifiable, not individualized. Masses of color suggest flowers in that setting, and they exude a sense of abundant color, aroma and joy. The color is actually what the painting is about, and it was not there in nearly the abundance that I wished to see. The color grew as the painting progressed, until it practically covered the street. Good! Flowers are the reason that the shop exists in this location, and is therefore the heart of the emotional content in this watercolor. Note how I determined what the emotional content would be; the location did not dictate it.

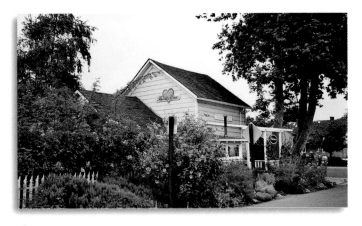

1 The scene
This photograph shows a little garden shop in Cambria, California. There are some blooming bushes, but most of the plants are varieties of green, with few flowers and little color. The demonstration painting was made to emphasize the color that I felt should have been there, but wasn't.

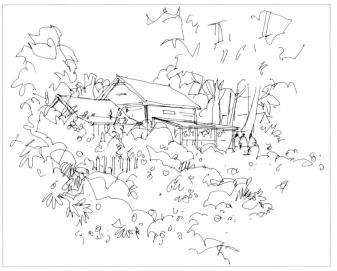

2 My contour sketch
A quick contour sketch began to grow the garden, which now has taken over part of the street. Isn't it wonderful what editing can do? While sketching, I began to sense what I wanted to say in the painting.

3 Inventing the garden color
Here I am finishing up on a few colors for the flower shapes I wanted to put in the scene.

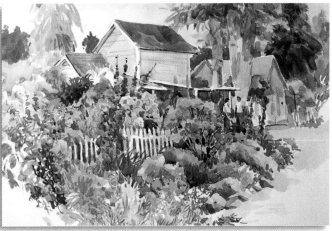

4 Finished painting — *Heart's Ease in Cambria*, watercolor, 15 x 22" (38 x 56cm)
The proprietor of the shop came to look at the painting before it was finished, and thanked me for making her place look better than it actually did at this time. See what editing and personal feeling about a place can do? The painting did not look like the subject, but certainly felt like it — in all its glory!

Chapter 5

Can tonal value effect emotional content?

Of course! Actually, tonal values help define and identify emotional content in more ways than one, as you will see.

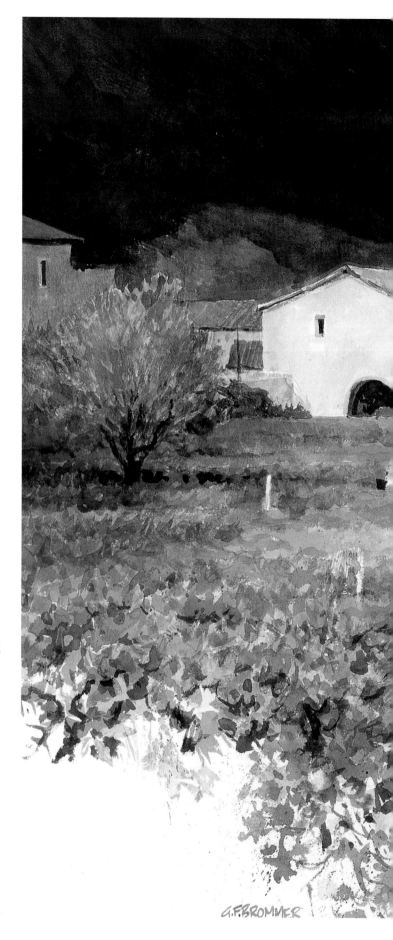

Our eyes read tonal value contrast — the difference between light and dark in a painting. That is how we see paintings. If all tonal values in a painting were the same, even if the colors were different, from a distance of twenty feet or so, we could not determine what the painting is about. It is therefore imperative that you understand how tonal values work and, better yet, how you can make tonal values and tonal value contrasts work for you in your paintings to help you define emotional content.

How does tonal value work?

First, let's look at tonal value itself, and the effect it might have on our visual messages — how it can be used to identify, clarify and emphasize emotional content.

Tonal value is determined, ranked or classified by using a gray scale, with successive steps from one to ten, or from white to black. When we speak of light tonal value we are referring to the light part of the scale, from white to number 4 or 5. When we talk about middle tonal values (about 4 to 7) and dark tonal values (6 to 10), we are referring to the location of relative positions on the tonal value scale. Special note: Some tonal value scales that you might see elsewhere put the numbers on opposite ends of the tonal value scale, with 1 being black instead of very light. (This is more proof that we need to clarify our nomenclature in art.) However, when I refer to light tonal value in the pages that follow, I will be using a spread from white to 4. Dark tonal values will range from 6 to 10.

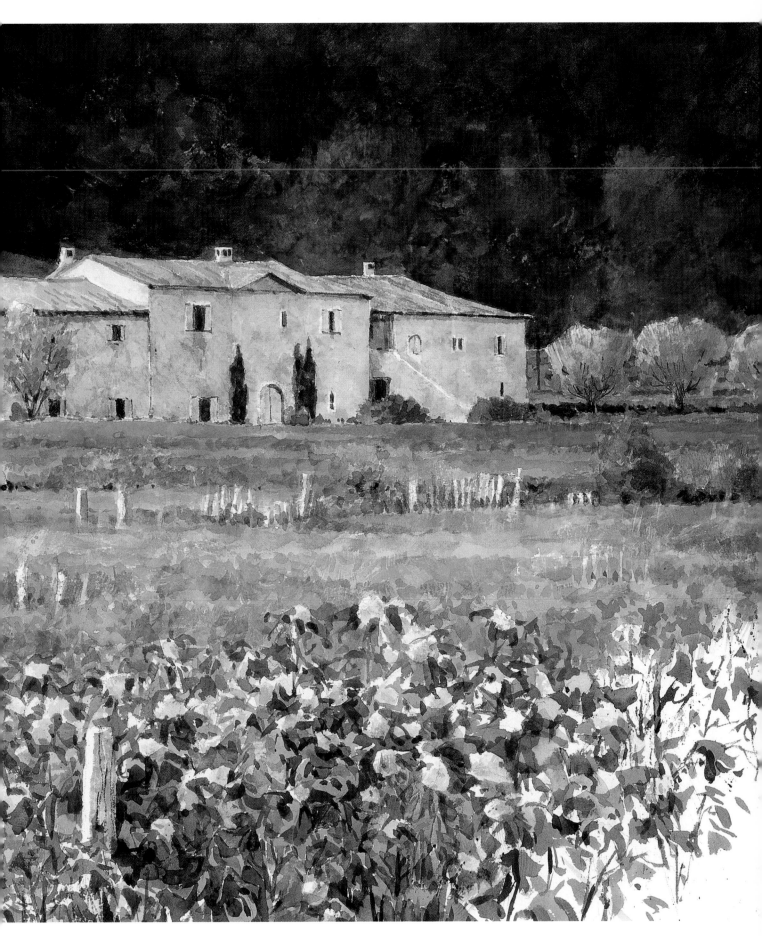

Harvest Time in Provence, watercolor, 22 x 30" (56 x 76cm)

Tonal value Scales

The gray scale used in this book

Gray tonal value scales will vary in their design and also in their numbering system and sometimes even in their exact shades. This is an example of a 10-point scale, plus white. No matter how gray scales are configured or numbered, it is only important to you as a painter to be aware of the relationships of gray tonal values from white to black, and to understand the use and importance of tonal values In structuring a painting.

A painting shown in color

Conversation on the Front Porch, watercolor, 22 x 30" (56 x 76cm)

The same painting shown as tonal values

Notice that every tonal value of the gray scale is represented in this black and white print of a full color painting. Even though the colors in the original painting are important, their tonal values are just as important, and this black and white print tells the tonal value story of the work. Darks, middle tonal values and lights make an easily readable image.

Working with a tonal value plan

I'm painting on location in the California desert near Palm Springs, and although the painting is only in its early stages, the dark, middle and light tonal value pattern have already been established. Contrast of tonal values is essential in telling viewers what I want them to see and feel in my work.

"We can make light red, medium tonal value red and dark red, and we can do the same with every color in the spectrum. Such color tonal values depend on how light or dark they are when compared to the gray scale tonal values."

Color has tonal value

Colors also have tonal values, and can be placed on a scale similar to the gray scale. When I talk about the tonal value of colors or hues, I am referring to full intensity colors, not washes or augmented hues. Compare the color tonal value scale with the gray scale. Yellow is the lightest hue and purple is the darkest. Red and green have almost the same tonal value, and occupy the middle slots of the color scale. Of course, we can change this entire tonal value structure by adding white or black to the colors, or by thinning them down with water or other mediums. We can make light red, medium tonal value red and dark red, and we can do the same with every color in the spectrum. Such color tonal values depend on how light or dark they are when compared to the gray scale tonal values.

Color compared to tonal value
Here you can see an eight patch gray tonal value scale compared to an eight patch color tonal value scale. Though the tonal value intensities might not be exactly the same, you can still sense the tonal value differences in full intensity primary and secondary watercolors.

A color tonal value scale
This shows an eight patch scale of reds from light to dark. The different tonal values of red were made by mixing black to make the red darker (called shades) and white to make it lighter (called tints). Each color in the spectrum can be treated to such tonal value contrasts, and it is these contrasts that are important in designing a painting.

Understanding dark, middle and light tonal values

Notice the tonal value system of darks, middle tonal values and lights in the illustrations of a house in Mendocino, California. The full color example and the black and white photograph should be compared to comprehend the tonal values of the colors used in the painting. The important thing to remember is that our eyes read tonal value contrasts, and in order to make our paintings readable, we need to establish a system of dark, middle and light tonal values.

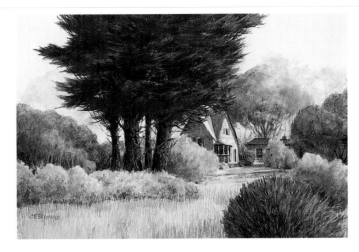

Tonal values of color

***Mendocino Morning*, watercolor, 15 x 22" (38 x 56cm)**
Color brings the painting to life, but tonal value contrasts help us read the trees, house, grasses and bushes. Color and tonal value contrasts work together, and are equally important elements in an effective painting.

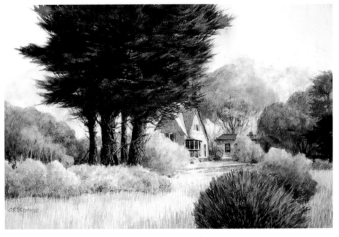

The same painting in black, white and gray tones
Compare the tonal values of the color image with those of the black and white image.

High key color

High Key color refers to colors that are light in tonal value — from white (1) to the middle of the tonal value scale (5). Paintings that are high-keyed are usually airy and light, and often (not always) delicate. They often project feelings of happiness and well being. Emotional content comes into the picture again! A painting of a foggy landscape is usually high keyed, as are many desert paintings. Many impressionist paintings are also light in tonal value, or high keyed, and some artists working today continue to use high key or light tonal values in much of their work. Although you and I have been taught to, and often wish to use a full range of tonal values in our paintings, you can often express personal attitudes about places better if you learn to control the tonal values you use.

A high key painting

***St. Paul in the Morning Mist**, watercolor, 15 x 22" (38 x 56cm)*
Fog paintings are often high keyed, and have a very limited range of tonal values due to poor light conditions. Notice the difference between the limited tonal value spread in this outdoor demonstration painting of St. Paul de Vence, and the black and white version of my painting "Mendocino Morning" on page 57, which has a full range of tonal values. I enjoy making paintings in the fog, and this demonstration was of a favorite village in the south of France. By the time my demo was finished, the sun had come out and the incentive for artists in the workshop to paint the fog had disappeared.

Low key color

Low key paintings are much darker and use the other half of the tonal value scale, from middle (5) to black (10). Paintings that are low-keyed generally are more moody, darker and may suggest a sense of diminishing light, gloom or even doom. (The concept of mood is fully explored in Chapter 8, page 92). The airiness is gone in low key paintings and is replaced by a feeling of confinement, heaviness and submission. These feelings might not always be intended or easily evident, but can be strengthened through the use of dark tonal values, if the artist is inclined to do so.

Look at the set of comparative images to notice the different feelings projected and emphasized by high-keyed and low-keyed paintings. This pair of images is drawn as nearly alike as possible, however, one is painted with a high-keyed palette; the other with a low-keyed palette.

The feeling in each is drastically different, even though the subject matter is the same. This remarkable difference in feeling is determined simply by the darkness or lightness of the tonal values used. You can use this information to help you project a special feeling that is desired in your painting because emotional content can be determined easily by changing the tonal values that are used and emphasized.

Examples of low key and high key paintings
Compare these two 15 x 22" (38 x 56cm) demonstration paintings of the same subject, a rural chapel in southern France. The subject matter in each is about as close to duplication as I can draw it, while the tonal values used in each are drastically different. Note especially how different the feelings are when comparing the high key (almost fog-like) image with the low key study.

A high key painting

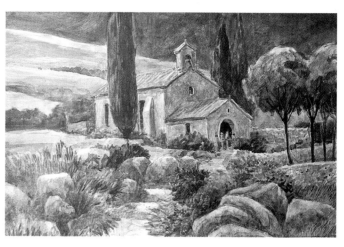

A low key painting

Making a powerful emotional statement with tonal values

Think how strong a personal statement you can make in your painting if you control the tonal values and control the colors or temperature and control the arrangement or composition of the elements in the painting. These factors (editing and color are explored in parts 2 and 4 of this book) are powerful elements in expressing emotional content, and all are relatively easy to control, especially with some practice. Putting them all together will allow you incredible freedom and latitude in making very personal statements about your subjects. You become editor-in-chief of your work, determining its content by controlling these factors.

Making decisions that improve your message

Using a full range of tonal values is often desirable because such images are probably more normal and visually more exciting than paintings with narrow ranges of contrast. A full tonal value range painting runs the gamut of tonal values from white through the middle tonal values to nearly black. It is easiest to describe the effect of bright sunshine on the landscape, for example, by employing a full range of tonal values. Many artists prefer to use a broad segment of the tonal value scale in designing their paintings. Notice how different the third painting feels from those that are limited to either end of the tonal value scale. Strong tonal value contrasts are generally used to produce strong paintings, but often mood and feeling can be enhanced with the use of limited tonal value contrasts — as in low key paintings. Close tonal value contrast paintings, even those that use only middle tonal values, will feel more unified and cohesive, but may lack the energy and vitality created by strong contrasts. Such decisions are up to you as you feel what it is that you want to say, how you might wish to say it, and determine how to develop the composition in your paintings. Decision-making is an important but generally overlooked aspect of painting.

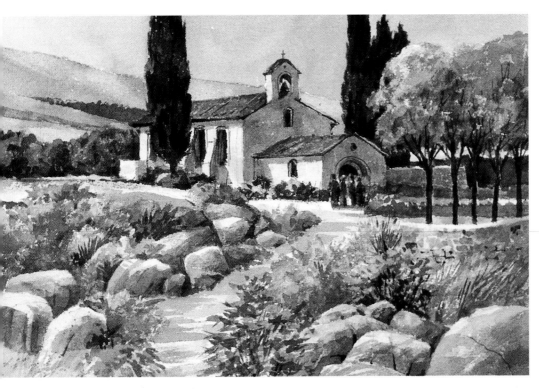

The full range of tonal values used

French Chapel, watercolor, 11 x 15" (28 x 38cm)
Here a full range of tonal values was used. Compared with the high and low key versions the feeling has changed completely. Working with a full range of tonal values is probably more popular, but notice how the feeling changes with each variation. Use this information to influence the emotional content of your paintings.

Exercise

Paint several versions of a location. This is a helpful way to begin to understand the concept of emotional content and how it can be controlled to help visualize what you want to say in your work. Think how successfully emotional content can be varied and determined by combining selection and editing with the personal use of color and a control of tonal values. These elements of art are free. They can be combined with incredible variety to meet personal goals and to make vital statements about your subjects — just what you want to say about them in your paintings.

Using tonal value contrasts to emphasize the focal point and create emotional content

Movement is a design principle that in itself does not have much to do with emotional content. However, it is a powerful asset in the creation of emphasis — which is, of course, a vital aspect of emotional content — and the goal of movement in a painting.

First, let's look at the focal area, the most meaningful part of a painting — the area of emphasis. The focus of a painting should stand out from the rest of the work and be recognized as being the most important part . . . the focus. Anyone should be able to find it!

Emphasizing the focal area

This can be accomplished by using tonal value, temperature or other forms of contrast. My first watercolor teacher stated it very simply, "The focus is where the darkest dark and the lightest light come together in the painting". There was not question in his mind about this, and there had better not be a question in our minds either. So he taught that the place of greatest contrast (darkest dark and lightest light) had to be found in the focal area. This is still wise advice, but I no longer feel that it is the only way to create a focal area in a painting. Other kinds of contrast, such as temperature or intensity contrasts may also be used to clinch the concept of a focal area.

An example of temperature contrast would be a red barn in a green painting — with the red barn naturally being the focus because it contrasts with everything else in the painting. If the barn is geometric (as most barns are) and the surrounding environment is organic (as it is most of the time) that creates another form of contrast. If tonal value contrast is added to these forms of contrast (a geometric, dark, warm red barn amid organic, light tonal valued patches of cool green color), there will be no chance of missing the place in the painting that is meant to be the most important.

With all these possible contrasts, the focal area should certainly be the most exciting part of the painting, and actually be the essence of the total image. It is the place where the emotional content of the painting is seen and felt most strongly — the epitome of the message we wish to share. Often, a small mat put over the focal area will result in a tight, well defined image of its own. (See the accompanying example).

***Mendocino Morning**, watercolor, 15 x 22" (38 x 56cm)*
If I place a small mat over the focal area of one of my paintings, it should create a concise and condensed version of the emotional content of the entire work. Here should be found the essential ingredients of my painting and the justification for its being made — the heart and soul of the work . . . its emotional content. You can see in the full image (page 57) the location and importance of that focal area.

Establishing and supporting

***Movement and Focus #36**, collage and acrylic, 11 x 15" (28 x 38cm)*
Here acrylic colors were glazed over a black and white collage, middle tonal values were added and the tonal value structure became more complex. Another movement ingredient was added, that of movement from areas of little contrast (outer edges) to areas of greatest contrast (the focal area). Still, there is movement toward the focus via passages of very dark tonal values, middle tonal values, light tonal values and color. The focus stands out because it is more detailed (busier), has more contrast, and the shapes are more organic than the simpler, geometric shapes farther away.

The focal area of a painting should receive special attention as you finish your work. More detail, more contrast, smaller shapes, concentrated effort — more of YOU — go into the focus. A small mat placed over the focal area should display much more detail than the same size mat would contain farther away from the focus. The very fact that the outer edges of a painting are more simple and have larger shapes, causes your eye to be drawn to the detailed focal area because your eye moves from generalizations (simplification) to specifics (details). (Note the simple areas outside the small mat placed on the painting "**Mendocino Morning**" at left.) The focus should draw attention to itself and be accessible from outlying parts of the painting in as many ways as possible.

Once that focus is established, the rest of the painting should support it. How can that be accomplished? By creating visual movement from the outer edges of the painting to the focus, and this movement is controlled primarily by the tonal values used. Our eye travels on similar tonal values that are linked together to create a visual path in a painting or drawing. Similar tonal values that are linked together in a painting produce passages, which should lead to the focus. Our eye can also move

focus

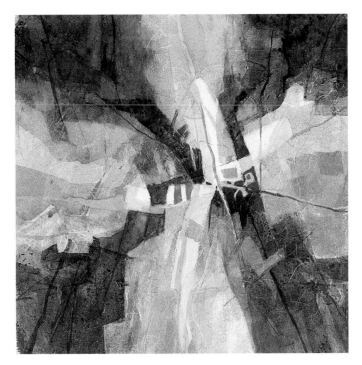

Cruciform #29, collage and acrylic, 11 x 11" (28 x 28cm)
This non-objective cruciform design also creates movement toward a focus, on paths of both dark and light tonal values. Color and texture were important additions to this design, because various kinds of washi (rice papers) were used in its construction. Note the contrast between the detail in the focal area and the simplicity at the outer edges of the design.

Identifying movement
In this picture, I am drawing arrows over a similar cruciform design to show the movement on both dark and light tonal value passages toward the focus, which has been circled. If you complete many such projects, your understanding and sense of tonal value contrast, movement and focus will be greatly strengthened and can be transferred easily into representational landscape paintings.

over color paths to get to the focal area, but it is important that you understand that paths of similar tonal values should also move through a painting to unify it by visually pulling various parts toward the focal area, which is the heart of the painting.

Creating movement and focus
Movement and focus are both determined and controlled by tonal value contrasts. I do not want to get into a long dissertation on design (a subject for another entire book or two) but I want to make clear that the use of tonal value contrast helps us develop movement to a focus which is the emphasis of the work. And emphasis is a primary aspect of emotional content. It is what the painting is about. You must tell me what is most important; lead me to it and then tell me all about it. I remember reading one of Robert Henri's comments in which he said that the greatest crime in painting is to move someone through the painting, and not have anything when you get there. Focus, to him, was a prime element in painting.

Several design projects that I use in some of my design workshops are included to show how movement is established in non-objective designs. It is easy to see the

connected passages if the design is in black and white. If color is used, you need to see tonal value in the colors you mix, so that passage from the borders of the work to the focal area can be seen and felt. If you work on many such projects, your sense of design will be heightened and become almost automatic — and your skill at creating movement and focus in your work will improve to the point that the information can be transferred to any type of painting you wish to make. Study the painting "**Gold Country Relic**" on page 65 and see how this movement and focus information is used in a painting of a house in central California's foothills to the Sierras. As with non-objective imagery, note how movement is directed toward the focal area, and what is done to make that focal area stand out.

"Emphasis is a primary aspect of emotional content. It is what the painting is about. You must tell me what is most important, lead me to it and then tell me all about it."

How tonal value creates form

Tonal value can be used to show the roundness of forms, creating the illusion of depth. Trees, rocks, people, automobiles, flowers and everything else that is three-dimensional, can be better described in your paintings with the use of tonal value contrasts. This happens because of light, and how it strikes three-dimensional objects. Entire books have been written on ways to simulate three-dimensional forms on a two-dimensional surface. But, in simple terms, the part of an object that faces the light source will be lighter in tonal value, and the part that turns away from that source will be darker, or in shadow. The space between these extremes will often be in middle tonal value. This is an extreme simplification, but light and shadow are used to create the feeling of roundness in the forms we paint. Not all kinds of painting need to show such three-dimensional qualities, but if what you wish to say about your subject is dependent on the feeling of three-dimensional form, then a knowledge of tonal value contrasts is essential. In the following demonstration, notice how tonal values are built up and used to define the form of the rocks.

Exercise
Building up tonal values to define form

This exercise shows a way to develop three-dimensional rock forms on a flat, two-dimensional surface. Trees and plant foliage can be handled the same way, except with different colors.

1 *I suggest you use 300# cold press paper for this sequence. First, put down a shape with a watercolor wash that is a medium tonal value color and very liquid. I suggest Ultramarine Blue and Burnt Sienna at the start.*

2 *Immediately, use a tissue to blot off the top of the shape — already creating a form that seems three-dimensional, with light and middle tonal values.*

3 *Add more rocks behind the first one — as many as you want.*

4 *When dry, brush a cool glaze over the rocks forms and blot off. Use Cobalt Blue and a little Burnt Umber.*

5 *When dry, put another warm glaze over the lower part of each rock and blot the edges.*

6 *Add final darks. To create texture or suggest the characteristics of the rocks you can do some scratching, more blotting, add dry brushmarks and crevice lines at any time.*

1

2

3

4

5

6

How tonal value creates texture

How do you recognize texture (which is slightly three-dimensional) when you look at the two-dimensional surface of a painting? Because of tonal value contrasts.

Textures are simulated with relatively dark and light marks that create the feeling of texture on walls, floors, ground, grass, cliffs, leaves, trees, mountains, and the like. I often make texture-looking surfaces by scratching, printing, blotting, lifting, spattering or other techniques that make use of dark and light contrasts to imitate textural surfaces. Oblique light slanting across textured surfaces will enhance the textures and cast small shadows which make the textures more easily readable. The tonal values used to create a textured look are not emotional content in themselves, but if you are trying to tell me about the old, deteriorating surface of a Nebraska barn or the rich textural surface of a Tuscan wall, then your ability to create surfaces that correspond to your needs is essential, and your skill at using tonal value contrasts is absolutely necessary. We examine texture in more detail in the following chapter.

Simulating textures with tonal values

***Rooftops of Siena*, watercolor, 30 x 22" (76 x 56cm)**
Even though the Duomo (Cathedral) in Siena, Italy is the focus of this painting, my real joy was in depicting the textures of the old tile roofs and the wonderful textured patina of Siena's walls. I blotted, scratched, dry brushed, printed and used every possible technique to gain rich, simulated textures, but the end result depends on contrasting tonal values. I feel the textures because of tonal value contrasts. Some of these contrasts are very close while others are stronger because of sunlight and the shadows. My goal was to help viewers comprehend the aged feeling and appearance of the walls and roofs, and their struggles to defy nature's forces.

How tonal value describes space

When I was in the fourth grade in school, I can remember exercises that we did with watercolor washes to show space or depth in our paintings. The most important fact I remember is that things in the distance were lighter in tonal value and things closer to the artist were darker in tonal value. That is a generalization that is still valid, and is even used by photographers at times, when atmospheric circumstances are right. As an experienced landscape painter, however, I now know that this is not always true. However, it is certainly one very convincing way to show depth in a painting, and is called atmospheric or aerial perspective. And if such deep space is an essential aspect of the content in my painting (perhaps the loneliness of a desert environment or a vast expanse of Montana land and sky) then the use of tonal value contrasts of that type help make such statements speak with intense personal expression.

Atmospheric perspective

An early morning haze in Siena, Italy provided the atmosphere for this color photograph taken from our hotel balcony. Wow! What a sight to wake up to! The distant cathedral almost disappears in the mist, while the successive tiers of buildings become darker the nearer they are to me. The close-up trees are, of course, the darkest tonal value. What a lesson in atmospheric perspective!

Aerial perspective in action

***Working on the Li Kiang*, watercolor, 22 x 30" (56 x 76cm)**
I used the same technique of overlapping washes that I learned in the fourth grade, to make this aerial perspective image, which makes use of tonal value contrasts to indicate deep space. The tonal values of the formations get darker and darker as they get closer to me as they advance in space.

What if tonal values are reversed?

To give you an idea of how important tonal values are in creating feeling in paintings, I decided to do a series of wash drawings that will clinch this concept. These drawings also show how emotional content (feelings and sensations) can be altered by changing the tonal value structure. I had a sketch from one of my sketchbooks duplicated on heavy paper stock at a copy shop — a novel technical trick which gives me duplicate drawings. Now, let's see what happens when the tonal values are reversed, switched in some places, and varied in others. Notice how the feeling varies with the change in tonal values. That is why it is important to understand the concept of tonal value structure and how you can use it to help express what you wish to say about your landscape elements.

Creating emotional content by varying tonal value structure

Starting with duplications of a contour sketch from my sketchbook, a series of wash drawings provides an example of the effect of various tonal value structures on the emotional content of exactly the same subject. Even in gray tonal values, the changes can be felt. Imagine if color were introduced, how many variations could be made of this one theme. The original sketch was made at Murrell's Inlet on the South Carolina coast, and is 8 x 10" in size.

The entire chapter summarized in one painting

Remember that tonal value contrast in the design or composition of a landscape painting is not emotional content by itself, but it can be used to strengthen the emotional content by placing emphasis on the most important element(s) of the painting. Tonal value contrasts used to recreate textures or describe forms or space is likewise not emotional content in itself, but can be used effectively to emphasize those characteristics that enhance your description of places and things, and thereby stress emotional content. This entire chapter on tonal value is summarized in this one painting.

Rounded forms of trees and rocks

Textures of grass, trees and the house

Paths of dark and light tonal values to the focal area

More detail at the point of focus

A full range of tonal values from white to black

The focal house is geometric and cool grayish-green against warm organic forms of intense color

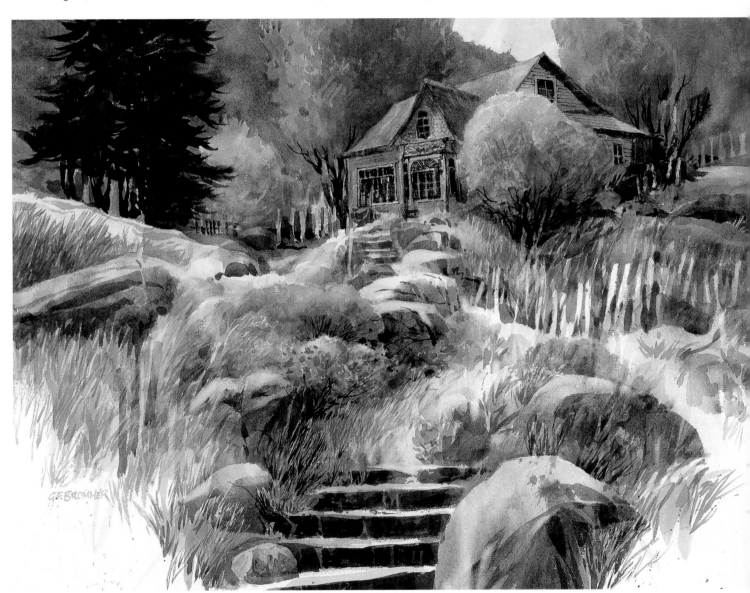

***Gold Country Relic**, watercolour, 22 x 30" (56 x 76cm)*

Emotional content

Every part of the painting is involved in some kind of movement toward the focus. Even though the design is important to the completeness of the painting, the sense of overgrown weeds, broken fences, a shabby house, the bright autumn colors and a kind of haunted atmosphere is what the painting is about — that is the emotional content. And the many uses of tonal value contrast make the emotional content readable.

Chapter 6

Does texture effect emotional content?

Definitely, because texture is a visual adjective that describes the surfaces of places and things that we put into paintings — it is therefore a significant aspect of emotional content.

I love texture! Any kind of texture! I love complexity in my paintings, and texture contributes to surface complexities. Texture is the feel of a surface. That tactile quality of paint is something I appreciate seeing in other artists' work, and I enjoy putting into my own work. Many oil painters use impasto and other techniques to build textures, which is something watercolor painters cannot do without augmenting the surface of their papers with gels, collage or other means.

When I verbally (as opposed to painterly) tell you about a field full of tall, dry, sun-bleached and "stickery" weeds, the words "tall", "dry", "sun-bleached" and "stickery" (a great descriptive word for artists, but not found in a dictionary), are adjectives that describe the weeds. If I paint those same weeds so that they appear to be tall, dry, sun-bleached and stickery, those visually descriptive elements contribute to the content of my painting.

When I verbally say, "The rusted old wagon wheel is leaning against the paint-peeling, splintery barn wall", I am describing the textures I see. Can such descriptive adjectives help me describe that same scene in my painting of that barn? We shall see! Phrases such as "an ancient rock wall" or "an old, rutted brick walkway", "smooth, stream-worn boulders" or "surf surging over deeply eroded rocks" will conjure up mental images that involve different kinds of textures. Since such words describe surfaces, they contribute to the emotional content of a painting that involves them. Visually, I can describe such elements by using either simulated or actual textures.

My environment is filled with textures. I am the only non-textured element in this scene, as I work on the rocks at Prout's Neck, the location of Winslow Homer's home and studio in Maine. Is it any wonder that I respond so intensely to textures in my work?

Texture to the max!

Carmel Confrontation: Rocks and Water,
watercolor and collage, 15 x 30" (38 x 76cm)

When I was first exploring texture and the possibilities of working with a collaged surface and watercolor, I made many paintings of imagined subjects that could be loaded with texture. The watercolor and collage technique used here will be demonstrated later in this chapter, but this painting emphasizes texture to the max! The entire surface is textured — with water textures and rock textures. The white water sloshing over deeply-rutted rocks brings joy to any texture lover like me.

I love texture! Even when my back is turned to it. Here I am shown sketching somewhere in England, while sitting in front of a fabulously textured wall of old bricks and even older stone. The wall speaks of age, of time, of history, of restructured windows, of remodeling and of wonderful, intricate and varied textures. I am probably sketching more textures across the street, but I should have turned around and worked at drawing this wall behind me.

Simulating texture

Simulated textures or implied textures are not textures at all. They might seem to be textures to your eyes, but not to your fingers. A photograph of a heavily textured wall is not textured at all (it is perfectly smooth and even glossy) but it appears to be textured. Simulated textures can be produced by printing with sponges, spattering, gouging the paper, scraping with a credit card, dry-brushing, scratching with various tools, blotting with a rag or tissue, or even simply by using sedimentary watercolor pigments — or by combinations of these and other methods. Simulated or implied textures appear to be real textures but are not, and yet they have the same tactile appeal that real textures have. Foliage of all kinds, masses of flowers, rocks, pebbles, ocean surf, sand, tree trunks, old walls, and brick surfaces can all be painted to appear to have the textures of their natural counterparts. To do this takes much practice, and if you can successfully paint the textures of a shoreline full of rocks being pounded by a violent surf, you will have contributed to the feeling or sense of texture, and to the emotional content of such a painting that relies on texture as a major feature.

Why we paint textures

*There are many books that will explain **how** to create textures and I will show you just a few, but I want to explore with you **why** we want to paint textures. And although there will be some technical explanations and demonstrations, I ask you to look past those activities to see why it is important to communicate to your viewers how important texture is in describing the surfaces of things in your environment.*

The three completely different paintings shown on these pages will help you understand texture and its importance in establishing what it is you wish to say in your paintings. The description of texture varies in each painting because each subject is so drastically different. And remember what I said in the last chapter about light and dark values being needed to describe textures. Here is proof of that belief. All three paintings are loaded with simulated or implied textures.

How implied textures tell the

Wow! Can you sense my love for these three subjects? Can you feel my desire to share my visual experiences with you? That is what emotional content is about — and here, implied textures help tell the story.

Robinson Canyon Oaks, watercolor, 22 x 30" (56 x 76cm)
I was absolutely enthralled when I discovered a magnificent stand of old oak trees in the California hills above Carmel Valley. I proceeded to make a series of about a dozen full sheet paintings describing how I felt about them. The tiny leaves of these coastal live oaks presented a challenge that was satisfied by printing watercolor on the papers with pieces of natural sponges. Layer upon layer was built up, and dry brushing was added until the sense of the foliage was fully felt. The trunks and huge, heavy swirling branches that rested on the ground were powerful contrasts to the tiny leaves. Textures, textures everywhere, to my delight.

Emotional content
This painting is about the textures of great age and oak trees.

story

***Incredible Rockscape, Death Valley**, watercolor, 22 x 30" (56 x 76cm)*
The Death Valley, California landscape abounds in textures, primarily those of fantastic rocks, cliffs, mountains and land formations of every imaginable form and color. Vegetation is at a minimum, since summer temperatures reach 120°F, and not many plants can survive. The low winter sun, however, makes for ideal painting conditions. This painting was started on location and finished in my studio. The rocks have a wonderful variety of textures and colors, as do the mountains and even the soil. Foliage textures are minimal, and are nearly white with the lack of chlorophyll. But the textures were exciting to experience, to develop on paper, and to share with people who have never been to Death Valley.

Emotional content

Sense of place — arid, sandy, warm and rock strewn — the essence of Death Valley.

***Confrontation: Rocks and Water**, watercolor, 22 x 30" (56 x 76cm)*
I scratched, dug into the paper, and painted textures to feature them. Look at the texture of the water spray! The contrast between the heavy, solid, immovable rocks and the sloshing, spattering, swirling sea was wonderful to experience and explore — and to share with others through my painting statement. The water is strong enough, however, to create the textures in the rocks.

Emotional content

The solid, heavy and rugged rocks have been withstanding the roiling, surging surf for many millennia, and so far they are even. The rocks gradually erode (see the crevices and smooth edges) but they are holding their own, and probably have never been more beautiful. Look at their textures!

"Three completely different paintings will help in understanding texture and its importance in establishing what it is you wish to say in your paintings."

Methods for producing texture

Those of us who really enjoy working with texture, and who seek and pick out textural subjects to work on, will find many ways to explore texture-making possibilities. Beside the watercolor and collage process demonstrated later, I try various techniques in watercolor to depict textural surfaces that are simulated or implied. A few pairs of illustrations will give you some ideas to play with. Every landscape painter who wishes to, devises ways to suggest the texture of foliage, tree trunks, cliff-sides, flower masses, old walls, rocks, earth, and the like.

Once you begin to explore possible ways to depict such surfaces you will find additional and probably more exciting ways to do this. Such techniques will then become important ingredients of your visual vocabulary. But practice is the key word. Work on the back of old paintings. Try scratch paper. Get paper samples of various surfaces on which to try different techniques. Some papers work better than others, but cold pressed papers generally work best for making simulated textures.

Texture that makes fingers itch to touch it!

Actual textures appeal not only to our eyes, but also to our fingers. We want to touch them. Feel them. See if they are real textures or imaginary. I once stood next to a very small Vincent van Gogh painting in a museum in Amsterdam. It was a painting about fifteen inches high and eight inches wide of a dense, dark green cypress tree, swirling toward heaven. There were small bits of color stuck between waves of paint that seemed to be about a quarter of an inch high. What a textural surface! I longed to run my fingers over that luscious surface. My fingers itched to touch it. Every time I would get my nose close to the surface, a crotchety old guard would cough, or clear his throat.

A succinct message, indeed. Finally he left the room, and my right hand came out of my coat pocket and moved toward the inviting rivulets of thick color. How would it feel? My fingers were about an inch away, ready to caress a small part of the painting. How did it feel? . . . I'll never know. I just could not touch it. It was too awe-inspiring, too wondrous, and my hand snuck back into my pocket. I finally had to let my eyes do the touching, and not my fingers. I can still see that surface in my memory.

The lure of texture and the desire to touch surfaces with our fingers and not only our eyes is exemplified in another event that happened to me many years ago. I was having a

solo show in a Hong Kong venue, and the paintings included fifteen or so collage works. These watercolor and collage pieces were mostly of English villages and were used to show the textures of Cotswold walls and buildings as well as the abundant undergrowth, trees, rocks and flower gardens. Lots of textures. The Chinese visitors to the gallery wanted to feel these textures — not with their eyes but with their fingers. They tried, but were separated from the surfaces by glass. The gallery director said that when she closed up each day, she had to use Windex and a cloth to clean the glass surfaces of fingerprints. So strong is the allure of texture, and the impulse to touch and feel it.

(Right) *Palm Canyon Palms*, watercolor, 30 x 22" (76 x 56cm)
I used a chisel-shaped brush handle to carve broad light lines into the palm trees in many places. Although the initial scraping and gouging is usually modified as the painting progresses, the surface provides wonderful marks that I can react to, and on which I can build colors and values. This painting is about the scraggly, old native palms in an Indian canyon near Palm Springs, California. What a wonderful time I had, scratching, lifting, gouging — and even painting with a brush, at this fantastic location.

Texture detail

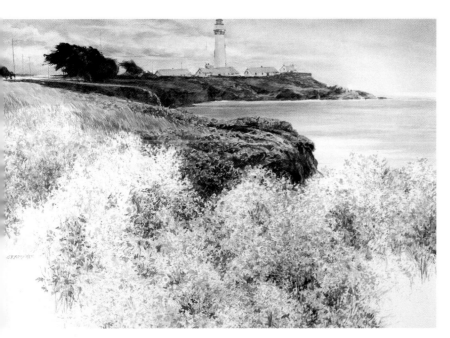

Pigeon Point Light, watercolor, 22 x 30" (56 x 76cm)

The lacy flowers in the foreground were a challenge until I remembered my sponges. Purples, greens, grays and dark grays were printed and overlapped until the feeling of the flowers was evident. The rest of the painting was done as usual with a brush, but the textured flower masses that so appealed to me on location, become a vital part of the statement. Their fragility contrasts dramatically with the powerful cliffs and the massive lighthouse, which is the tallest on the Pacific Coast.

Texture technique Printing with a sponge

Natural sponges work best, and can be ripped apart to find incredible textures inside and out. Dip the dry sponge into a pool of watercolor and dab the paper. When dry, change colors or values and dab again. And again. And again. Until you are happy with the surface. Try the sponge slightly damp. Drag the sponge a bit. Experiment. I print with crumpled papers at times. Even a wet tissue will print, as will wood objects, leaves, and anything else that can be dipped and printed.

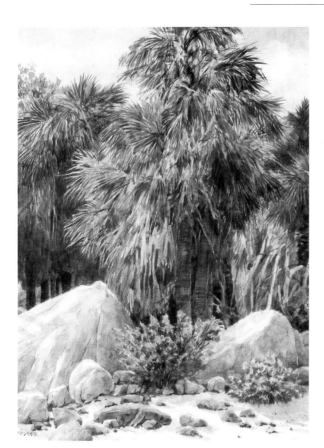

Texture detail

Texture technique Scraping

Gouging and scraping the paper. After a wet brushful of middle-valued color has been laid on the paper, the chisel-ended handle of some brushes can be used to scrape away color. (The corner of a credit card can also be used). This creates linear or chunky patterns of contrast, depending on how the tool is used. The pressure needs to be quite firm, and one swipe is enough. I use this technique often on tree trunks, in foliage, or rocks and so on. Try screwdrivers or other tools, but be sure to practice.

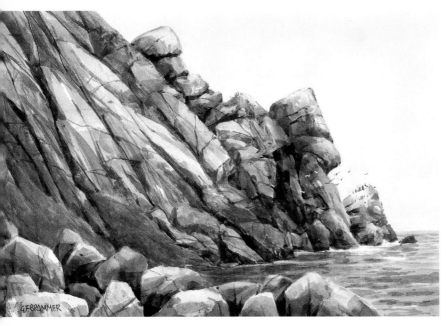

Texture detail

Cormorant Heaven, watercolor, 15 x 22" (38 x 56cm)

This painting was done as a demonstration and is of the base of a huge monolith called Morro Rock, at Morro Bay, California. The rock was overwhelming! Where to start?! After seeing the perplexed look on the faces of twenty artists, I wanted to be loose and imaginative. Rather than paint each facet of the monolith as it was, I let my credit card push colors around until they gave the impression of the immense rock-mountain. After the scraped surface dried, I finished the impression with brushes.

Texture technique Scraping with a credit card

Use an old card, or one of those that are sent without your asking! I cut some of these up to make different shapes and edges. Scraping works best on cold pressed papers, or sheets with not too much tooth. Put down dark or middle value washes and then scrape. Turn the card and try several different swipes. The technique will produce broad light areas with dark linear accents caused by the edge of the card and the build-up of pushed liquid.

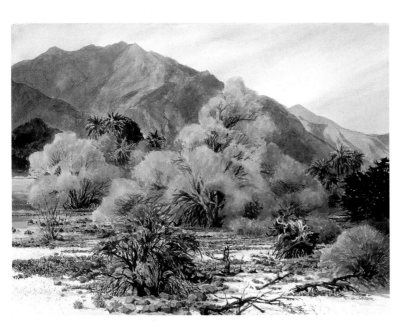

Texture detail

The Desert Comes Alive in Spring, watercolor, 22 x 30" (56 x 76cm)

The subtle textures of the California desert's smoke trees, as well as other foliage textures, can be effectively dry brushed. I put the tree shapes down first with light-valued washes, and then began a dry brush process over and over again to gently build up the subtle value contrasts. Smoke trees seem to be feathery light and soft in their spring greenery, and the linear quality of a dry brush can describe these textures. The painting is about that spring green softness. Notice other textures in this painting, also.

Texture technique Dry brush painting

By loading a round brush with a colored wash and then blotting some of it off with a tissue, I can use the side of the brush (not the tip) to scratch down color. A very unpredictable texture is the result, one that works well on foliage, grasses, rocks, cliffs, tree trunks, and so on. These unique textures can be applied over colored washes or over more dry-brushed underpainting. Dry brushing works well on both rough and cold press papers, although the same strokes will look different.

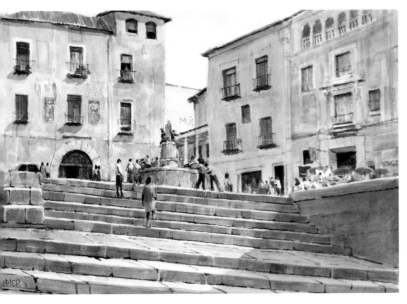

Texture technique Blotting with tissue

Plaza Fountain, Segovia, watercolor, 15 x 22" (38 x 56cm)

This town plaza in Segovia, Spain received the full blotting treatment. I demonstrated the technique to the enjoyment of our group of artists and a dozen or so local Spaniards. The building walls (the facing one enlivened with raking sunlight) and steps were painted and blotted, painted and blotted again and again — each time changing the color temperature from warm to cool and back to warm again. When I look at the painting, I can almost feel the surfaces and the variety of textures — thanks to Kleenex in my left hand.

The Library Journal once printed a review of one of my videos and said, "I don't think this artist can paint without a Kleenex in his left hand." And the reviewer was right, because I use tissues constantly to blot and lift, creating many of the textures that I find so fascinating. Old Tuscan walls, adobe missions, countless rocks, trees and flowers get blotted by my trusty Kleenex. Color brushed over a dry blotted wash and blotted again will increase surface complexity — which I really like.

Texture technique Brushing textures

Indiana Afternoon, watercolor, 22 x 30" (56 x 76cm)

The textures of everything in this painting were made with brushes. The texture contrasts were subtle to duplicate the softness of autumn grasses and the distant trees, while the dry thistles crackle with stronger contrasts. I was intent on creating the soft feeling of a lazy autumn day. The soft colors, subtle contrasts and even the lazy, meandering stream witness to this sensation. I can almost smell the countryside. A little dry brush and some lifting help finish the visual description of my feelings about this day.

Many simulated textures can be created simply by brushing and making marks. It is essential to remember that textures are readable because of value contrast, so when you practice painting textural areas you need to think in these terms. Such differences can be subtle or strong, depending on the look and feel desired. The painted marks should also simulate the foliage, rock surfaces, grass or whatever is being painted. Try different brushes and fill pages with practice textures.

Collaging watercolors for texture

Actual textures can be created, as Vincent did, with thick oil paints applied with impasto techniques or with globby acrylic gel. When I am working with watercolor this is not normally possible. However, as we have seen, actual textures can be created by incorporating textured collage papers into my watercolor or acrylic work, or by gluing textured objects onto the support and painting over them.

Texture is a vital element in much of my work — so much so, that over many years I have developed several collage methods that make use of the textural qualities of washi, or Japanese rice papers.

Collaging is a studio project, simply because it is impossible to keep track of small bits of lightweight paper if there is even the slightest breeze. The working method demonstrated produces a fully integrated collage surface in which individual pieces of paper are not identifiable, but their textures are evident. The entire collaged surface is textured but the textured papers are fully assimilated into the painting. Other collage processes may allow the paper pieces to remain visible and therefore retain their integrity even though they may have been modified with paint.

If I am concerned with sharing my feelings about a place and want to help viewers of my work feel the same textures I am trying to describe, this technique works well for me. Such techniques or processes are not emotional content in themselves, but the resulting surfaces exude emotional content. They can vividly describe the surfaces of rocks, tree trunks, rushing water, cliffs, foliage, flowers, old walls, Provencal farmhouses, ancient ruins, old barn walls, adobe surfaces weed patches, and so on.

Texture technique Watercolor and collage papers

These close-up looks at surfaces made with watercolor and washi collage will provide a hint as to why I really like to work with actual textures. These detailed photographs of surfaces taken from different paintings show that such exciting textures simply cannot be painted with any existing painting techniques. Combining watercolor and collage has pushed the envelope for me when it comes to making descriptive surfaces in some of my paintings.

Collage textures can be very descriptive

Look at the details of one of these watercolor and collage paintings to see how incredibly descriptive these surfaces can be — surfaces which speak of textures that characterize the elements of the landscape I am painting, and therefore emphasize emotional content. Textures are a powerful ingredient of my visual vocabulary.

Texture and contrast

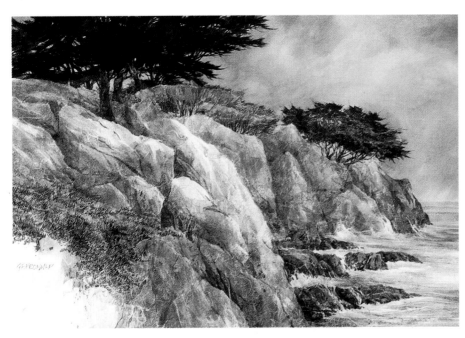

Stormy Coast, Carmel, watercolor and collage, 22 x 30" (56 x 76cm)
Some of my favorite rock and cliff areas are along the central California coast, near Carmel, where the rugged cliffs have been eroded by incessant wave action into wonderful forms. Their rich textured surfaces contrast dramatically with the dark Monterey Cypress trees and fascinating ground cover. In the painting, rocks, water and ground cover are treated to rich doses of watercolor and collage texture. Study the details of this surface to become aware of the beautifully enhanced textures made possible with this watercolor and collage process.

Texture detail
Rocks were treated to many layers of watercolor washes with a relatively dry brush — first warm colors; then cool; then warm again; for as may times as it takes to build up the desired contrast and color. The textures take care of themselves.

Texture detail
Pieces of washi that contain long white fibers make ideal textures for sea water that slaps and sprays against immovable rocks. A very (very, very) dry brush was used to scrub subtle watercolors to tone the water. The papers do all the hard work.

Art in the making **Texture with watercolor collage** *Vineyard in Provence*

1 Drawing my ideas

Using material from one of my France sketchbooks as a resource, I edited the sketch and drew a few lines on a 15 x 22" (38 x 56cm) sheet of Arches 300# rough paper. When I know I'll be using collage, I like to work on good, heavy paper that already has some texture. No details were drawn. If I needed them, they could be drawn on top of the collaged surface.

2 Underpainting

During the underpainting process it might be good to explore texture — just for the fun of it. By this stage I had blotted with Kleenex, gouged with a chisel-ended brush, spattered and dry brushed. However, I intended to collage quite a bit of the surface. The bottom two-thirds of the painting and the big tree on the left would eventually be covered with collage, so details were not necessary — only some color and value contrast.

5 Enriching the color

Light valued hues were put down first, and often blotted. I like to cover most of the collaged surface right away. When the surface was starting to dry, or was dry, I began to enrich the color areas with transparent glazes, and began to feel the value pattern developing. The transparent glazes allow the rich textures to remain visible. Both the plain and collaged surfaces were painted equally to create a unified surface.

6 Adding the darks

Finally, the darkest areas, shadows and details were added. Through the entire process I was trying to take my mind back to that day in Provence when the sketch was made. I wanted to remember the colors, smells, wind direction, textures, and sounds of the place, if I could. All of these elements help to get the feeling of the place, complete with all its various textures and colors. I wanted to share all of that with you.

3 Collaging textured paper

Once the surface was covered with paint, I let it dry and then glued down small pieces of washi (rice papers). I had ten paper textures and I used a bristle brush and acrylic matte medium to adhere them. The papers were torn and randomly placed, not on specific shapes. I blotted off the medium if it was too shiny. When it was dry, I put a 50/50 mixture of water and matte medium over the collaged areas.

4 Applying a semi-wet wash

Since the collaged surface now contained matte medium, it was no longer as absorbent as either the washi or paper surfaces had been. For painting I used a dry brush — that is, a brush that had been dipped in the color of the wash I wished to use, and then blotted off on a paper towel or wad of Kleenex. When that semi-wet wash was laid down over the collaged surface, the resulting textures were glorious to behold.

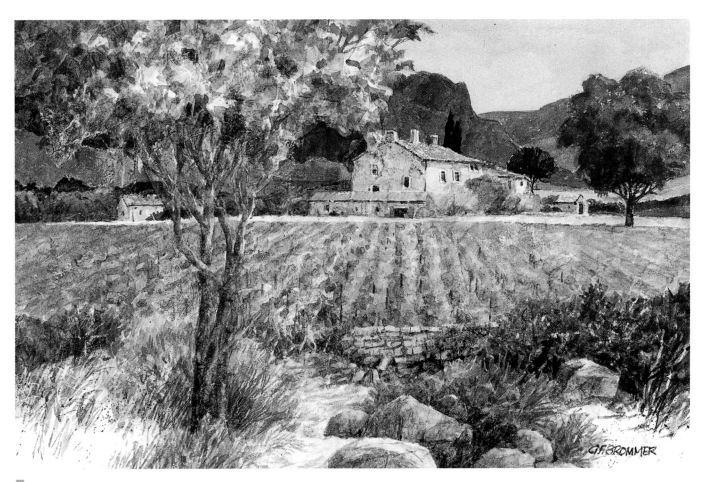

7 Finished painting — *Vineyard in Provence*, watercolor and collage, 15 x 22" (38 x 56cm)

How raking light emphasizes texture

Raking light, or light passing over a rough surface at an oblique angle, will naturally emphasize textures, because it hits areas that project from the surface. When I am sketching or painting a building or part of a village, I will occasionally wait for the light to be just right, and then take a photo of a wall or building when such light is emphasizing the textures of the surface. That sensation will only last for a few minutes and will be gone until the next day. Such a photo can be a valuable resource when it comes time to paint from a sketch or finish a painting started at the same location. If you wish to emphasize texture, raking light can sometimes be the enhancing quality that makes it happen.

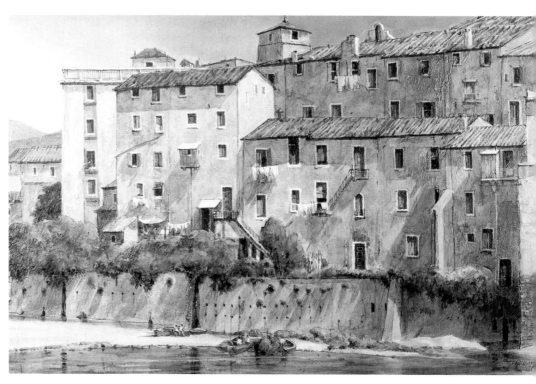

Village in Umbria, acrylic and collage on canvas, 30 x 48" (76 x 122cm)
As light slashes across a textured surface at an oblique angle, it will not only cast long shadows but will also emphasize depressions in the surface and projections from it. Depressions will be a bit darker (in shadow) and projections will be lighter (catching the sun) than the rest of the surface. The old surfaces in the Italian river village of Umbertide are pock-marked and gouged to make beautiful poetry for those of us who love texture. The details will help demonstrate the play of raking light on these textured walls.

Remember that emotional content is determined to a great extent by visually descriptive adjectives that answer questions such as "what kinds of texture do I sense or feel?". It is often a good idea, before starting to paint, to write down in your sketchbook, some of those adjectives that describe the place or objects you are going to paint — including their textures. Then look at the list every fifteen minutes or so, to see if you are actually visually describing the textures, colors, shapes and surfaces of the objects that you verbally described. Even when painting in the studio, this is a very efficient way to understand and emphasize emotional content in your work. Think about and use visual adjectives, because when you do that, you are sharing with the world some of the things that you know, sense and feel about your subject.

Texture detail

Texture detail

The entire chapter summarized in one painting

Everything except the sky was painted with implied textures, made with a variety of techniques and all in response to my remembrances about the area.

An edited selection of flowers, different kinds of trees, tall waving grasses, honey-colored stone walls, old and scratchy thatched roof, bushes of many kinds and splotchy tree trunks.

Notice how I edited the entire subject from sketch to painting composition and invented the required textures.

Some textures are subtle while others are strong in character.

Dark, middle and light values describe the simulated textures which vary in character and intensity all over the sheet. No monotony here.

***At Little Barrington**, **Cotswold**, **England**, watercolor and collage, 22 x 30" (56 x 76cm)*

Emotional content

Color and form are important, but the painting is about the wondrously varied textures of the Cotswold countryside as I remember them to be on a calm, summer afternoon.

Establishing a sense of place

Sense of place begins with complete awareness of what is being observed and painted.

My love affair with French perched villages and Italian hill towns dates back to the early 1960s. My wife and I were on our first European adventure and we were driving north along the French-Italian border, above the town of Ventimiglia. Coming around a curve we were confronted with an incredibly dramatic view of a medieval village perched up on the side of a huge mountain. What drama! What incredible tenacity! What endurance! What history! That village seemed to grow right out of the mountainside and it had been there for hundreds of years. How did they ever build on that precarious site? What a tremendous subject to paint. Since the road was narrow and twisting, and there were few places to turn off to set up and paint, we stopped ever so briefly on the road and I made quick sketches and took some photographs. For me, this was the start of a long personal relationship with hill town villages. I have painted them from the outside and below, looking up, from above looking down, and from the inside looking out. I have come to admire the tenacity of the people who built them hundreds of years ago, and those who still live in them — a continuing history that can be felt while walking their streets.

I have since painted hill towns in Provence, Mexico, Tuscany, Greece and on the island of Madeira — each one different in local color, appearance and structure, but the same in their feeling of tenacity and enduring strength.

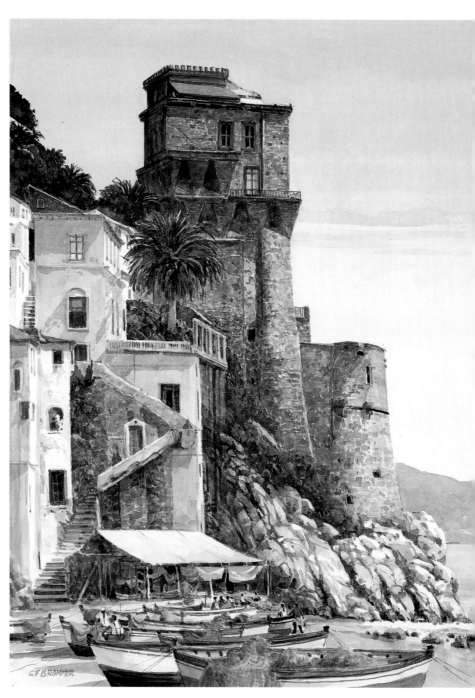

After work — Amalfi Coast, watercolor, 30 x 22" (76 x 56 cm)

I really like to paint hill towns. They were one of my first experiences with understanding the concept of a sense of place. Here I am pictured working outside a little perched village on the Portuguese island of Madeira, and have several local observers as critics. It was the day before Christmas and I could hear people in the village chatting, birds singing and church bells ringing. What a glorious place to be — and to paint!

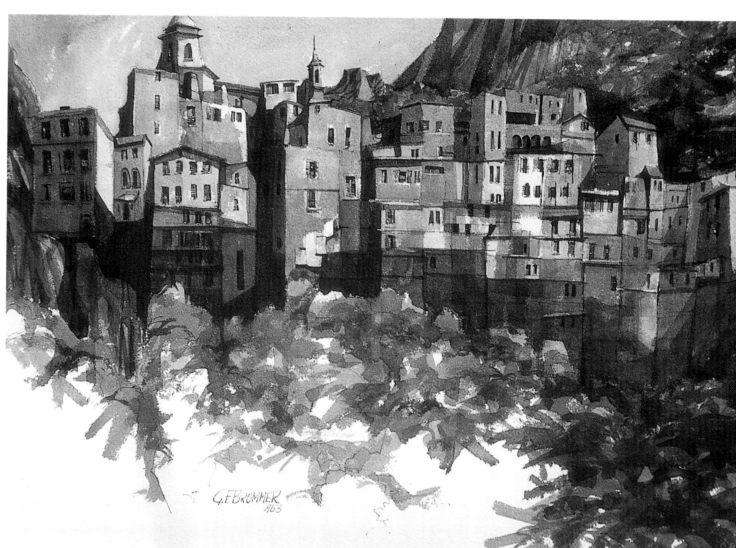

North of Ventimiglia, watercolor, 22 x 30" (56 x 76 cm)
This is my very first hill town painting (1963) and was done in my studio after confronting the village above Ventimiglia from the road below it. We never did find a way to drive up to it. I can still remember how I gasped when I first saw this village, seeming to almost float above the trees. I used a sketch and several photographs for resource material. I have painted several hundred hill towns since this initial attempt.

Evoking a sense of place

Eventually, I began to invent hill town images based on my past experiences and a lot of imagination. In these imagined paintings I tried to capture the sense of place — Tuscan and Umbrian hill towns in Italy and Provencal perched villages in France. I also wished to emphasize my feeling that these villages appear to grow out of the rock mountains on which they are built, and seem to sink their roots deep into them. I became so convincing that often people would study these images and begin to tell me that they had actually been there and tell me where the villages actually were — and which road from Florence or Siena to take to get to them. The sense of place was felt by those people viewing the paintings as strongly as it was felt by me while I was working on them.

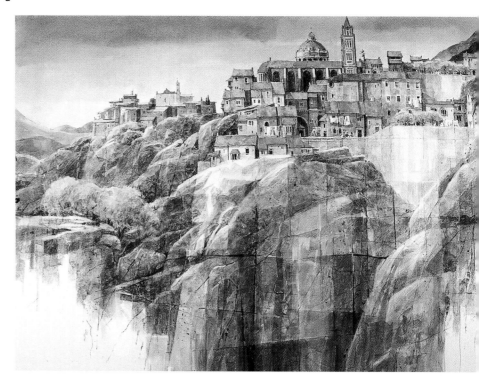

Autumn Light — Tuscany Hill Town, watercolor and collage, 30 x 40" (76 x 102cm)

Sense of place

When working on impressionistic images of remembered and imagined locations, it is essential to understand the importance of a sense of place. Local colors, textures, typical buildings and characteristic relationships of elements cause this watercolor and collage work to feel like mountainous, central Italy. No place looks like this, but many parts of Italy feel like this.

Impression of Tuscany, **acrylic and collage on canvas, 24 x 36" (61 x 91cm)**

Sense of place

Almost ten years and a different medium separate these two images from my very long, sporadic series of hill town images. Although a more impressionistic image, this painting still makes use of the same elements (color, texture, and so on) to characterize the subject and create a similar sense of place. It also feels like many locations in central Italy without looking like a single one of them.

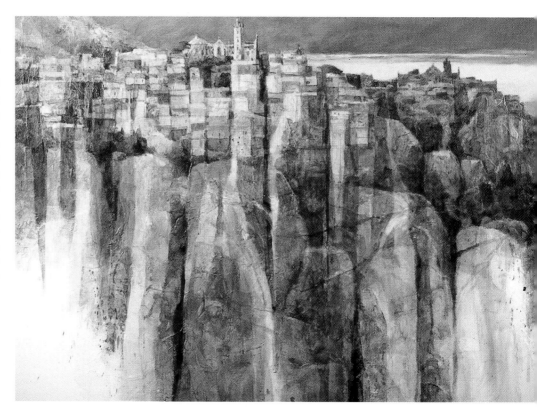

Sense of place as emotional content

In my own landscape painting, the sense of place is actually emotional content. If I can visually describe a location or area well enough that people recognize its characteristics (textures, colors, landscape situations, light, typical shapes and forms and feeling) and can identify the approximate location, I have communicated vital information about that place — and that communication is emotional content.

Conveying how I felt at that place at that time

When I am working on location, I will lean the paintings I did that day against a wall in the hotel room at night. When I wake up and look at them the next morning, I want them to feel like the actual location. Or I want them to give me the same feeling I had yesterday when I was painting each one. If a painting does not do this, then it is not successful because my goal was to capture the sense of the place — a vital feeling that communicates its essence.

Some artists prefer to make generic landscape statements that represent any number of possible locations, or no specific location at all. They are not concerned with the sense of a particular place, but rather with the universality of the landscape. Or their aim is simply to make a good looking painting. Others, myself included, need the painting to feel like the location from which it was derived — to be identified by the sense of place.

Where does sense of place begin?

Much of this sense of place starts with a complete awareness of what is being observed and painted. As I have suggested before, when on location, I don't simply look at the landscape in front of me, I try to describe it in all its nuances, internally to myself at first and visually on paper or canvas. I want to be aware of the sun and its warmth; of what the wind does to trees, grass or water; of what age, wind and storms have done to painted surfaces; of how buildings relate to their environments; of the sounds of wind, church bells, birds, people talking, water and so on.

Instead of just painting tall grass, I want to see what happens to it when the wind blows or when people stomp through it. Instead of just painting a tree, I try to describe its flexibility or its sturdiness, its ability to withstand the tortures of wind and storms. I want to get in tune with my surroundings while I look and feel; look and sketch; look and paint. If I paint from that kind of feeling and awareness, I will do a better job of communicating and describing the essence or spirit of the place in my painting — of capturing the sense of place.

Asking questions

If I work from photographic images or sketchbook studies, I ask such questions as "What was it like to be there? Why did I take this photograph? How was the wind blowing? Was it warm or cool or cold while I was there? How did it smell? Was the sun high or low in the sky? What sounds do I remember? Where were the people (if any) and what were they doing? What season of the year was it? How old were the buildings, and in what kind of repair were they? Were they important to the scene or not? What do I want to say and share about this place?"

Answering such questions provides me with a sense of place. I can almost duplicate the feelings I had when I was at a place, simply by answering those questions and recalling some of those facts, sensations and feelings. My memory then supplies many of the requirements to redevelop the sense of place in my studio painting.

How I convey what I feel

My next consideration is how to tell viewers about the place, and what my reaction was to it. Why do I want to paint it? What about the place do I want to share with others? What elements of the location can I still recall and see in my mind? How can I best describe the scene as I wish to paint it? Since I do not intend to replicate places or things, I can paint the scene any way I wish, not specifically the way it was. To do this I must think about every aspect of the subject, my response to it, and the personal sense of the place that I wish to express, and what I want to share with other people.

"Answering such questions provides me with a sense of place. I can almost duplicate the feelings I had when I was at a place, simply by answering those questions and recalling some of those facts, sensations and feelings."

The viewer must get the point — and believe it

It sometimes happens that no matter how well we communicate our ideas and reactions, they do not get picked up by the viewers. For example, my wife and I made our first trip to China in the mid-1970s, when not many outsiders had been there. We spent a few days in Guilin, which has now become a travelers' Mecca in China. But at that time, we were among the first tourists to see this incredible city and its mind-boggling location. When I returned home and painted edited scenes along the Li River, the response to them was something like, "Those are really interesting images, but nothing on this earth looks like that!" I was communicating nicely, but no one could relate to the subjects and their dramatic visual impact, unless they considered them as fantasy paintings.

Five years later we returned to China, and again visited Guilin and boated down the Li River. This time, when we returned and I painted similar scenes, they were met with much more enthusiasm, because more travelers has been there and magazines and travel brochures had illustrated similar subjects, which were now much more familiar. Communication was much easier, and the paintings were received with greater understanding and enthusiasm.

Pages from my sketchbooks provide the resources for most of my studio paintings. These and similar pages from my first China sketchbook led to dozens of paintings that were impressions of our boat trip downstream from Guilin to Yangshuo. To me, the boats were as fascinating as the Karst topography.

Morning Silhouettes, watercolor, 22 x 30" (56 x 76cm)

Sense of place

Our first trip down the Li Kiang was in winter and the sun was so low in the sky that the incredible limestone formations were silhouetted against it. I later made dozens of images based on this edited combination of river boats, the wonderful rock formations and the hazy winter atmosphere.

"You must develop your own visual vocabulary (your own way of using the elements of art) so you can effectively express your feelings, responses and thoughts about places you wish to paint."

differences

Compare the three images below and note their differences. Then note their similarities. It is the similarities that communicate the sense of place, while the light, color, value contrasts and textures are visual adjectives that describe the place at a certain time or season — but the sense of place is a constant!

Chinese Meeting Place, watercolor, 22 x 30" (56 x 76cm)

Sense of place

I composed and recomposed many situations that used several of the local elements: river boats, trees and the fantastic rock formations. This painting was based on a summer trip down the same river. The light is higher, the colors are warmer, and the emphasis has shifted to the boats — but the sense of place remains the same.

Summer Dawn in the Li Valley, watercolor, 24 x 36" (61 x 91cm)

Sense of place

A more literal approach to the same general subject again emphasizes the sense of place. Anyone who had traveled in this part of China will know where this location is, even though the scene is heavily edited. To me, this is how it was! If I looked at a photo taken at this location, it would look incorrect. Here the cool morning light and fog are emphasized, but the elements and sense of place are the same.

Look for the uniqueness of the place

All contemporary artists (and all who ever lived) have the same few elements of art with which to work: line, shape, form, color, texture, value and space. The ability to express personal feelings and sensations with these elements comes only with observation and practice. You must develop your own visual vocabulary (your own way of using the elements of art) so you can effectively express your feelings, responses and thoughts about places you wish to paint. From my own experience, I know that the more I paint, respond and think, the more easily content becomes an increasingly important dynamic in my work.

Places on earth have unique characteristics and very few places are exactly alike. Look for the uniqueness, the things that set them apart: local color, temperature, amount of rainfall, typical light, denseness of vegetation, kinds of rocks and tree forms, textures, surrounding hills or mountains, wild flowers, gardens and so on. Emotional content deals with such aspects of the environment, and how we interpret them in our painting — how we describe the sense of place.

After many years of painting, and after working in countless locations, and after much practice, it becomes much easier to select and depict the elements that characterize certain locations. At the mention of Sedona in Arizona, Kauai in Hawaii, Tuscany in Italy, Cornwall or the Cotswolds in England, Hong Kong in China, Oaxaca in Mexico, and so on, I can envision possible locations in those areas of the world and, after a few exploratory sketches, I could start to paint them.

Establishing a sense of place

The sets of paintings here illustrate common elements that help establish a sense of place. The first image in each set was painted in my studio from sketches made on location.

The second ones were painted based on my remembrances of these locations. Such remembered images are very likely to express the sense of place more clearly than any other way of working because they contain the elements that are most characteristic.

Cornwall Harbor, watercolor, 15 x 22" (38 x 56cm)

House in Cornwall, watercolor, 15 x 22" (38 x 56cm)
Two different locations about fifty miles apart in Cornwall, England, illustrate common characteristics that can establish a sense of place.

Sense of place identifiers

Cool light, rock-strewn beaches, sturdy and solid house styles, low-growth vegetation, whitish sunlight and cliff-side coastal locations are commonalities that characterize the southwestern coast of England. They are elements that contribute to a sense of place in each painting.

Sedona Juniper, watercolor, 15 x 22" (38 x 56cm)

Sedona Impression, watercolor, 15 x 22" (38 x 56cm)
The red rocks and fantastic formations of Sedona, Arizona are very strong indicators of the location of these two images.

Sense of place identifiers

Cottonwood trees, juniper trees, purple sage and other kinds of local vegetation also characterize this picturesque part of Arizona. As in most other locations, local color is a vital element in identifying and describing a sense of place.

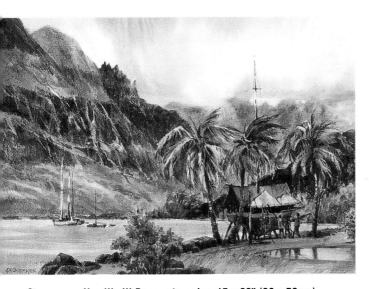

Storm over Nawiliwili Bay, watercolor, 15 x 22" (38 x 56cm)

On Kauai's North Shore, watercolor, 22 x 30" (56 x 76cm)
Two images of the island of Kauai, Hawaii were painted several years apart and are locations on opposite sides of the island. The first image is a demonstration done on location, the other was imaged in my studio with only a sketch of the house to start the painting process. The rest was invented.

Sense of place identifiers

Both paintings contain similar elements of local color, stormy weather, tropical vegetation, steep mountain sides and textures and a sense of lushness that is typical of the wet parts of the island.

Death Valley Suite

Study these three paintings depicting various locations in Death Valley, California as an example of a sense of place or uniqueness of environmental characteristics. Several years ago I spent a week in this wondrous part of the world with my wife and good friend and painter, Dwight Strong, and his wife. Death Valley is very dry, even in winter, and extremely hot in summer, reaching the mid-120°s regularly. It is inhospitable in its climate, but the incredible rock formations, dramatic color changes in the earth, sensational vistas and awesome landforms cry out to be painted in the winter months. I started a series of ten full sheet watercolor paintings during the week we were there.

My emotional content in this series deals with the unique sense of place as I emphasized the dryness, the vivid almost blinding sunlight, the feeling of vast space, the grainy texture of sand and rocks and of the high-keyed values of plants that seem to lack chlorophyll and color. Though each painting is of a different subject, the unique qualities of surreal color and mystical landforms seem to emphasize a similar sense of place. If such characteristics identify a location, the sense of place had been handled with persuasion and the emotional content is enhanced.

Death Valley Suite #5, watercolor, 22 x 30" (56 x 76cm)

Sense of place identifiers

A white, yellow, orange and chocolate landscape could only mean a fantasy location — or Death Valley in California. The dryness of this very low desert and the lack of cactus and other plants that we normally think of as typical desert vegetation are distinct aspects of Death Valley. They are the primary features that wowed me the first time I drove into this incredible location. What a delight to paint!

Death Valley Suite #9, watercolor and collage, 22 x 30" (56 x 76cm)

Sense of place identifiers

A small canyon carries water (if and when it rains) to the valley floor — the lowest elevation in America. This image was begun on location and was finished by collaging with washi (rice paper) and repainting with watercolor. This collage surface really emphasizes the textural quality of local rocks and land formations. White sand and wondrous rock colors again identify Death Valley — the sense of place.

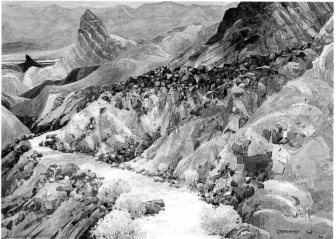

Zabriski Point, Death Valley, watercolor, 22 x 30" (56 x 76cm)

Sense of place identifiers

After studying these three images you should be able to identify paintings made of Death Valley because the characteristics are so similar and so strong. Although desert flowers bloom in the spring and add color to the location, these winter images really characterize the region. The sense of place is clearly expressed by the unique land forms, their colors and the lack of recognizable vegetation.

Pinpointing the emotional content in 3 Hawaiian scenes

When I think of the Hawaiian Islands, I envision bright sunlight, lots of color, small cottages, lush vegetation, the trade winds, and beautiful landscapes and seascapes — not the urbanized chaos of Honolulu or the tourist areas of Lahaina or the major resort hotels. Actually, Hawaii is very green — very, very green. The local color is green. But since almost every plant in the islands seems to bloom at one time or another, my expressive response seems to favor the color of flowers rather than the green of foliage. I therefore tend to push the color when responding to Hawaii and its landscapes and the feeling of the places.

Because color is a major part of emotional content in my Hawaiian paintings, I often resort to using stained washi (rice papers) collage to express it. (This collage process was demonstrated on pages 48/49.) The technique allows me to use color and shape to create abstracted images that express the content described above. Each image in the ongoing series (which now numbers over thirty pieces) glows with color. The colors are exaggerated, but this very fact places the emphasis on the lush color that to me is Hawaii. In a sense, these images are more like Hawaii than the location paintings I have done on all the islands, even though the *plein air* images may be more accurate and generally involve local color.

Color, shapes and value contrasts are used to epitomize emotional content — to tell the story of tropical lushness, varied vegetation, intense sunshine, deep shadows, hideaway cottages, and a pervading sense of relaxation and joy. That is Hawaii to me! That is a sense of place! The sense of place therefore relies on the artist to express his or her feeling about the place, and that may be done in representational, abstract or non-objective ways. Compare these abstracted images with the two representational watercolors of Hawaii on page 87. All describe a sense of place that is Hawaii, but each type is different. If space permitted, I could show you thirty location paintings and thirty colorful collages of Hawaii, and you should be able to identify each as being based on Hawaiian subjects. So strong is the sense of place. Other artists will express this sense of place that is Hawaii in still other ways. Wonderful! The quest of each artist is to find his or her own vocabulary for developing a way of expressing a sense of place — a way of sharing with other people the experiences and impact that the location made on them.

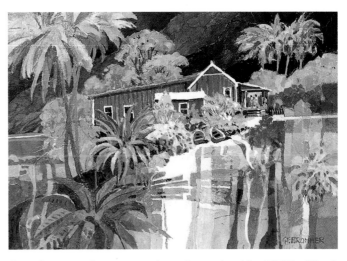

Kona Cottage, collage, watercolor and gouache, 11 x 15" (28 x 38cm)

Sense of place identifiers

Whenever I get the urge to work on Hawaiian subjects, these kinds of collage images jump into my mind. Tropical vegetation, cliff sides, the ocean and cottages are simplified and abstracted from sketches made on location. As abstracted as they are, they still feel like Hawaii to me, and express a sense of place.

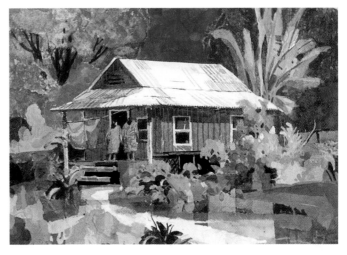

Maui Cottage, collage, watercolor and gouache, 11 x 15" (28 x 38cm)

Sense of place identifiers

Even with a cottage and people pulled up close, I still can abstract all the typical Hawaiian landscape elements into simplified shapes. The color is expressive and not natural, but the sense of place is still evident. The feeling I have for Hawaii is often better expressed in these abstracted terms.

Another Kona Cottage,
collage, watercolor and gouache,
11 x 15" (28 x 38cm)

Sense of place identifiers

Color is always expressive when I work with this collage technique employing watercolor-stained rice papers, but it still defines a sense of place. The design principles of movement and focus are emphasized, but the sense of place dominates the image — at least to my own eyes.

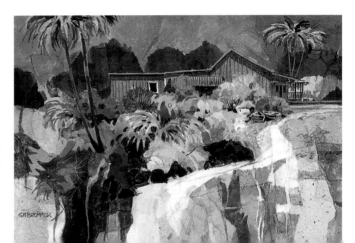

Can you identify these places?

In this little gallery display, there are four images from different parts of the world. Even though four different media were used, I hope that each has a strong sense of the place in which it was painted. Each was painted in my studio after trips to the locations using sketches as resource material, and I had to re-think the sense of place from many miles distant and often years apart in time.

1. Where is this place?

This would be a hard place to identify exactly, but let me tell you about the location. It is an autumn evening and the warm sun is setting to the left. The mountains behind the scene are covered with trees and grass that are still green in autumn — which reads as a high elevation. The descending clouds also indicate mountainous country. The land slopes downward to the left and at the bottom of the long ten mile slope is a river. The cottonwood tree is beginning to change color and the grasses are coarse, dense and almost impenetrable.
See answers at bottom of page 91.

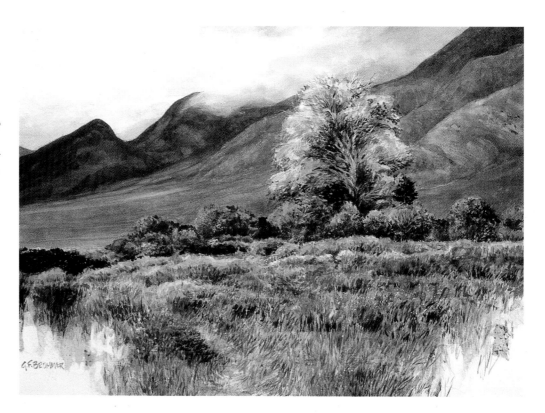

2. Where is this place?

The general location of this image is a bit easier to determine, because the hints are quite direct. The pervading greens indicate an area of plentiful rainfall and the rocks have been taken from the fields and used to make walls and hedgerows. The little white houses with thatched roofs and brightly painted doors are huddled together for protection from the elements. The background hills place it in hilly country, the cool light and the myriad wildflowers seem to indicate early summer in a northern land. The opening in the broken wall has been used as part of a walking path.

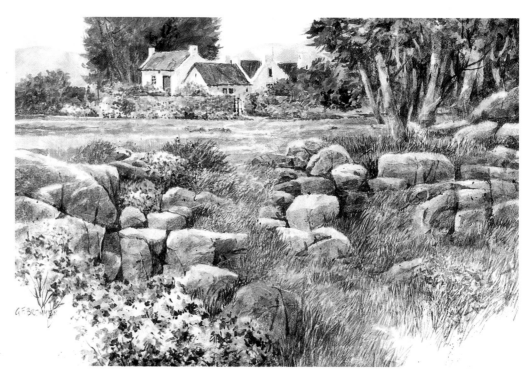

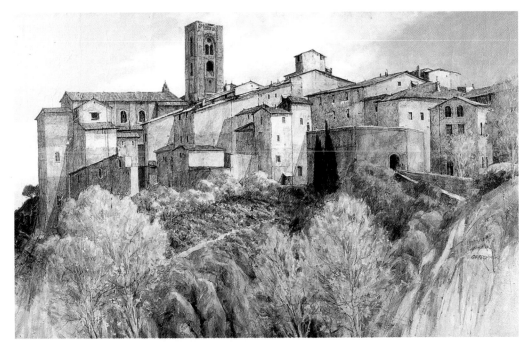

3. Where is this place?

The colors of the structures and the steep mountain side suggest this place is where? The huddled, tile-roofed buildings (that are very old) are perched atop a stony ridge — another indication to the likely location. Can you feel the sense of place developing? Note the gray-green olive trees. The warm, clear light and the changing colors of the trees hint at autumn. The large church structure dominates the town. The architectural style indicates fourteenth to fifteenth centuries as the time of construction.

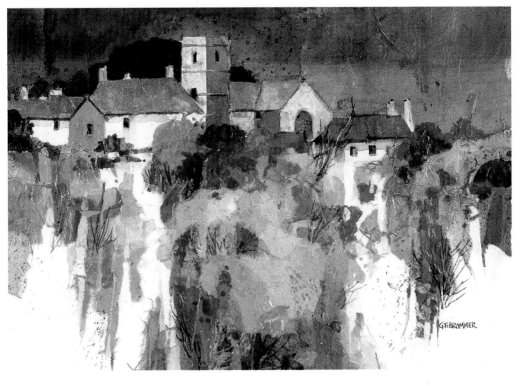

4. Where is this place?

This little abstracted collage image is of an English village in western Cornwall, almost at the Atlantic Ocean. I am telling you this right at the start, because there is a little story here. I had just delivered a group of paintings to a gallery in Carmel, California, and this image was included. An English artist who also shows in the gallery came walking in when the collage was being hung. He studied it a very short while and then turned and asked, "That's the village of Zenner, isn't it?" It is an abstracted image based on an edited sketch of the village, which is so little and so obscure that our bus could not be driven into it to allow us to paint. I thought no living being would be able to recognize my subject except Zennerites — but the sense of place was convincing enough that the artist picked up on it immediately. I almost fainted!

ANSWERS

1. Autumn Evening, Taos, watercolor, 22 x 30" (56 x 76cm) If you could see Kit Carson riding near the big tree, you might be able to identify the place as being just north of Taos, New Mexico. My personal immediate reaction might be that this is high country in either New Mexico, Colorado or Wyoming. **2. Irish Cottages, watercolor and collage, 15 x 22" (38 x 56cm)** The sense of place indicates a northern country area in Europe — and Ireland is the actual location. If you have visited Ireland, it would be easy to sense the general place. **3. Autumn Shadows in Tuscany, acrylic and collage on canvas, 30 x 48" (74 x 122cm)** The town is Colle di Val d'Elsa, a bit northwest of Siena, in Tuscany, and is painted from several sketches and a location demonstration painting. **4. Village in West Cornwall, collage, watercolor, gouache, 11 x 15" (28 x 38cm)**

Chapter 8

Buildings in the environment as emotional content

There are 5 ways to include buildings in your paintings.

fter looking at an exhibition of my work that includes many with buildings in them, people often ask me, "Were you an architect at one time?" The answer is no, but I have always enjoyed architecture and what architects have designed and built throughout history. As an art history teacher in high school, author of a school text on art history and as a trained urban geographer, cities, buildings, city planning and the adaptation of peoples to their environment have always been one of my strong interests.

***Village in Haute Provence**, watercolor,*
22 x 15" (56 x 38cm)
One of the most dramatic villages I have ever painted, is Rochebaudin in the Haute Provence area of France. Its four-hundred year old buildings are sited in a narrow defile between steep, rocky cliffs with a bubbling stream running through the town's middle. On the day I painted it, the hazy, early morning sun almost obliterated the surrounding landscape, allowing me to focus on the buildings. The emotional content is the old and enduring buildings in a hostile, natural environment, which is almost reduced to insignificance.

Two examples

Even though the design is practically the same, there is no similarity in the subject matter of these two images, nor in the emotional content.

Below Bishop's Peak, **watercolor, 28 x 40" (71 x 102cm)**

This California landscape centers on the glorious mountain that backs the city of San Luis Obispo. The farm buildings add human interest and scale, but are actually not very important when it comes to the emotional content of this piece. The bright sunlit hills and the dark oak trees lead our eye to the focal area, which is the wondrous rocky peak. Nature dominates human activity and structures. This is a painting of a landscape that includes a few buildings.

Emotional content

The solidity and strength of the mountain and its rolling foothills dotted with oak trees is what the painting is about.

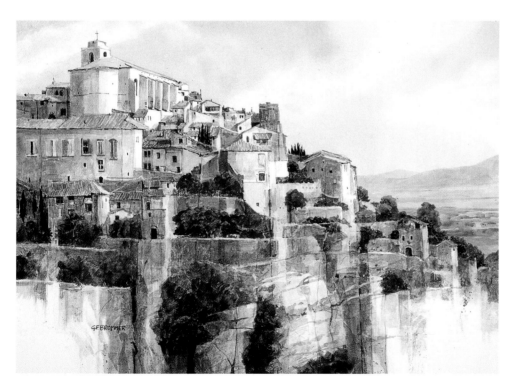

View of Gordes, **watercolor and collage, 22 x 30" (56 x 76cm**

In this painting, the architectural elements are dominant and the trees and distant valley are the overshadowed natural landscape elements. There are landscape elements present, but they are only environmental props that support the presence of the town. This is an architectural painting that includes some landscape elements.

Emotional content

The painting is of Gordes, a perched village in the Provence area of France, and it shows the considerable strength and endurance of this town and its fortress-like appearance.

5 Ways to Include Buildings In Your Paintings

When asked the question, "How do we handle architectural elements in our paintings to contribute to the emotional content or sense of place?" I would suggest that there are five different and distinct directions:

1. Dominant landscape, with buildings included
2. Dominant buildings, with a bit of landscape included
3. Landscape and buildings in balance
4. Buildings as urban landscape
5. Structural integrity

In fact, an entire volume could be devoted to this topic of structures in nature.

Painting buildings in the natural surroundings in many different ways is not very difficult for me because I have a great affinity for both architecture and the natural environment. It is a joy for me, and has been for many years.

How to begin

When I wish to include both elements — structure(s) and nature — in a painting, I need to make a basic decision before I even start to sketch: Will the subject be a landscape with structures, or structures with some landscape, or structures alone? The decision is important because it involves emotional content, what I want to say about the subject. I need to decide where the emphasis will be placed in the painting. For instance, will the building(s) be more important or will the landscape dominate? Which element will the painting be about? Can these two elements be treated equally in a painting? Can the painting ever be about the adaptation of human construction to the environment? These and other questions are answered after determining what is to be shared and communicated in the painting.

Look at the paintings on page 93 to understand the diversity of this dichotomy. Both have a similar composition. Both include structures and natural landscapes. Visual movement directs our eyes in each to the apex of the pyramidal form, and value contrasts are similar in their strength. But the sense of place and the emphasis on emotional content in each is drastically different. Let's work through the 5 ways to include buildings in your painting.

1. Dominant landscape, with buildings

If the landscape is the dominant feature, the building(s) must be integrated into the scenic environment. It is difficult to have a structure that is not part of the focal area of a painting, because its features are so different from those of the natural landscape. This very contrast creates a focus, because it is usually geometric and often a different color than organic trees, foliage, rocks, rivers and flowers that surround it. But if handled carefully, the structure can contribute to the sense of place and also provide the necessary focus for movement through the painting, without being the dominant element.

Because humans naturally relate to structures as places of protection, gathering, social contact, home, worship and daily activity, structures become vital aspects of the landscape, even if they are not intended to be the most important elements.

If a house, barn, castle or other structure is to be integrated into the landscape, it is often a good idea to hide part(s) of

Dominant landscape

Cool Mist, Point Pinos,
watercolor and collage, 22 x 30" (56 x 76cm)
Landscape elements dominate this fog-shrouded California coastal scene in which the structure, a lighthouse, is almost indiscernible. The painting is about a rocky environment, the cold, foggy weather and the necessity for a lighthouse in such a perilous spot and in such dangerous conditions. In this painting, the features of the natural environment are clearly dominant.

included

the building behind trees, rocks or bushes. Flowers, tall grass or shrubs can be placed over corners, or can hide half the structure. In this way, the building seems to be absorbed by the landscape and is secondary to natural elements — even if it is part of the focal area of the work.

Buildings may be far away, with great chunks of landscape in front of them, or structures may be diminished in importance because they are hidden in fog. Impressionistic structures can be fully absorbed into the environment because of brushstrokes, color, dusky atmosphere, rain or other methods, so that the total environment (including the buildings) makes a single statement and is completely integrated. I suggest you experiment a bit to find ways of hiding buildings in the natural environment so that they are present, but are not dominating influences. The four paintings on this page are of landscapes with buildings included.

Dominant landscape

**Georgia's Favorite Bookshop,
watercolor and gouache, 22 x 30" (56 x 76cm)**
On the eastern coast of the North American continent, Maine abounds with scenes such as this. The heavy foliage of a variety of trees nearly hides my wife's favorite tiny used bookshop in a small village near Port Clyde. The landscape elements dominate the composition even though the eye is eventually drawn to the structure. For several months I pursued a compositional plan of having a tapestry-like section of decorative elements at the bottom of the sheet.

Dominant landscape

**Below Mont Sainte Victoire, Provence,
collage, watercolor and gouache, 11 x 15" (28 x 38cm)**
This little collage, made with watercolor-stained washi, is an impression derived from a sketch made near Aix-en-Provence, of Mont Sainte Victoire, one of Paul Cezanne's favorite motifs. The little houses almost disappear because their values are so close to that of their surroundings. Sunflowers, an old olive tree and the glorious limestone mountain dominate the scene. This work would be almost as effective without the structures, but they add a sense of scale to the mountain and the ridges before it.

Dominant landscape

Whaler's Cabin, watercolor, 22 x 30" (56 x 76cm)
Point Lobos State Park near Carmel, California, was one of Ansel Adams' favorite places to photograph — and it is also one of my favorite places to paint. This old whaler's cabin nestles amid gigantic cypress trees and is fronted by a tall, dry grass and weed-filled coastal meadow that almost hides it from view. The painting is about the protective trees and impenetrable meadow foliage. The enduring old cabin is vital to the content of the work, but the landscape elements dominate the location and the painting.

2. Dominant buildings, with a bit of landscape included

When I am painting and teaching in Tuscany, I find there are two basic types of landscapes — rural and urban. In the rural landscapes, the natural environment tends to dominate the scene, with a farm complex of buildings perhaps tucked among trees on a sunflower-filled hillside. But a few miles away, is a village perched on a grassy hillside, or atop a rocky ridge, where the buildings are the dominant feature and the landscape elements play second-fiddle.

Along the Amalfi Coast of southern Italy, the mountains dramatically plunge almost vertically into the Tyrrhenian Sea. The coastline is rugged and exciting, but so are the villages and towns that perch precariously on steep hillsides or occupy every indentation along the shore. These sites are spectacular, and before starting to sketch or paint, one needs to decide whether to feature the dramatic natural landscape or the villages and structures that are masterpieces of human imagination and ingenuity.

In many parts of Europe, one has to make decisions about such emotional content. Greek islands, the Provence and Dordogne regions of France, and much of central and northern Italy contain wonderful and exciting examples of villages perched on solid mountains. Some Native-American pueblos, as well as villages and towns all over the world, call for similar decision-making — should building or landscapes dominate? The artist needs to sense the place in order to make the decision, "What do I feel is the dominant element in this scene? What do I want to tell other people about this scene?" In the two examples shown below, the dominance and importance of the structures are evident — you can see the result of my decision easily and immediately.

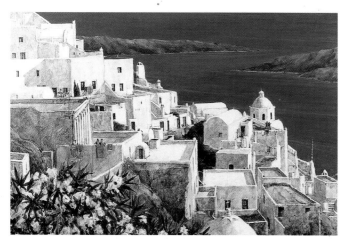

Dominant buildings

***White Geometry**, acrylic and collage on canvas, 30 x 40" (76 x 102cm)*
The Greek island of Santorini contains several incredibly bright villages such as this. Where land is scarce and where people are crowded together, buildings tend to dominate the immediate environment. Viewed from an aircraft, we would find more bare land than structures. So the choice of which elements should dominate is left to the artist. In this case, I chose to have the village dominate the scene as a marvelous example of human adaption to a severe natural environment

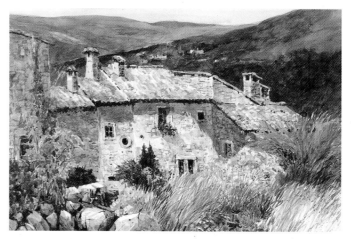

Dominant buildings

***Stone and Tile, Haute Provence**, watercolor, 15 x 22" (38 x 56cm)*
A 400 year old stone building at the edge of the village of le-Poet-Laval in Haute Provence occupies most of the space in this composition. Natural environmental elements afford nice contrasts to the structure and are seen in front and behind the building. They provide the proper setting to define the sense of place, especially the hills of Haute Provence in the background. They are, however, only the setting, and are not featured elements. The painting is about the buildings.

"As the visual impact of structures increases, the relative importance of the natural landscape decreases."

3. Landscape and buildings in balance

Often, both the natural and architectural elements are essential to the sense of place and the emotional content I want to share. When the natural elements are dominant, the structures can almost be deleted, or edited out, and the feeling will remain about the same. When architectural elements are dominant, the natural features could almost be lost in the fog or omitted completely without changing the feeling or purpose of the painting.

When the natural and structural elements are balanced, they rely on each other to express the sense of place and therefore the emotional content to be shared with viewers. Neither element can be eliminated, or reduced in importance, without destroying the sense of place.

This is a decision I need to make when painting in locations where both natural and human-made structures are present. Do I emphasize one or the other, or do I balance their importance? The answer lies in how I feel about the place, what seems to be the most interesting scenario on the day I am there and what I want to tell viewers about the place. What I choose to emphasize would probably be different from what you or other artists might choose. As I am sure you realize by now, emotional content relies on the personal statement that each artist wishes to make about a place. All artists need to understand that and learn to rely on their personal insight, sensitivity and response to the subject or location.

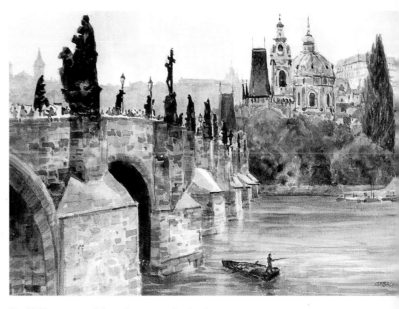

Buildings and landscape in balance

The Charles Bridge, Prague, watercolor, 12 x 18" (31 x 46cm)
When painting on location, the decision concerning the content must be immediate and decisive. When I was standing in Prague with my dear friend Bob Wade, looking across the Vlatava River and the Charles Bridge, I was confronted with both architectural and natural elements — buildings, river and trees. Both are vital to my response. If the river and trees are deleted I do not have Prague. If the bridge and buildings are omitted I do not have Prague. They are equally important to my response at this location and are therefore treated equally in the painting. I want them to feel comfortable together. They are balanced.

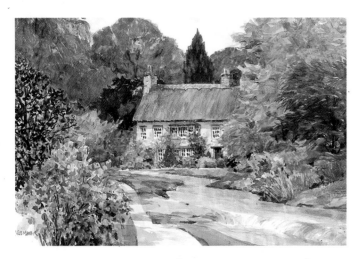

Buildings and landscape in balance

Cottage by Dalby Beck, watercolor, 15 x 22" (38 x 56cm)
A house in a wooded area of a small village in Yorkshire, England was the subject for this demonstration painting. The emotional content concerns the relationship of the house to its garden-like environment. The stream, flowers, bushes and trees provide the wonderful setting for the thatched house. When planning the painting, I made several positioning sketches for the class, with the house smaller and farther away, and with it closer and more important. I chose the sketch that showed a balance of natural and human-made elements with the house comfortably situated among wonderful trees.

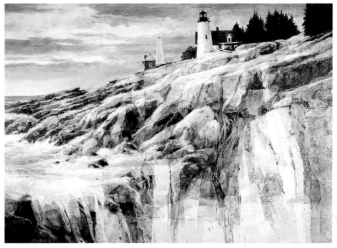

Buildings and landscape in balance

Pemaquid Point, acrylic and collage on canvas, 36 x 48" (91 x 122cm)
The massive rock mound at Pemaquid Point has probably been painted many thousands of times. The lighthouse and accompanying structures are an integral part of the scene — a relationship I chose to keep in balance. The acrylic and collage painting was done in the studio, and I worked from sketches and memory to capture the reaction I always have to this magnificent location. At times I have emphasized or de-emphasized the structures, depending on my expressive intent each time. Here I chose to balance the power of the physical location with the need for a warning to boats along the rocky coast of Maine.

4. Buildings as urban landscape

If we eliminate natural landscape elements altogether and paint the interior of a village, town or city, we are dealing with an urban landscape. Instead of trees and streams, we have buildings and streets. Instead of rocks and bushes, we have chairs, tables, windows and doors. Since buildings are erected and towns are laid out for people, the people will probably become an important aspect of the urban landscape, adding vitality and life to the inanimate structures.

Clusters of buildings may create their own environment. Buildings and streets can be edited or recomposed to suit our personal tastes, desires and reasons for creating a visual statement about them. If we have no qualms about deleting trees or rocks in paintings about the natural environment, we should have no qualms about deleting a few windows, or even a building or two, or changing the number of floors in a downtown building. We can move buildings with ease, or eliminate one or two of them completely. What fun it is to compose our own village!

The vital ingredients of urban landscapes

Marketplaces cause us to focus on the people and their activities and movements. They move as we work on them, and so we can put them anyplace we wish, to make a better composition and to emphasize them or de-emphasize them. People, flowers and trees are sometimes used to contrast with or to soften the hardness of buildings. But no matter how many flower pots or neighborhood trees are included, the essence of the town, village or city lies in the buildings, and how we interpret them. Vegetation becomes a softening decoration rather than an important landscape feature.

The textures and colors of walls are vital components of urban landscapes and often can be determining factors in creating a sense of place. The character of local stone becomes an integral aspect of content. I remember the first time I saw a Cotswold village in the sun. The color and texture of the houses and walls was something I have

Buildings as urban landscapes

Sorrento's Main Piazza, **watercolor, 22 x 15" (38 x 56cm)**
Probably the most editing fun I ever had on location was in the town of Sorrento in southern Italy. I did this image as a demonstration painting, with many local Italians and a few tourists gathering around my group of artists. You might think that this is the way this piazza looks. Not so. There is a large, ugly, gray building between the yellow church and the white building. It vanished in the process, and not a critical word was uttered about my getting rid of it. People were present in the piazza, but of course these are invented as the painting progresses. This certainly doesn't look exactly like the location, but it definitely feels like it.

never forgotten. The ochre hues of Roussillon in France, or of the whitewashed buildings of the Greek Islands, or the muted earth colors of villages in Tuscany and Umbria are identifiable characteristics that an artist can use to create a sense of place.

The coastal villages of Cornwall have a different feel than the coastal villages of New England — or those of Denmark, Mexico or Japan. As an artist, you must become aware of these differences — of the uniqueness of each urban location, and use those characteristics to identify the sense of each place. Study the color, texture, architecture and siting of each location and then sketch, paint and emphasize the characteristics that identify each place in your own mind. This is what you wish to share with others through your paintings. Study the two examples to see how I try to depict the uniqueness of each urban landscape.

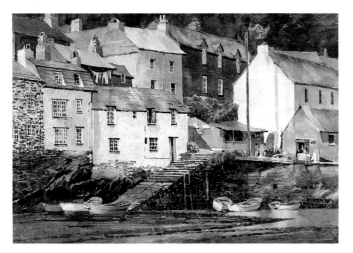

A Corner in Polperro, **watercolor, 22 x 30" (56 x 76cm)**
Polperro, on the south coast of England, is among my favorite locations to sketch and paint. The buildings crowd down on the little harbor which, when the tide is out, has only a little stream running through it.

Emotional content

The town huddles around this harbor, with old stone buildings crushed against each other, as if trying to keep the cold winds from getting into town. I like the crowding and clustering of unique structures — no duplicated buildings here. The boats and people add life to the scene of a working coastal village with typical Devon/Cornwall architecture, color and texture.

5. Structural integrity

Architects and engineers use the term structural integrity when referring to the necessary strength of the various parts of a construction. I have adapted the term in my own thinking and painting to describe the essential qualities and characteristics of a structure that identify it and make it recognizable. Farm houses, barns and country villages do not require this quality and can be edited at will, as we have seen. Some buildings, however, are recognizable when we see them in person, in photographs, in sketches or in paintings. They are often famous and recognized by people all over the world. If I mention the Taj Mahal, Notre Dame Cathedral, St. Peter's Basilica, the United States Capitol, The British Parliament Building and so on, we can conjure up fairly good images of those structures in our minds. We know in what cities they are located and how they should look.

Often, in my own painting, I want viewers to recognize a structure because of its architectural appearance or because of its important in a city's landscape. Think of the Duomo in Siena, the Opera House in Sydney, the Ponte Vecchio in Florence, the Basilica of St. Mark in Venice, the Acropolis in Athens, the Alamo in San Antonio, Mont Sainte Michel in France and many others. Structures such as these are identifiable because of their architecture, decoration, color, shapes and sometimes their location or environment.

In such cases, I try to capture the essential aspects of the building as well as the feeling I had when first confronted by it. I try to retain its structural integrity so it remains recognizable, but I also want it to feel like an interpretive painting rather than a photographic copy. It is in this borderline situation that I find excitement and challenge. I want the building to be identifiable but not simply duplicated. I want the structure or group of structures to look and feel like the place without being a replication. I hope to retain the integrity of structures without trying to make exact copies. Photographs and sketches and even paintings made on location provide the basic resources for much of this work. The examples will demonstrate some ways in which this sense of structural integrity can be accomplished.

Structural integrity

Ponte Vecchio, watercolor, 22 x 30" (56 x 76cm)

I have probably painted the Ponte Vecchio in Florence more than a dozen times — from both sides and from many angles. This is my favorite view, photographed and sketched many years ago from the balcony of a shop on the south side of the Arno river. It is a dramatic view, and a glorious sight in the afternoon light. The structure in the painting is recognizable to anyone who has seen it in person, but in fact, this was a composite of several photographs taken years apart, and several sketches of details. The structural integrity is retained and felt, but it is a painting, not a replication of the bridge.

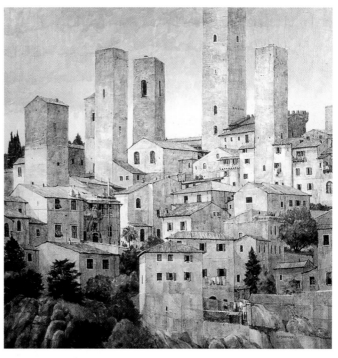

Structural integrity

San Gimignano, acrylic and collage on canvas, 48 x 48" (122 x 122cm)

The entire town of San Gimignano in central Italy is an architectural treasure. It is difficult to ignore the tall family fortresses that have stood for hundreds of years, and which have put a cultural imprint on the surrounding landscape. But the town itself, inside and out, is an urban landscape of incredible beauty and complexity. I have painted it often from many vantage points, and always the tall towers dominate the urban landscape. The entire town's structural integrity demanded architectural awareness and care in preserving size and shape relationships, as well as color, line and texture.

Art in the making Building up structures with acrylic and collage

As you will have gathered, I enjoy using acrylics and collage on canvas. I use this technique to create large images and to develop the textural quality that often epitomizes the structures I wish to paint. Every inch of the canvas surface is collaged with washi, or Japanese rice papers, as well as textured papers from Sri Lanka, Nepal, Thailand and India, to provide the tactile quality I want. Both line and color are used to create edges, delineate details and provide the local color necessary for structural integrity. The collage process is one of constructing and building a surface, a method very appropriate when dealing with subjects that are architectural constructions. The following demonstration illustrates the steps I follow to achieve these goals, to capture the feeling of the place while still retaining structural integrity.

1 The drawing

The construction of my large acrylic collages begins with the foundation — the drawing. Working from one or more resources (sketches, photographs, old paintings or imagination) I roughly sketch in the major elements with a pencil. I use vertical and horizontal guidelines to make sure my buildings stand straight. Here I am using one of my sketchbooks to get this painting started.

4 Adding collage

When this surface is dry, I begin to add bits of rice paper or washi, torn into pieces about 2 x 5" in size. I will almost obliterate the underpainting and the lines, but this is the textural basis for the work. Papers are adhered with undiluted acrylic matte medium — applied to the surface and brushed over the paper immediately with a firm brush. Every square inch of the surface has some kind of paper covering it. No canvas texture is evident.

5 Building texture (detail)

I overlap papers and build textures with fifteen or so different kinds of paper. These papers have no sizing and adhere without wrinkles or bulges — provided they are pressed down firmly with the bristle brush. Changes can still be made, but I like a rough textured surface that almost cries out to be glazed and painted. On a surface like this no details can be seen.

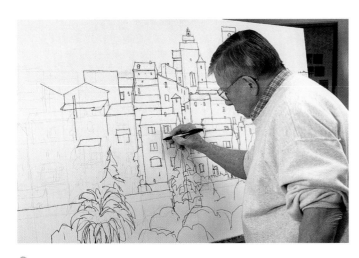

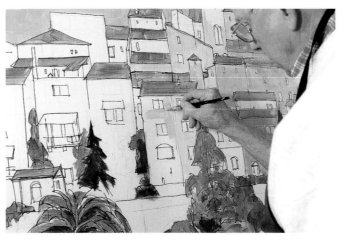

2 Redrawing

I then use a fat, permanent marker, and roughly redraw the contours of the buildings, editing as I go along. Some windows are moved, some structures are deleted or moved so the best shapes will be retained. The structural integrity deals with the feeling of this image as typical of the geographic location in Provence. The heavy lines will be lost in the collaging process, but they set the pattern for the painting.

3 Starting with basic color washes

When the line drawing begins to feel comfortable with my evolving plan, I put down basic color washes of acrylic paint, matte medium and water. This is brushed quickly and then blotted and wiped down in places using absorbent tissue, a process that begins to create textures. These shapes will soon be covered. This underpainting begins to capture my imagination and is the ground for my collage surface.

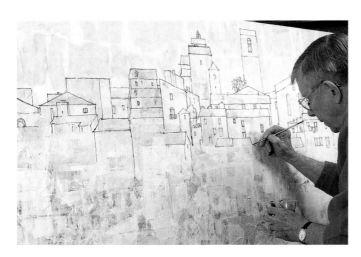

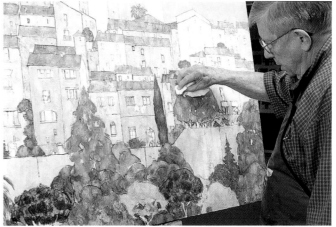

6 Going back in with line

I now go back into this wonderfully textured surface with line to identify each building and its important parts. I use medium viscosity dark acrylic paints thinned a bit with water, as a drawing medium, and use a liner as my brush. Many of these lines may remain visible in the finished work, so care is taken to capture the structural integrity of buildings in a typical Provencal town.

7 Blotting the shapes

Big shapes are brushed down first, using acrylic color, matte medium and some water. While wet, some areas are blotted or lifted with Kleenex to create simulated textures over the actual textured surface. The transparent glazes brushed down when previous layers are dry, allow the textures and colors beneath to show through. This is the basic underpainting for the final look and feel of the painting.

8 Developing the shapes

Gradually, the color surface is built up, glaze upon glaze, warm color over cool, and cool over warm, until I feel that my painted walls reflect the feeling of the walls of the original town. Dark glazes are used to develop the darkest areas. Some light glazes, using a bit of white or other opaque colors, are used to lighten parts of the painting that might have become a bit dark.

9 Adding final details

Final linear details are added in color, or with a dark mix of liquid acrylic paint, to complete the windows, tiles, tree branches, clothing on the line, and so on. The jumbled, almost chaotic feeling of this part of St. Paul de Vence is becoming evident. The gray stone of the walls and the warm tiles of the roofs are suggested and their character is felt, rather than spelled out. The painting is nearing completion.

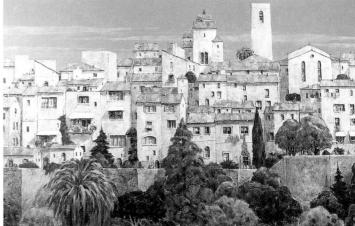

10 Glazing

The final shadows and dark glazes are brushed on to provide the dimensional quality I remember from this part of Provence. The painting reflects my fascination with tactile surfaces, mazes of clustered structures, solid and durable architecture and the patina of time. All of these features emphasize the sense of place and the structural integrity of Provencal perched villages.

11 Finished painting — *St. Paul de Vence*, acrylic and collage on canvas, 36 x 60" (91 x152cm

The finished painting has a wonderfully textured surface that is mostly transparent, because, as you have seen, I used transparent acrylic glazes for most of the painting. The depth or three-dimensionality reminds me of the narrow streets that climb up through the densely clustered structures. Notice how value patterns create movement up the structures to the church and city hall atop the closely-packed and crowded hill.

Go-togethers: buildings and people

I like to include people in most of my urban landscapes — often working, carrying, talking, shopping, playing, walking or standing alone. People often contribute to expressing emotional content because their activities are part of the message I wish to communicate.

1. People give a sense of scale because they are a known and recognizable size, and buildings will be seen in relation to them.
2. People can be used to develop focal areas because we easily relate to them and their activities, and their presence will capture our attention.
3. People can be incidental to the emotional content of the painting when they are not vitally involved with the activity, or when the emotional content would be the same without them.
4. People make a likely focus because they may be different in size, shape and color from anything else in the work. Figures add life and action to a painting.
5. People and their activities can be the emotional content or what the painting is about — such as in images involving markets and numbers of interacting figures.
6. People are vital links between the artist and viewers and can be excellent additions to paintings to help convey our messages.

A lack of people in paintings indicates emptiness, sadness, a dearth of activity, and probably siesta time or a period of rest and quiet in the day.

In my own paintings, I use figures in many of the above ways. When I know I will be painting market scenes in Mexico, Italy, Greece or France, I draw pages full of figures in my sketchbook while flying to these destinations. After practicing for several hours, figures seem to magically appear in my paintings made later at such locations.

Practice drawing figures
I like to practice figures by drawing prior to visiting another country or area. These are drawn in anticipation of the visits, and will not be used for painting resources. Because I do not use figures daily in my work, such practice provides a comfortable freedom of expression when the paintings are begun. These drawings were made prior to visits to Guatemala and Mexico. Each is 8 x 10" (20 x 25cm) in size.

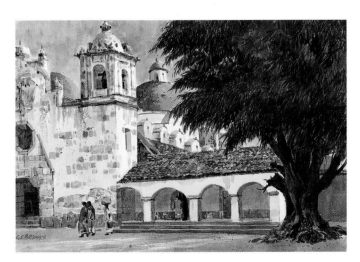

The church at Teotitlan del Valle, watercolor, 15 x 22" (38 x 56cm)
I like to include figures with buildings, even if they are not the focus of the painting. Here, the Mexican church tower is the focus, but the people are a vital aspects of emotional content since they convey the purpose of the structure: an open-door village church that welcomes parishioners and visitors alike. Without the people there would be no village church.

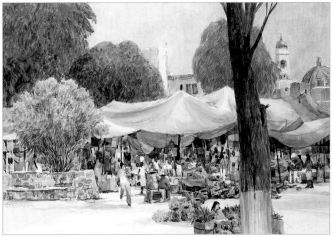

Mexican Market near Puebla, watercolor, 15 x 22" (38 x 56cm)
Morning marketplaces are alive with chattering, bargaining, carrying, active and busy people. When I look at my finished market paintings, I like to think that I can hear the noise and bustle of the place. Congestion and implied complexity are necessary for this sort of emotional content. Notice the quiet simplicity in the background that contrasts with the bustle and noise of the marketplace.

Chapter 9

Using mood, weather and season to enhance emotional content

Mood, season, time of day, weather and the presence of people are powerful determinants in conveying the emotional content of a painting.

Sometimes, nature provides all the mood and weather necessary to make an interpretive painting. I am painting here on the rocky central coast of Maine during a typical summer fog. In this case I do not have to invent or emphasize dampness, muffled sounds or pervasive grayness, because nature has provided all those aspects of content for my taking. What a pleasant feast for the senses!

Looking back at what has been a probing journey through emotional content, let's review the options available for making personal visual statements that stress spirit and emotional content in landscape painting:

1. Editing — deleting, adding or rearranging visual elements to design the best possible compositions that enhance the content.

2. Sketching — as a way of seeing and providing multiple possibilities from which to choose subject arrangements.

3. Color — selecting colors that either emphasize the local color or are personal options chosen for expressive color use.

4. Tonal values — selecting tonal values or value structures that will best emphasize the message in the painting, and therefore heighten content.

5. Textures — using tonal textures as visual adjectives to describe the surfaces of varied elements in the painting.

6. Sense of place — establishing a feeling or sense of place, which necessitates making use of many of the above activities.

By combining some or all of these options it is evident that you have an incredible array of choices when you begin to paint your chosen subject. These are personal choices. You choose them, and how to use them in each particular painting. Remember that the subject (actual location, photograph or sketch) is simply a visual resource which must be edited and presented to the world with your personal insight and feeling. Let's look at more possible ways that this can be done — by understanding and relying on mood, weather and seasons of the year to visuallly express your intent.

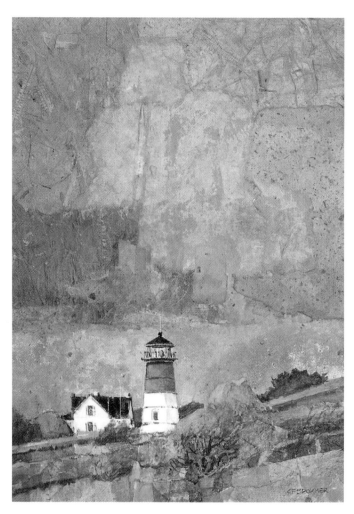

Cape Cod Lighthouse, collage, watercolor and gouache, 15 x 11" (38 x 28cm)

Mood or spirit

When I was teaching high school painting classes and we were working with mood as a driving force in emotional content, I would have the students read the first paragraph of Edgar Allan Poe's "Fall of the House of Usher". As you read his words, think about his verbal adjectives and sense the intense atmosphere, mood and place that he is mentally creating and verbally describing.

"During the whole of a dark, dull and soundless day in the autumn of the year, when the clouds hung oppressively low in the heavens, I had been passing alone, on horseback, through a singularly dreary tract of country, and at length found myself, as the shades of the evening drew on, within view of the melancholy House of Usher. I know not how it was, but with the first glimpse of the building, a sense of insufferable gloom pervaded my spirit."

Later in the same paragraph, we read Poe's words, " . . . utter depression of soul . . ." Then, "There was an iciness, a sinking, a sickening of the heart,"

and if that was not moody enough, he added, ". . . unredeemed dreariness of thought . . ." Mr. Poe knew how to use words to establish mood, time of year, sense of place and how to vividly express intense feelings. If he had been a painter, think how he would have dealt with content in a work with this kind of gloomy and dour content! Needless to say, my students reacted and responded with paintings loaded with dark, sullen and intensely depressing images.

The mood that Poe created with verbal adjectives can be felt and the scene can be envisioned by all who read it, because he was a master at creating moods with words. As we deal with mood and content in our paintings, we should feel compelled to employ visual adjectives as Poe used verbal adjectives to obtain similar results. Mood is a descriptive force in developing content and artists use visual adjectives to describe the physical elements in a painting — and to express the mood they wish to project.

Words that suggest mood

Here is a list of mood words — not merely dark words, but all kinds of mood words:

Ancient	Somber
Quiet	Elevating
Tragic	Wet
Heavy	Complex
Foggy	Golden
Lonesome	Dreary
Cold	Bright
Old	Rainy
Happy	Dark
Speedy	Clear
Brisk	Colorful
Dull	Vivid
Flowery	Textured
Serene	Anxiety
Exciting	Brooding
Hot	Dusky
Congested	Busy
Isolated	Brutish
Windy	Gritty
Gloomy	Silvery
Young	Icy
Dismal	Acidic
Glowering	Ashen
Funny	Bleak
Gruesome	Austere
Monotonous	Refined

Mood for emotional content

There are many ways mood can be used for emotional content, and some have been explored previously. A few are condensed and combined here to emphasize how you can convey the descriptive force of mood.

1. You can change and adapt the value pattern that will best describe the mood
2. You can paint monochromatically — or using a very limited palette
3. You can intensify colors — and/or change colors completely, as you wish
4. You can change, intensify or diminish the quality of light
5. You can use painting media and techniques that create and even intensify the feeling you want to express

Before you start painting, study the subject (photograph, sketch or location) and decide what mood you might like to convey. Something that fits the subject. Some feeling that you get when analyzing the subject. Decide how you might develop this thought and feeling, and then go to work. You will make personal statements about the mood of the subject and will automatically be introducing yourself into the painting. When you and your spirit are in the painting, the emotional content will be evident, and will evolve as a natural outcome of your painting process.

Mood doesn't have to be dark!

Usually, when the word "mood" is used in art, we consider such Poe-like adjectives as somber, dark, foreboding, serious, heavy, stormy, and so on. But words and feelings such as bright, sun-drenched, light-hearted, joyous, frivolous, party-time and contented also describe moods. And what about calm, blustery, benign, soft, foggy and so on. You can even make up words to describe moods with which you might wish to work — jungley, brrrry cold, over-foliated, windrific, rockscape, and so on. Such made-up words can be part of a personal vocabulary and may effectively describe moods or landscapes with moods. The mood of a painting literally describes the atmosphere, and therefore becomes a large part of the content of a place. Moods are created by the manipulation of tonal values and the degrees of tonal value contrast, with help from the six criteria listed on page 104.

The options to manipulate a single subject with these six criteria create an endless number of possibilities — actually hundreds of them. When you are painting, you need to hone in on only one or two at a time.

Look at these illustrations of lighthouse paintings that were derived from a single photograph. The various elements of buildings, rocks, trees and vegetation were manipulated to create several arrangements: in this instance the artist can push the buildings back, pull them forward; make them small; hide them; increase the rocks; feature the vegetation, and so on. Notice how the quality of light changes in each image, because light is such a vital aspect in creating mood. Dull monochrome, bright sunshine, distant loneliness all help create a variety of moods and aid in presenting visual description and feeling. Low-key images denote gloom, dreariness and even mystery. High-key paintings seem bright, happy, and have a sense of joy and lightheartedness. More variations on this one lighthouse subject can be seen in the next few pages when weather and seasons of the year are discussed.

The source
The photograph of Two Lights in Maine was the resource for nine images that appear in this chapter. Notice how editing has been employed and how color, value contrast and mood have been used to develop the various adaptations, each with a different content.

Compare the moods present in these three images

A dark or low-key painting projects a sense of drama, gloom, heaviness and often a feeling of mystery.

High-key paintings seem springlike, airy, free and often joyful, even if the subject is almost exactly like the one painted with low-key colors and dark values.

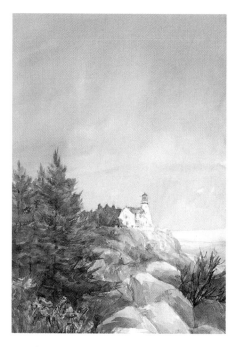

By editing the same elements and making the focal buildings very small, and introducing an immense dark sky, the mood is one of overpowering nature and a lonely and pitifully insignificant human presence.

Using the weather for emotional content

Beside mood, there are several other ways to explore and enhance the spirit of your painting. Consider weather for a moment. The same scene in bright sunshine, drizzling rain, drifting snow, biting wind, dense fog or threatening storm will each convey different feelings and will deal with distinct emotional content. You do not have to wait for rain or fog, however — just paint it! You can sit in your studio or backyard and practice painting in countless weather conditions. You do not have to wait for the next storm or for the next front to pass through to experience these changes. Weather is an aspect of a landscape painting that you can manipulate, and is a variable that will instantly and dramatically change the emotional content in your painting.

Visit museums and galleries to study how other artists use weather in their paintings. As you page through art books, note how weather may be used to express intense drama or to show quiet gentleness. Learn the subtleties about weather that other artists have discovered and introduced in their work.

There is a dramatic story of the French painter Eugene Delacroix, who wanted to accurately portray the action and drama of a violent storm. In order to experience such an event first-hand, he had himself lashed to the mast of a ship in a brutal storm, to fully know and understand the power, tension, stress and his own physical response to a violent storm at sea. His visual interpretation was certainly based on fact.

Note how the visual statement changes when weather becomes a dominating aspect of emotional content. In the accompanying pictures the lighthouse sequence continues. See how, with editing and the introduction of various kinds of weather, the entire landscape looks different — and each image is emphasizing a different sort of visual message.

Examples The elements at work

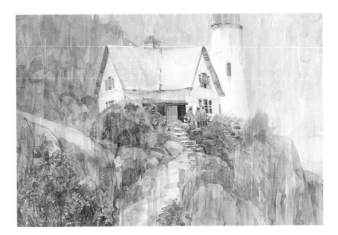

Rain
The lighthouse complex was brought up very close and people were introduced. In this high-key painting done on hot-press paper, the colors were muted and a tissue was dragged vertically over wet paint to create the linear rain pattern.

Fog
The lighthouse buildings were edited to a distant cliff, almost lost in the fog. This is also a high-key image but was painted wet-in-wet to preserve soft edges. (See the next demonstration sequence). As in most fog situations, tonal values were kept quite close.

Storm
In this monochromatic, gray painting, the lighthouse buildings were centered to show their sturdiness and resistance to the elements. The wind is blowing, the clouds look ominous and rain is visible in the distance — but the lighthouse stands secure.

Art in the making Painting fog

I like to paint fog — both on location and in my studio. In order for me to suggest a foggy feeling, I need to work in ways that I normally do not use. I generally work wet-on-dry (that is, I apply wet watercolor paint to dry, unsponged paper). However, fog demands soft edges, high key colors, little detail and very little tonal value contrast. Let me show you the process with a short demonstration of a shrimp boat in a South Carolina river harbor on a chilly, foggy, spring day in March.

1 Making a contour drawing
Working from my sketchbook drawing of a shrimp boat at dock in Georgetown, South Carolina, I am making a contour drawing of the subject with pencil. I edit as I draw.

2 Brushing in the background
Since this is destined to be a foggy painting, I wet the 140 pound cold-pressed paper with a sponge, and am now brushing in the soft gray, foggy background over the top part of the sheet.

▶

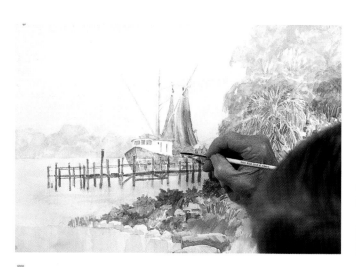

5 Working with muted color
Some color is introduced, but is kept muted and grayed to strengthen the spirit of a fog-bound landscape. No dark values will be used at all, because they would suggest sun and shadows.

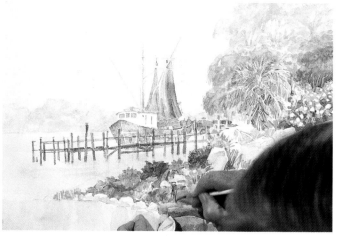

6 Coming together
The visual image is beginning to feel the way I want it to feel — cool, wet, and suggesting the muted sounds that accompany a drippy, foggy atmosphere.

3 Establishing the distant trees
Soft-edged distant trees and foliage are added while the sheet is still quite wet. Note that the gray sky color has been brushed over the water and boat areas and part of the large trees on the right.

4 Introducing darker tonal values
As the paper dries, darker tonal values are added, but are kept close to enhance the feeling of fog-filtered light. The initial busy drawing of boats and people at the bottom of the sheet has been edited out. Notice the tissue which I use for blotting, lifting and controlling pigment.

7 Glazing for mood
Finally, the water is given a few glazes to create the feeling of calmness and stillness. A wet, drippy, quiet, foggy morning has emerged and materialized from the damp, gray background.

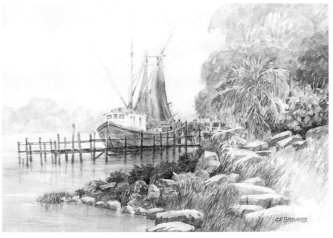

8 Finished painting
When I look at the final image, I can almost hear the stillness, and await the muffled sound of fishermen's voices as they unload the boat. I am also listening for the fog horn to sound.

Autumn Rain in Provence,
watercolor,
15 x 15" (38 x 38cm)
On a workshop in Haute Provence, we had spent five perfect days in ideal autumn weather, joyfully painting in small mountain villages near Dieulefit. When we were deluged by rain, our group couldn't leave the hotel, so I painted a rain demonstration while looking out a large window. This is the back gate to our hotel grounds — a perfect rainy-day motif, with people walking their dog in the rain.

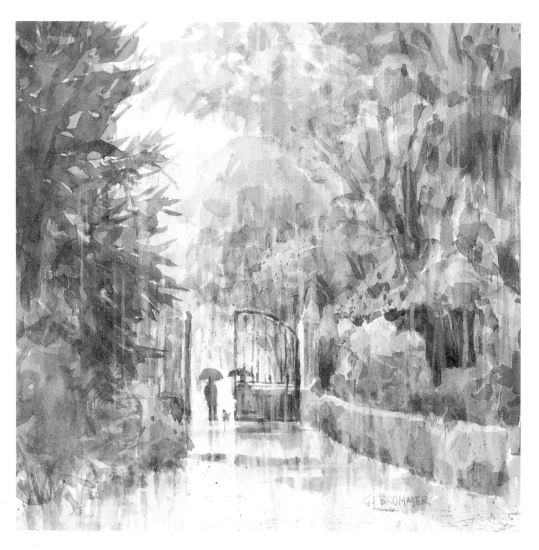

Mykonos Chapel, collage,
watercolor and gouache,
11 x 15" (28 x 38cm)
One of my favorite painting times is after rain, when the light grows brighter, the dark clouds still hover, and puddles and reflections indicate remnants of the passing storm. Even in my studio, I often like to recreate this type of weather situation in my paintings. In this stained paper collage, I used watercolor glazes over collaged papers to achieve the wet, after-rain feeling.

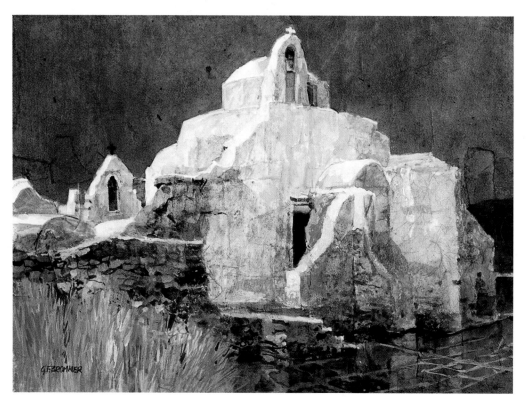

Skies and emotional content

Entire books have been written about how to paint different sorts of skies and the influence skies have on a painting. Here, I want to show how skies help to emphasize mood, weather or time of day.

Skies are a source of light and color and can be serene, active, stormy, intense, agitated, benign or calm. Skies can describe morning or afternoon sunlight, sunrises and sunsets. Their warmth or coolness helps express the characteristic feelings of the seasons or of geographic locations. As I page through my issues of *International Artist* magazine, I can find skies from around the world, of almost every hue, containing every kind of color and cloud formation. Skies can be dark or light, active or calm, decorative, designed or real.

Skies may seem non-important or simply backgrounds for the essential landscape elements, but they always contribute to the feelings that artists want to express in their work. In my own work, I sometimes paint the skies first. At other times I wait until the painting is developing and my message is clear, before I paint the sky. I suggest you experiment with the character of skies to sense the range of possibilities in your paintings.

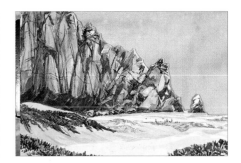

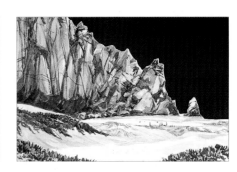

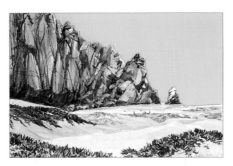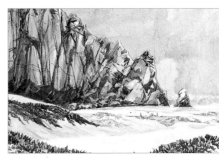

Same landscape — different skies — different moods

Changing the mood by changing the sky

I have never tried this experiment before, but I am sure that I can use the results in some aspects of my teaching. I take a single landscape painting and cut off the sky — and then place that landscape against a number of different types of skies, and even against a few different colors. Let's see what happens. Let's see how the feeling of the painting changes with the alterations in the sky.

I took one of my old quarter-sheet paintings of sand dunes and Morro Rock, on the central California coast, and cut off the sky. I then placed that cut image against a variety of painted skies and also against a few sheets of color. Notice how different each one feels — emphasizing the concept that skies have a powerful influence on content in landscape painting.

I could have included several dozen more skies, but these should aid in understanding the importance of skies in expressing content in landscape paintings.

As you can see, skies have a powerful effect on the spirit and feeling of a painting. This landscape didn't change at all — just the sky changed — and see what a difference a sky makes.

If I were going to change a sky in a finished painting, I would probably have to change other aspects of the landscape also — color, shadows, amount of value contrast, and so on, to unify the image. Skies must be considered an integral part of emotional content in landscape painting. Choose the color and activity of your skies

carefully and use them to clinch the concept you are developing and expressing in your work. If you page through this chapter you will see a wide variety of skies, each of which was developed to enhance each painting's emotional content.

With some computer software programs, you may try many different skies in your landscape paintings to determine which might work best for what you want to say, before actually committing yourself to a specific kind of sky.

I was once studying and enjoying several of John Constable's powerful landscape paintings in the National Gallery in London. Since Constable was a master at painting clouds and

"You need to think autumn, to paint autumn. You need to think rain to paint rain. Your mind and spirit must feel the temperature, wind, quality of light and color in order to paint with sincerity from your heart."

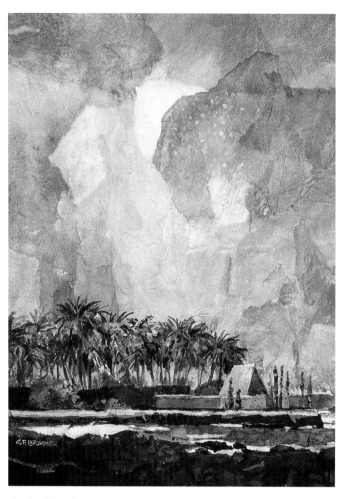

On the Kona Coast, collage, watercolor and gouache,
15 x 11" (38 x 28cm)
Chunks of various kinds of stained rice paper can be seen in the huge and active sky, which makes the Hawaiian landscape on the Kona coast seem diminutive. Diluted white gouache glazes were painted over all the sky area and partially wiped off again to achieve the unifying quality of this sky.

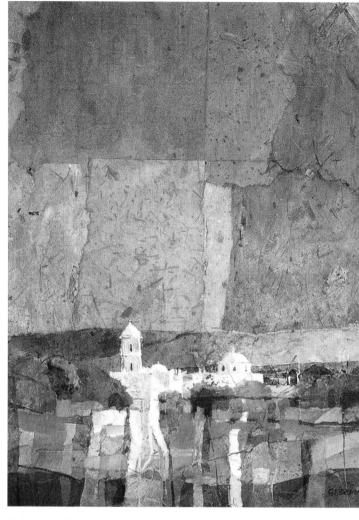

Tubutama, Sonora, collage, watercolor and gouache,
15 x 11" (38 x 28cm)
The glowing white of a Mexican church is set against a glowering, gray sky, collaged of several dark hues of stained papers of various textures. A transparent, gray watercolor glaze brushed over the sky surface unifies it and sets the emotional feeling for the entire piece.

skies, I made some offhand comment to my wife, wondering if Constable ever painted just skies, since he knew them so well. The next day, in the Victoria and Albert Museum, by chance we found our way to a room in which there were four or more paintings of skies by this master. Just skies. No trees or land at all. They gave me an insight into what he thought of skies. He certainly understood them

and their importance in his landscape paintings, because he obviously felt they were the crowning glory of nature.

I enjoy constructing landscape collages using watercolor-stained papers and glazing over them with transparent watercolor and/or gouache. In some of these images, I actually emphasize skies by having them occupy the largest part of a

space-division landscape design. Old Dutch landscape masters used this same design format to emphasize the flatness of their land and the hugeness of their skies. Note in the illustrations, how the large skies seem to squash the landscapes to the bottom of each work, thereby creating visual tension. Each sky has its own character, which contributes mightily to the emotional content of each piece.

Seasons of the year and times of day

The portrayal of summer, autumn, winter, spring or the time of day will also determine how the subject must be painted. An image painted with the cool greens of spring will differ in feeling from the same composition painted with warm fall hues or winter whites or the deep greens of summer. The selection of colors and the temperatures that dominate a landscape painting will naturally influence the emotional content by creating a sense of season, and thereby an essence of time.

Since the sketches in my sketchbook are all done with black ink on white paper, and since I do not make color notes that identify local color when the sketches are made, I have free rein when it comes to selecting the colors to use in paintings derived from those sketches. When I start to work from such resources, the first questions I ask myself are, "What basic colors do I want to use and what season of the year do I want it to be?" I do not attempt to replicate the colors of the original place. Instead, I use seasonal colors that satisfy my intent from the moment I start to paint from the sketch in my studio.

Suggesting the seasons

You need to think autumn, to paint autumn. You need to think rain to paint rain. You have to place yourself and your mind in the season and weather you want to portray. Your mind and spirit must feel the temperature, wind, quality of light and color in order to paint with sincerity from your heart.

Often I experience a situation such as this while painting in my studio: I am painting an autumn scene in Provence in which people are walking down a country lane near Avignon. They have raised umbrellas and are wearing long coats. Their reflections are seen in the spattered puddles on the ground, the skies are leaden with wisps of rain causing the image to be streaked. The trees and vineyards are turning orange, red and brown. After painting for a while, my mind is on wet and gray and autumn hues. When I look up and out the window at the vivid flowers in my summery garden, it is difficult to believe the sun is shining and the leaves are green, because my heart and soul are wet with rain and flooded with autumn color. Nature outside my window seems wrong, somehow. I need to think autumn, to paint autumn.

The lighthouse series continues with the editing of the landscape elements and this time the emphasis is placed on the season of the year. It is easy to see that many more paintings could be included in this series simply by moving the elements around, and changing the time of year, or the time of day, in each one.

Autumn

Our familiar lighthouse complex is edited again and this time is perched above huge boulders and surrounded by autumn foliage. Look back at the other images of this subject to see how the season of the year provides dramatic contrast and change.

Early spring

The damp fog is pervasive and trees are turning green, but some of winter's gold grasses are still evident. A little more of this wet fog and rain will cause rich greens to appear. I enjoy working in the shoulder times, between seasons.

Late summer

The lighthouse has moved again and the trees are just starting to turn color. Summer rains have tapered off and the grasses are turning gold. Hazy light, resulting from a thin overcast of clouds, produces a bright but cool atmosphere.

More examples

A few other examples of seasonal images will help to establish some basic criteria for creating paintings that contain a sense of time and season. It is good practice to take one of your old paintings and edit and repaint the composition while changing the season. Bear in mind that location may determine the colors of the seasons.

For example, in central and southern California, in southern Australia and areas around the Mediterranean Sea, the hills are dry and golden in summer. They are not green as they are in many other parts of the world. Be authentic. You can change the season, but don't change the country's climate.

Winter

Winter's almost Over, watercolor, 15 x 22" (38 x 56cm)
— Since I now live in southern California, I no longer see snow up close, and therefore do not often paint snowy winter landscapes. This painting was done as a commission — a middle United States winter landscape with cold light, but with a hint of spring in the color and the melting snow.

Spring

Central Coast Dunes, watercolor, 15 x 22" (38 x 56cm)
The sand dunes along parts of the central California coast come alive in the spring when the undergrowth inherits a light green glaze — the gift of a benevolent nature. Much of the foliage and flowers was painted at the start using a natural sponge.

Summer

Lane in Napa Valley, watercolor, 15 x 22" (38 x 56cm)
Often the trees and crops in the landscape help identify the season. Here, in California's Napa Valley, the grape vines and oak trees are green and the hedge around the house is full of flowers. It is summer and time to go for a walk along the lane.

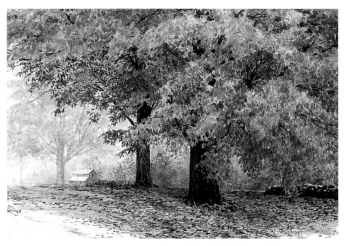

Autumn

New England Autumn, watercolor, 15 x 22" (38 x 56cm)
Trees turning color in some parts of the world signify autumn, as they do in this New England landscape. The soft blue haze is another omen of a fading summer and approaching winter. The leaves were initially painted with a natural sponge.

Time of day and emotional content

If you add the element of the time of day — early morning, high noon, late afternoon or sunset to all of the previous options, the number of possible paintings that can be developed from a single subject doubles and triples to an uncountable number.

Do not be overawed by the possibilities. I only want you to realize that there are more ways than one to paint the same subject. Each way will be based on your personal response to the subject and what you want to say, and each will project a different feeling and emotional content. The subject matter might remain the same, but the mood or season of the year or the weather or the time of day might change to create completely different circumstances, and intuitively cause you to paint in a different way. Determine what you would like to say in your painting and then "sing your song", as Robert Henri once said, "and sing it with all your might!"

The time of day is often determined by the length and direction of the shadows. Color and color intensity are also involved because hues are brighter at noon than at six in the morning or evening, when they are often warmer and more mellow. If I want to tell you about the time of day or the quality of light, or even the color of the light (which gets warmer in the evening hours), I must find ways to express that aspect of content in my work.

I often sketch a subject in full sunlight, only to change the time of day when I begin to paint from the sketch. Even if you photograph to gather subject matter resources, consider changing the time of day or season of the year when you start to paint from such resources. Editing the descriptive elements of mood, seasons, time of day and weather will help make the painting your own because your own feelings for the subject will be included in the content. Put yourself

into your work and emotional content will take care of itself.

I have selected a few images in which I tried to capture the time of day in one way or another. Look at the titles of each one, to see if I have been able to convey the time of day in a positive way.

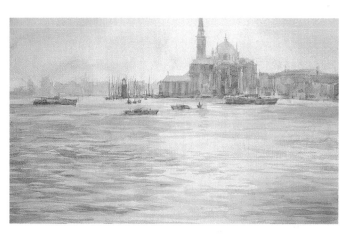

Morning

***Golden Sunrise*, Venice, watercolor, 15 x 22" (38 x 56cm)**
I walked out on an early morning to the edge of the Grand Canal in Venice to paint San Giorgio Maggiore across the canal, and was dazzled by the yelloow-gold haze and high-key values. This quick reaction took only forty five minutes of intense response to the brilliant morning light.

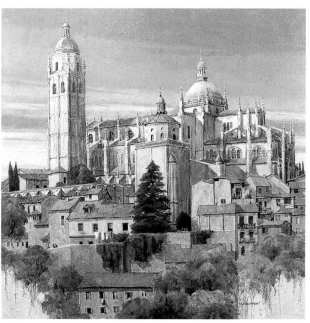

Evening

***Segovia at Dusk*, acrylic and collage on canvas, 48 x 48" (122 x 122cm)**
Evening in Segovia, Spain is a mind-refreshing experience as the warm western light bounces off the equally warm colors and intricate facets and details of the cathedral. From this angle, the massive structure seems to rise and float up from the surrounding city. The enduring power is evident, but the soft, warm light creates a sense of calm.

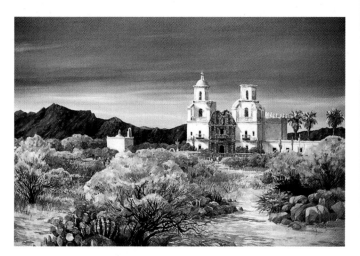

Late afternoon

***San Xavier: Time for Vespers*, watercolor, 27 x 37" (69 x 94cm)**
To witness the drama of late afternoon light in the southwest American desert is a powerful, unforgettable experience. The clear desert atmosphere on this Native American Reservation was awesome and inspirational to paint. Father Kino's church was a rare architectural gem.

Can people help establish mood?

Artists have used people in their landscape paintings for many centuries, and for many purposes. Late Renaissance artists emphasized figures and simply placed a background of some sort behind them, almost like a stage set. Leonardo da Vinci's Mona Lisa has such a scenic background. Much later, artists began to paint landscapes with figures in them — paintings in which the landscapes were most important. Then artists like Thomas Gainsborough included small figures in large landscape scenes to show the insignificance of humans and the grandeur of nature.

A single figure can emphasize a mood of loneliness, introspection or solitude. A crowd can create a sense of community, interaction, bustling activity or the chaos of a village market. Two figures might seem romantic in a natural setting. Look at the beach painting in various stages to see how the number of people present (or the lack of people) changes the content of the painting. The titles would also have to be changed to indicate the difference in mood, feeling and content.

If I make a set of images that include the same number of people in scenes of markets, downtown streets, a city park, on a front porch, in a stadium or watching a regatta, the feeling will be much the same as that projected by figures on the beach.

Example Same beach — different numbers of people

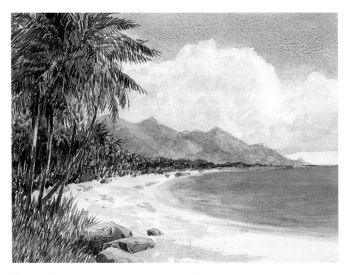

No people
A tropical beach landscape with no people seems to project a sense of being deserted, pristine, quiet and/or very early in the day — with nature being supreme.

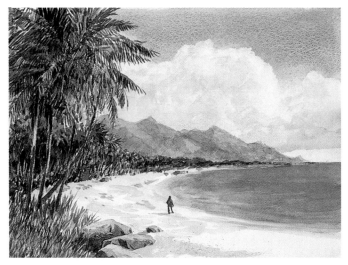

One person
The same beach with one person on it, seems to project a feeling of loneliness, freedom, exploration and/or discovery — or maybe being lost.

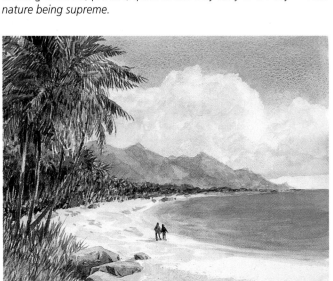

Two people
A scene of the same beach with two people on it seems romantic, intimate, pleasurable with maybe a sense of getting away from the rat race — together.

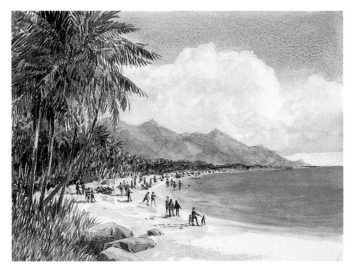

Lots of people
The same beach crowded with scores of people projects a feeling of congestion, crowdedness, chaos and a sense of vacationing summer hordes — with the accompanying noise.

The entire chapter summarized in one painting

This complex landscape subject deals with the weather (lifting fog)

A sense of place (the dunes and reed-filled bird sanctuary in Carmel)

A feeling of calm and quiet (pelicans at rest in the water

The harmonious palette (muted greens)

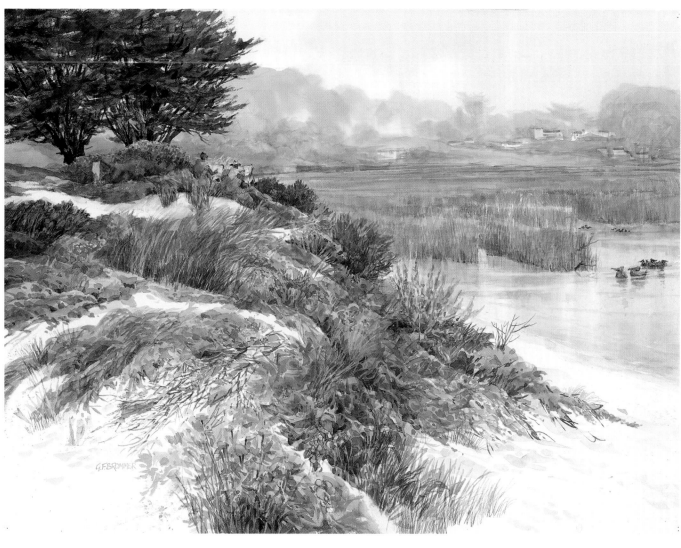

Artists at Work, watercolor, 22 x 30" (56 x 76cm)

The two artists and their trees were edited into the mix from about fifty yards away, but they clinch the emotional content. Their quiet work and evident respect and love of nature complete the emotional content with a visual exclamation point!

Figures will usually become the focus of landscape paintings because they are different from trees, bushes and rocks, and because we easily relate to them. They can be active — working, standing and talking, shopping, carrying things, walking along a trail, or engaged in other activities. They can aid in conveying the emotional content of a painting by providing an active focus which centers on a person or people engaged in a specific act such as rowing boats, cutting flowers, climbing a hill, having a picnic, working at some task, playing a game, carrying things from market, and so on. If the figures are kept small, they become part of the scene, but do not dominate it. If they are painted large, they might dominate the subject and the work will be about them, with the landscape being secondary. These are still more options from which artists must make their personal choices to help say what they want to say.

All these options for you to use

Mood, seasons of the year, time of day, weather and the presence of people are powerful determinants in conveying the content of a painting. They are part of your many options and your personal choices. Practice them all so you can implement them when you wish. If you think that such practice is boring, remember how Claude Monet worked on a series of haystack paintings in different seasons, at different times of day and in different light. Or, consider his series of paintings of the facade of Rouen Cathedral.

The number of possibilities from a single resource is staggering. First, determine what you wish to say, and then consider the multiple options. Make your choices. And then PAINT!

How to work on location to inject emotional content

Ultimately, painting outdoors is all about capturing your honest reaction to a subject so that it sparkles with life.

I am extremely happy when I am standing at my half-easel, in some exciting and inspiring location, and painting my feelings and interpretations of some unique place. It is my favorite art activity. As much as I enjoy studio painting, building collages, working from sketches, teaching workshops or making large acrylic and collage images, I would honestly say that for me there is no painting activity more pleasurable than working outdoors.

Heaven is painting on location

We were workshopping one spring in Cornwall and Devon, in England. In a shop in Exeter I had seen a photograph of Bickleigh, a picturesque village on the River Exe, in the moors above Exeter. Our intrepid bus driver was able to find the village and the view across the river was fascinating, and even more exciting than the postcard image. After obtaining permission for our group of artists to paint in a green pasture where the view was most interesting, we needed to keep the cows at bay while we worked, but the experience was well worth the effort. At lunchtime, my wife brought me a ploughman's lunch from the village pub across the nearby stone bridge. As I was standing in the pasture, with chutney, a great chunk of bread and sliced onions on my plate, a slab of cheddar cheese in one hand, a loaded paintbrush in the other and a pint of ale by my palette, I thought to myself, "Heaven will probably be something like this! What a euphoric state to be in! How fortunate I am to be a painter! This is as good as a painting experience can get!"

Not all *plein air* experiences are as pleasant and heaven-like, but most of them are positively thrilling adventures into the personal realm of experiencing and painting visual and sensual responses to the natural environment.

When I am painting alone, this kind of experience is quiet, introspective and solitary — a personal communication with nature. In a workshop, it is a shared experience and is seen through many sets of senses. It is my privilege as a teacher to make such experiences as personally rewarding and enriching as possible. Notice, I said "experiences". I feel the experience of exploring personal responses to an environment is much more important than the finished product, because of what happens to us when we paint on location.

Let us now explore the impact and importance of emotional content in some location paintings.

Different locations — different emotional content

These three photographs were taken of my half-easel in three completely different locations in three distinct parts of the world. (My easel is an indispensable and well-traveled bit of equipment.) On the drawing board are three different types of location subjects that exhibit three kinds of visual responses and three kinds of emotional content.

Emotional content
The lonely, arid, severe and monochromatic landscape (almost a moonscape) in Death Valley in California.

Picnic at Prout's Neck, watercolor, 18 x 30" (46 x 76cm)

I was walking over these rocks on the Maine coast at Prout's Neck. I was carrying my half-easel and all the necessary painting gear for a day on the rocks in front of Winslow Homer's home and studio. I stopped to chat with a man who was walking his dog, and naturally the conversation turned to painting outdoors just as Winslow Homer did. After a bit, the gentleman told me he was Homer's great grand nephew (I have trouble remembering such complicated relationships) and that if I wanted to, I could paint right on the Homer property. Talk about excitement! I was painting this

watercolor where the American master painted some of his watercolors! What a trigger that was. This painting is a direct response to the place, the personal excitement I felt, and its history and its powerful connotations. I painted directly for several hours on two pieces, and then finished them a few weeks later in my studio back home in California. The sense of place is so strong with me, that when I look at this image I can feel the biting wind, hear the sea gulls screaming, smell approaching rain in the air and feel the sharp, craggy rocks under my feet.

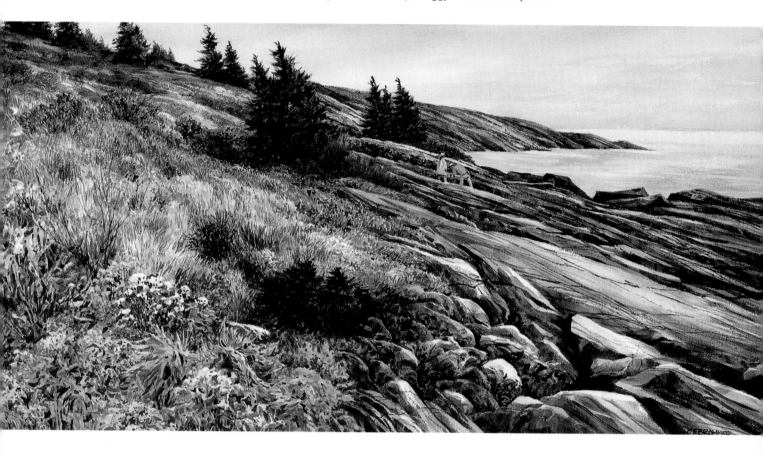

Emotional content

The congested, busy, active and exciting urban landscape in the Plaza Colon in downtown Madrid, Spain.

Emotional content

The contrast of a lush, tropical, green landscape with an abandoned sugar mill on the Hawaiian island of Oahu.

Responding to the location

A landscape painting done on location possesses emotional content when it offers the viewer a visual description not only of the literal or physical elements of the place, but of the artist's feelings and understanding of those elements and a spiritual response to the place. We have discussed the concept of "sense of place" at length in Chapter 7.

Visually describing and responding to a subject begins with learning to sense when you are in the presence of a subject that will excite and inspire you. Does it make you say Wow!? Does it elate your spirit? As you have often heard, paint what you know and what is important to you, because you will be completely involved with the subject. However, how do you know what is important and inspirational to you when you are confronted with an entire French village, or the endless

indentations and islands along the coast of Maine or the western coast of New Zealand's South Island?

I strive to be open to what I will see and experience, and not have a preset plan before I even arrive at the scene. I gave that practice up years ago, after I visited Sedona, Arizona for a bit of vacation and some painting. Several years before, we had been to the same area, and I remembered the rushing waters of Oak Creek tumbling over huge boulders and splashing merrily down the canyon. So, on the drive from Los Angeles to Sedona, I was planning paintings in my head — all centered on rushing, white water and intense, colorful boulders. HA! Not so! When we arrived in Sedona, we found the river to be nothing more than a very tiny trickle — the result of a year-long drought. No splashing water. No tumbling stream. Just boulders. That

was my last attempt to predetermine the subject and emotional content of my location paintings before I even arrived at the place.

You'll know it's right if it excites you

When I get to a location, I look around the area to try and select a single subject and two or three options from an incredible array of resources. I try to use all my senses and be extremely alert. I try not to take too much time for this, since I could spend hours looking for the perfect spot, and when finally found, be too tired to even paint the subject. We make the perfect spots in our mind and on our papers by editing the elements in the surrounding environment. Above all, I want to be very excited about what I am going to paint.

Often, something will happen while I'm looking around. For example, a

Art in the making Getting the initial emotional response on site then finishing

This demonstration was started after a workshop in Palm Springs at another location. The day was almost gone, and the evening light was warm and glowing on the Agua Caliente Indian Reservation.

On location . . .

1 The scene
This is what I am looking at, over my easel. It is late afternoon and the sun sets early behind the high Santa Rosa Mountains to the west, so I need to work quickly before the warm light is completely gone.

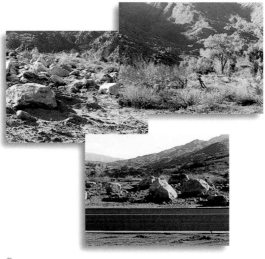

2 Choosing elements I can include
Looking around for elements that might be included in my composition, I can use rocks, the warm evening color, shadows and other desert vegetation to complement the distant trees and mountains.

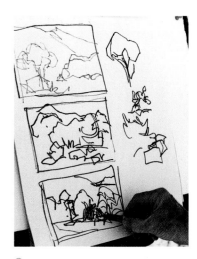

3 Composing the scene
I quickly sketch a few of the major elements, and then make three quick arrangements of things I wish to include. I want to pull the distant trees up close, delete the parking lot and move some rocks and plants.

Decisions to make before beginning a location painting

Before starting a new painting on location, you can do what I do and go through a quick series of decisions while setting up your easel and getting things ready. The more you practice this routine, the easier and quicker the choices can be made. Sometimes other decisions need to be made too, but this is a convenient basic list.

1 Look for subject matter that gets you excited.

2 Select the elements to include in the painting.

3 Arrange and rearrange them through four or six quick sketches.

4 Select the arrangement that seems best at the time.

5 Select the format — vertical, horizontal or square.

6 Select appropriate mood, feeling, sense — happy, old, bright, rainy, bright, gloomy, foggy, isolated, lonesome, windy, cold, stormy, quiet, somber, exciting, tragic, hot, heavy, congested, and so on.

7 Decide on appropriate high-key, low-key or mixed values.

8 Decide on a temperature dominance, and thereby the appropriate colors.

9 Decide on light quality, such as overcast, filtered, bright, raking, evening, backlighting, warm or cool.

10 If necessary make a few written notes on these decisions.

11 Start the painting.

off in the studio

4 Blocking in major elements

I don't really copy one of the preliminary sketches, but they make me aware of what I want to include. I often use a pointed brush and a light wash to block in major elements. (This type of brush prevents you from getting too detailed.)

5 The first tones down

The large tree shapes are put down first, and kept light in tonal value to catch the late sun. A dark warm wash already on the mountains contrasts nicely with the light tonal valued trees, and I begin to feel the composition.

woman opens her shutters and looks outside, or calls to a neighbor. A few men gather to sit in the sun and talk. A fishing boat ties up at the dock. The sun comes out and casts dramatic shadows. A storefront door opens and a grocer begins to set up his market for the day. The sun suddenly glints off the ocean's surface or the wave activity increases on the beach. The texture and color of a Tuscan wall comes to life when the sun strikes it, sending chills down my spine. An open gate invites me to look inside . . . what could be there? A sudden breeze causes a shower of autumn leaves to float to the ground. These and similar happenings can get me started on a stimulating painting adventure.

I remember walking one morning, and leading a group of artists to the lighthouse at Pacific Grove, in California. It was a walk of about a hundred yards, but when we were about halfway there the sun suddenly burst through a broken sky and lit up a nearby hillside that was covered with a red and magenta succulent ground cover, locally called ice plant. The flaming color was absolutely brilliant, and simply demanded to be painted. I stopped, set up my easel and explained a change in plans. I ecstatically painted the hillside in all its glorious color — and later dropped the nearly forgotten lighthouse into the background. Editing the landscape is wonderful! The lighthouse was now relegated to a spot in the background. A process like this is likely to happen when responding to the location with all of your senses. It is reacting to a trigger that generates excitement and propels us into action.

Whatever it is that really grabs my attention, that is what I know I should paint! Then I ask myself, why this subject or this scene excites me? That will determine the emotional content I wish to inject into my work. I always get more enjoyment and do a better job of painting when I am excited about the subject I want to paint.

What if a response doesn't happen immediately?

Sometimes when I am before a landscape or cityscape, the response is immediate, and the emotional content I wish to build on, hits me with powerful connotations and multiple possibilities. At other times, the emotional content I might wish to communicate only becomes evident after painting for a short while and gaining an increased awareness of the environment — and sometimes it happens during the studio part of the process. It doesn't matter when this sense of urgency to establish emotional content and to sincerely express myself becomes manifest. But it is important that I recognize the need for it, and respond with all my heart when it does becomes evident.

6 Lifting off color with a tissue
Darker mountains with deep, cool shadows are first painted down and then lifted off with absorbent tissue to simulate desert textures and establish contrasting tonal values. These cools will be warmed with later glazes.

7 Feeling for volume
Cool shadows in the trees will be warmed up later, but initially are used to help me feel the volume of the trees and in some places to separate them from each other.

Editing for optimum emotional content

Provencal Village Market,
watercolor, 22 x 15" (56 x 38cm)

The emotional content for this painting was predetermined. I knew what I wanted to say before I picked up my pencil to start drawing. While in Tourettes-sur-Loup, I had just finished a demonstration painting. The group were off searching and painting their own subject matter. Then I turned my easel around 180 degrees to face this view. However, much editing was done, because there was no market there at all. I liked the buildings, moved the church steeple into view, gave the piazza an undulating surface and moved a little market into place.

Emotional content

I wanted to convey the importance of the village market to the residents who daily shop in such marvelous medieval towns, and who have been doing it for centuries. I had experienced this first hand, while making a painting here. I have actually used the idea of such a little market as a focus in several paintings since experiencing this fortuitous event.

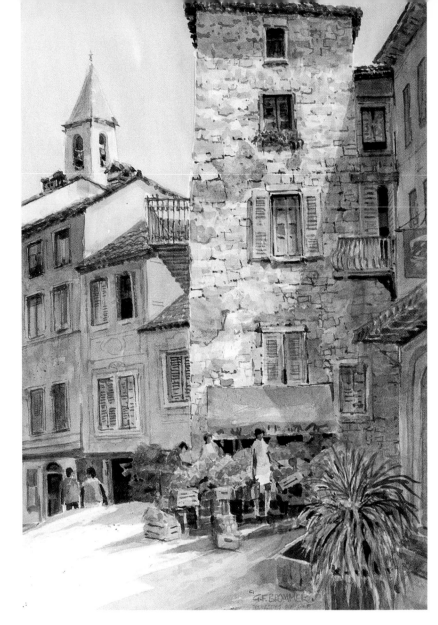

8 Placing darks

Some darks were added in the focal area, which will be developed much more fully in the studio. The value pattern and focal area are evident. Some sizes will need to be changed, but that can also be done in the studio.

9 The on-site work finished

Before leaving the site, I add a few details and punch in some of the darkest darks. I have warmed up the mountains, foreground rocks, desert shrubs and some shadows. I feel that the sense of place has been established. Now — off to the studio.

Capturing emotional content with the very first marks on paper

The working method shown on page 120 will not be comfortable for everyone, but over the years it has proven successful for me. It enables me to think about the sense of place and emotional content from the very first marks on paper. The response process can be simplified like this:

1. Make a few quick organizational sketches (30 seconds for each).
2. Do a direct outline drawing with pencil or with a pointed brush and a light wash.
3. Paint big shapes first, trying to fill the sheet with light tonal values of local color rather quickly.
4. Begin to build up value structure and establish movement patterns with glazes to darken some areas.
5. Add a few details in the focal area, primarily.
6. Drop in the darkest darks, although not yet full strength — to sense the possible range of value contrasts.
7. Check for overall sense of place.

When I begin to fiddle with details or find that I am painting without looking at the resource, I stop. The rest of the painting can be finished in the studio, under the best possible lighting conditions, and with a reduced sense of urgency.

The response/reaction (on site) is the emotional and creative part of the experience, while the finishing and design parts of the process (in the studio) are intellectual. The first process is (so called) right-brained and the second is (so called) left-brained. As soon as I sense that I am beginning to shift gears and intellectualize the design aspects of the work, I stop. Then I take up another sheet of paper and begin another painting. I may never be back at this location again, and I want to gather as much resource information and start as many responses as I can. Remember that the experience of painting out in nature is valuable in itself, and is more important than the finished product.

Santa Giustina, Padua, **watercolor, 15 x 22" (38 x 56 cm)**
The dense simplicity of this church, plus the fact that it is sited on the edge of the largest open square in Europe (the Prate Della Valle), simply took my breath away. The combination and contrasts of white marble statues in the piazza and the dark brown brick building were fascinating. But the concentration of people, buses and automobiles flitting around the area was exhilarating. What a wonderful combination of elements. Immediate emotional content!

Emotional content

I wanted to convey the feeling of the bulk and solid enduring quality of the church; the rare openness of the huge space in front of it; the ever present and almost incongruous white sculptures (scores of them) in a large oval formation around the open space, and the constant movement of vehicles and pedestrians along with the accompanying noise. Instead of leaving the sculptures in a structured line, I decided to make them appear to be walking around the area, seeming to mix with contemporary citizens of the city.

In the studio . . .

The demonstration continues in the studio. Notice in the captions that I explain why I make each change or alteration, rather than simply show you how to do it. I want to make sure my emotional content is as readable as possible — that I have captured my response to the place, and the feelings that I experienced and felt when the painting started. Everything I now do must not only help describe the subject, but clarify my intent in painting the location subject.

10 Lifting lights and softening edges
When I get in the studio, I study the unfinished work to check for mood, focus, emphasis, size relationships, feeling of space, color and sense of place. I take a damp sponge and lift some lights and maybe use a wet bristle brush to lift and soften some edges.

11 Warming and darkening
The sky and distant mountains get a touch of warm, to begin the feeling of late afternoon, direct light. Warming and darkening the nearest mountainside pushes the trees into the sunlight. I like that feeling because it speaks of my desired emotional content which emphasizes the time of day and sense of place.

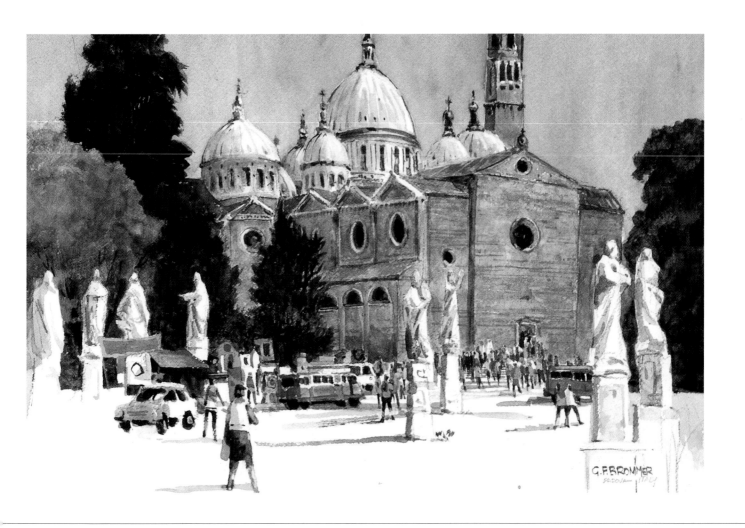

12 Enhancing movement

Starting with the major tree forms, I begin to establish a tonal value pattern that will make use of lost edges and crisp shadows to create the feeling of early evening desert light. Some areas are scrubbed out, others are painted to link darks and lights. A sense of movement and design is vital at this stage.

13 Detailing

Detail is added in the focal area to create some visual excitement and to pull the viewer's eyes into that part of the painting. Color, shadows, texture and tonal value contrasts are employed to create the desert evening.

> ## "I want to respond to the location with all my senses (sight, hearing, touch, smell) as well as with the sensitivity of my spirit."

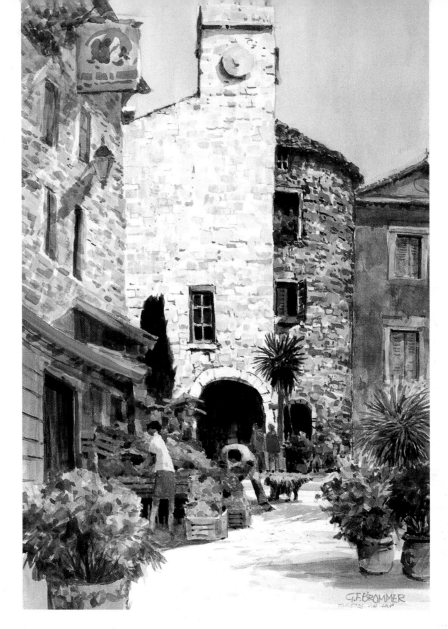

Changing the emotional content

Tourettes-sur-Loup/Morning Market,
watercolor, 22 x 15" (56 x 38cm)

When I entered the French village of Tourettes-sur-Loup in the hills above Nice, it was early morning and I planned to do a demonstration focusing on the ancient stone tower and gate into the old part of town. The emotional content was about the feeling of ancientness and durability.

As I was setting up my easel, a doorway opened a few yards ahead and a grocer began moving produce boxes outside to set up his little market — taking away part of my view of the tower. Wow! The emotional content of the proposed painting immediately changed. The focus shifted from the tower to the activity around the little market place. The emotional content now concerns both the sense of place that characterizes the village, but more importantly the color, life and daily activity of the contemporary inhabitants of this ancient village. Such contrasts make for intriguing images.

14 **Unifying with glazes**
Warm tones and shadows are glazed over other colors to create a sense of unity, as well as to establish the feeling of late afternoon light and warmth. Notice how darks are used in many places to push parts of the composition into the fading sunlight — one last bit of warmth — evening glow!

15 **Finished painting — *Coachella Desert: Evening Glow,*
watercolor, 15 x 22" (38 x 56cm)**

The entire chapter summarized in one painting

This painting was done on location on the westernmost tip of the Sorrento Peninsula, in Italy. When I was about finished with the response aspect of the painting on location, I turned and found six people standing behind me, speaking very quietly in Italian. When I acknowledged their presence, I saw tears flowing down the cheeks of one elderly woman. They used to live in this village, but left to live and work in New Zealand. They were simply back home for a visit. In perfect English, she told me, "This is the most beautiful painting of my village that I have ever seen!" I had communicated to her, my feelings about her village and my own personal reaction to it.

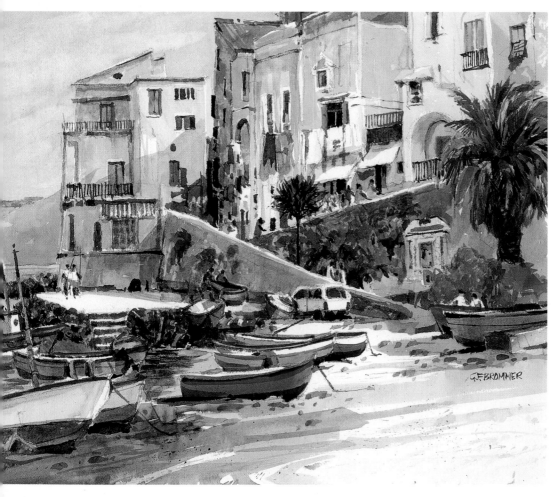

My response to this harbor scene
Harbor at Massa Lubrensa, watercolor, 16 x 20" (41 x 61cm)

I chose this location because of the combination of elements — the boats, the daily activities of the people and the fascinating cluster of hillside structures.

The color, activity and light triggered my response.

The place made me feel happy and contented because of the comfortable daily life here.

I want you to feel my contentment — nothing fancy, but an active, daily routine.

I painted the elements directly, with no pretense toward being a world class subject or masterpiece material — just good vibrations. Color would be important to the sense of place.

I felt the day as mid-morning with activities in the town in full swing. Everybody doing something. A beautiful day in the village.

I wanted others to feel my enjoyment with this typically active Italian coastal village. The emotional content would be concerned with this activity.

Ultimately, painting outdoors is all about capturing your honest reaction to a subject in a way that sparkles with life and bears witness to your personal response to the site. That response is content. The experience of painting this way on location is far more important than the painting itself. Painting as a verb (the doing of it) is more important than painting as a noun (the finished product). So allow yourself to react honestly and freely, and enjoy the process of reacting and painting that reaction. The visual manifestation of your feelings will inject genuine life into your work and help you better understand the concept of emotional content in painting.

Some conclusions and a look ahead . . .

I have tried to define emotional content in landscape painting to the best of my abilitiy, and have provided and illustrated many ways that personal involvement and response to our natural and human-built environments can be expressed. I believe emotional content is the life force in painting. Without it, painting is merely colored decoration.

I was once jurying a national watercolor show with my friend Millard Sheets, and as we talked before starting to study the paintings, he said, "We have to look beneath the surface of the paintings to see what the artists have to say". This was his concept and statement about emotional content.

My friend Katherine Chang Liu put it this way, "I want to be able to find the artist in the painting". No matter how it is understood or defined, emotional content concerns the communication of ideas, concepts, sensitivities, responses and feelings between artist and viewer.

Emotional content cannot be successfully and continuously employed in painting without a solid foundation in drawing, design and technique. We need the tools and vocabulary before we can say what we want to say in our work. Developing such skills takes practice, and practice takes time and effort and dedication.

There is an appropriate story about Ludwig van Beethoven who had just finished performing one of his compositions. He was surrounded by a crowd of admirers and each person was trying to outdo the other in praising both the work and the performance.

"If only God had given me such a gift of genius", one woman gushed. Beethoven turned an unfriendly look on her. "It isn't genius, madam," he said coldly. "It isn't magic either. You can be as good as I am. All you have to do is practice on your piano eight hours a day for forty years!"

Practice is vital, but what we practice is also important, because there is no substitute for basic skills. John Wooden, renowned basketball coach at UCLA, once said, "If you spend too much time learning the tricks of the trade, you may not learn the trade". In other words, work and practice on the basic skills until they are fully ingrained in your being, and then paint to your heart's content. Or as Robert Henri said about painting and life, " . . . then sing your song with all your might". Don't neglect the basics which are the foundation of good art.

As I conclude the work on this book, I am continually thinking of other things I would like to include, and perhaps should have. And many might be of significant importance. But that tweaking process could go on forever. Terri Dodd, my editor, is calling and I need to move on. I hope what I have communicated about emotional content will be helpful to you in your quest to become a complete artist.

Emotional content is communication and that is art.

I want to close with a meaningful photograph of me painting in the village of Tourettes-sur-Loup in the hills above Nice, France. The reason I like it is that while I am busy dealing with emotional content in my own painting, in the sunshine there are two delightful French children painting their own pictures. They are not concerned with emotional content, but unknowingly are involved with it because they are visually telling their stories — expressing themselves with their art. They are part of the next generation of artists, carrying on present traditions along with those of the past — visually sharing feelings, ideas and responses with others.

The beat (and art) goes on!